NEW ZEALAND
The·
LIVING LAND

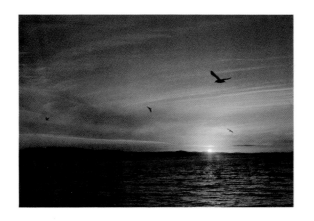

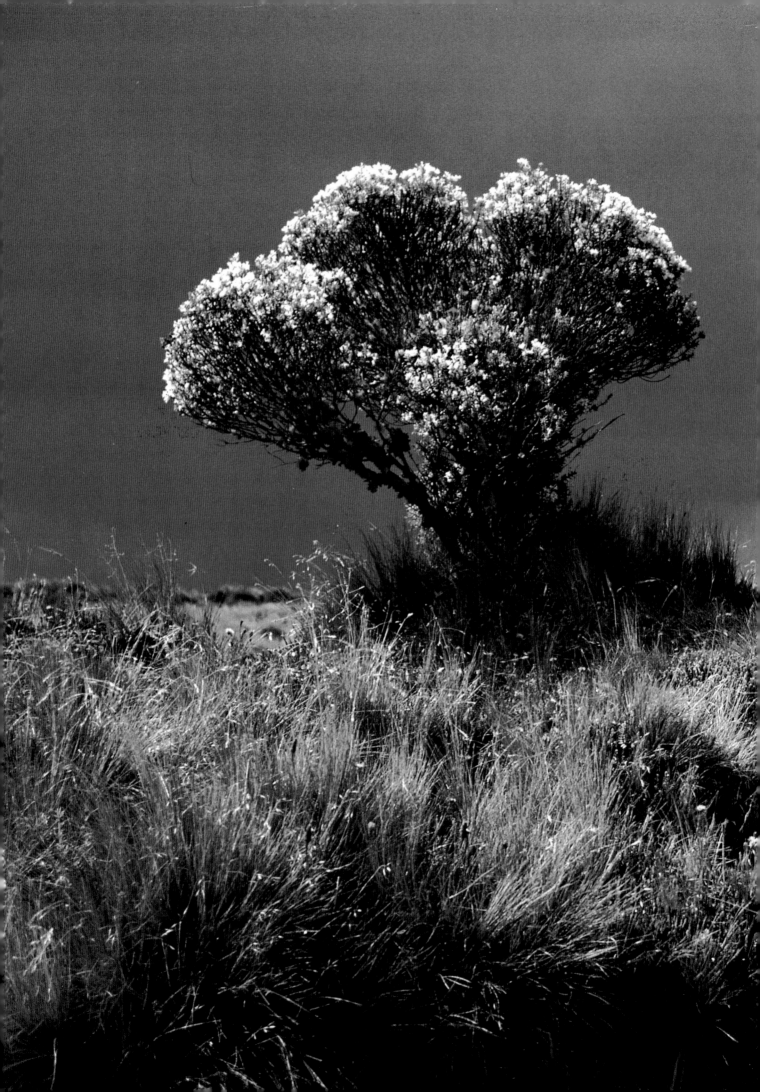

NEW ZEALAND
The
LIVING LAND

GEOFF MOON

COLLINS
AUCKLAND
in association with
DAVID BATEMAN

First published in 1986 by William Collins Publishers, P.O. Box 1, Auckland, New Zealand, in association with David Bateman Ltd, "Golden Heights" 32-34 View Road, Glenfield, Auckland 10, New Zealand.

ISBN 0-00-217576-2

Typeset by Rennies Illustrations, Auckland.
Printed in Hong Kong by Everbest Printing Co. Ltd.

Design by Neysa Moss.

Distributed in the United States of America by Sheridan House, Inc., Dobbs Ferry, New York 10522.

To my family

CONTENTS

FOREWORD

A good way to understand the essential things about New Zealand is to take up Geoff Moon's overview of its landscape. A surprising amount of its living cover is still natural: forests, wetlands, tussocks, up to rock and snow. Then there are coastlines with far-reaching harbours and estuaries.

New Zealand's beauty owes little to man's creation — and we haven't yet irrevocably spoiled it, but the human species is a constant influence on the landscape nowhere more than in some of our world's richest farmlands and fastest growing exotic forests.

In ecological language, man 'interacts' with the biosphere, sometimes spoiling and wasting it, regularly producing from it, and at times keeping it natural. Our reaction with the landscape is unique to our species. We may not only exploit it, but approach it with wonder. We can enjoy it, and appraise and reflect on it. Such reflection will be needed, by our children and politicians and ordinary people. Remember how 'ordinary' — and like ourselves — politicians are, and how much they will need to know if our exploitative use of the landscape — and the sea around it — is to be tolerable or sustainable.

New Zealanders are becoming good at thus interpreting Nature, and by any reckoning Geoff Moon stands near the forefront. His superb skill as a photographer of birds in their habitats has broadened here to cover the whole landscape. As this book will help us realise, appreciation of the landscape and its species is first an emotional, even ethical, thing. The living world has a transcendent appeal that is beyond economics, in the sense that poetry or music is beyond prose. But we have a prosaic and practical need of it, too. Whatever virtue or sacrifice we lay out in conservation will bring us sound rewards in farms and forests and fisheries, and, in today's New Zealand, in our horticulture and tourism.

JOHN MORTON
Professor of Zoology
University of Auckland

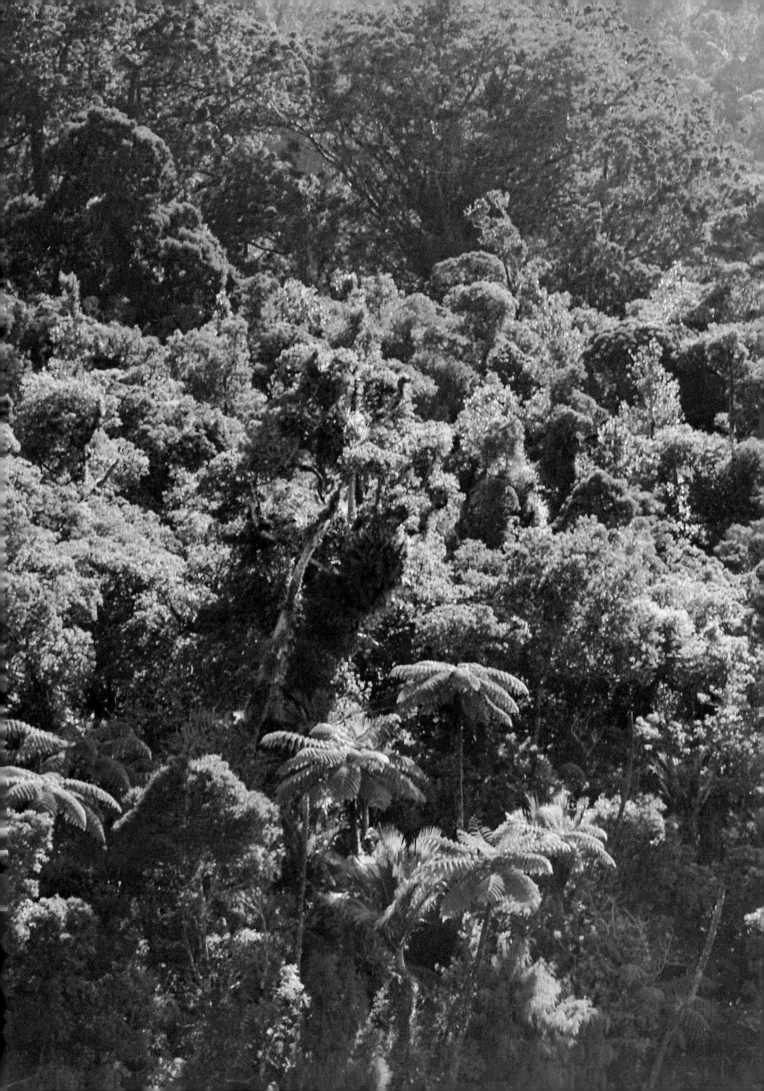

INTRODUCTION

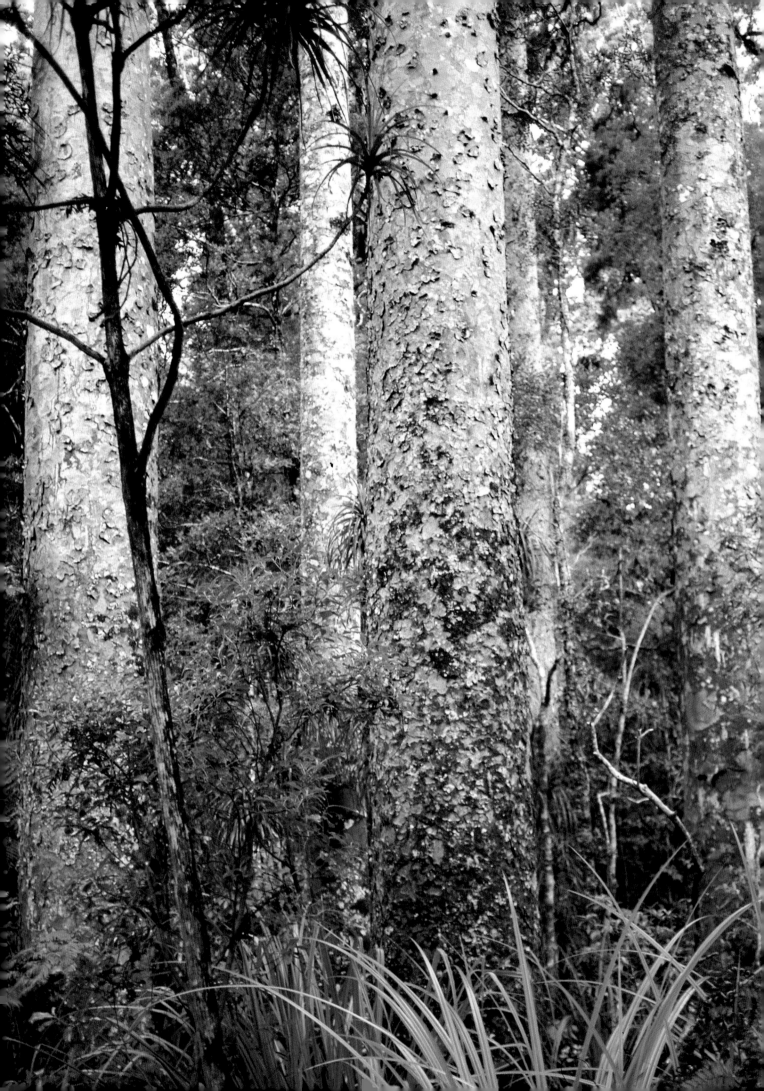

This book is a celebration of the beauty and grandeur of the landscape of New Zealand and of the wildlife which lives there.

In the settled rural areas, which now occupy much of the New Zealand land mass, the most conspicuous animals are introduced domestic livestock: cattle, sheep, horses, goats and, more recently, deer. Most noticeable of the accompanying wildlife would be several species of introduced and native birds, with perhaps rabbits in certain localities. In more remote and rugged landscapes, however, it is the rich birdlife which first captures the attention, but a closer look uncovers insects and the occasional reptile. Some of these creatures existed here long before the advent of human settlement, and a select few are of very ancient ancestry.

The original primeval forest, which once extended over a large part of the central North Island, was destroyed by the cataclysmic Taupo eruption of about 200 AD. Tussock and scrub vegetation soon colonised the pumice layer and this was progressively invaded by larger tree species seeded from neighbouring forests which had escaped the volcanic showers.

When the Polynesian settlers first came to New Zealand, the land was covered in dense forest with some areas of tussock grassland, lakes, wetlands and alpine vegetation in the high country. The Polynesians first settled in the coastal regions of both main islands, using fire to clear vegetation and so provide land for cultivating their crops. Sometimes these fires spread uncontrolled and ravished extensive areas of forest. Where the burned land was not used for cultivation, it was soon overtaken by tussock grasses and shrubs, a type of vegetation which still persists in low rainfall regions, particularly in eastern parts of the South Island.

Apart from their food plants, the Polynesians also introduced two mammals, a dog (kure) and a small rat (kiore). It is difficult to gauge what effect these two animals had on the pristine environment. However, we know the dogs were used for hunting and some undoubtedly escaped into the wild. Besides eliminating many species of moa, the Polynesian hunters and their dogs were responsible for the extinction of at least a dozen other species of birds.

According to the palaeontologist and ornithologist, C. A. Fleming, writing in Volume 1 of *New Zealand's Nature Heritage*: 'The arrival of Polynesian man in New Zealand, together with his dog and rat and his knowledge of fire, brought about changes in New Zealand ecology more severe than any of the violent

Kauri trees.

'Below, a realm with tangled rankness rife,
Aloft, tree columns in victorious grace.'
— William Pember Reeves

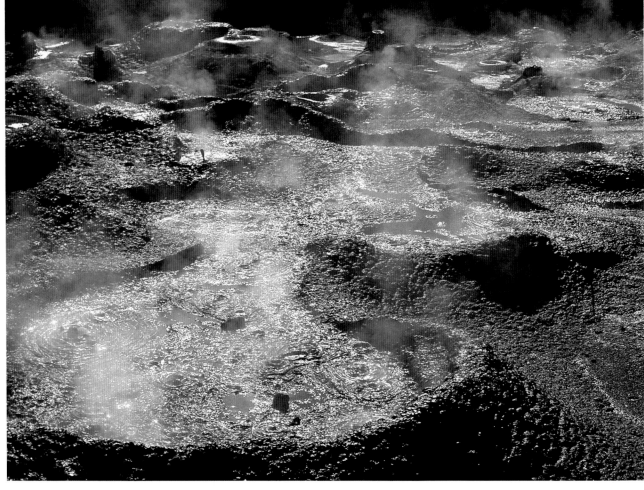

fluctuations of climate that had taken place since the first Ice Age some 1,750,000 years ago.'

At the time of the first European settlement, probably sixty per cent of the land below about 1000 metres was still forest clad, with tussock and alpine vegetation growing above the treeline. However, almost all the original forests on the east coasts of both main islands had disappeared; only a few areas such as Banks Peninsula and the Catlins had escaped destruction. The forests of Stewart Island remained intact.

The arrival of settlers from Europe, however, had a far more devastating effect on the New Zealand environment. It was understandable that newcomers hoping to make a living from farming would clear land and create pastures, but much of the forest removal was unnecessarily ruthless. The extensive clearing of the native bush from steep country caused rapid rainwater runoff which eroded hillsides and flooded lowland areas.

At the same time the settlers introduced many exotic plants and trees. Some, like gorse, broom, blackberry and wild rose, spread rapidly in the favourable climate and, although many of the exotic deciduous trees brought beauty and shade to the countryside, certain species, such as willows, soon began to pose ecological problems.

Introduced browsing mammals, notably deer, goats and opossums, began to cause widespread destruction of the forest. Opossums damaged shrubs and canopy trees, often completely denuding them, while deer and goats grazing on the forest floor prevented regeneration of the trees. Rabbits and hares threatened native vegetation in high-country areas and had a devastating effect on farm pastures.

The country's abundant birdlife, which had evolved in an environment free from mammalian predators, was easy prey to mustelids such as stoats and ferrets, brought in to control the rabbits. The domestic cat too was a formidable predator and threatened even larger birds and reptiles.

The transformation of native forests into pasture and arable land for farming was undoubtedly the most dramatic of all the changes wrought by the European settler. Throughout both islands you can now view extensive panoramas of farmland without sighting a single native tree, though the magnificent spring and autumn foliage of introduced deciduous species does bring welcome relief to the monotony of paddocks and sombre pines. Nevertheless, had it not been for the widespread plantings of pine forests for timber several decades ago, there would today be far more pressing demands to log our remaining native forests to meet our need for timber.

In the twentieth century the demand for electric energy has had a major impact on the landscape, and the waters of many of

TOP LEFT First the early Polynesians and then the European settlers progressively burned and felled the forests to create open land on which to grow their crops and graze their stock.

TOP RIGHT Polynesian settlers brought with them the small rat (kiore) which they used for food. The kiore is now only found on offshore islands, and is not considered to be a serious threat to wildlife.

BELOW RIGHT The tuatara is now only found on predator-free offshore islands. The tuatara is a reptile with very ancient origins dating back to the age of the dinosaurs.

BOTTOM Main areas of volcanic activity occur in the central North Island volcanic plateau.

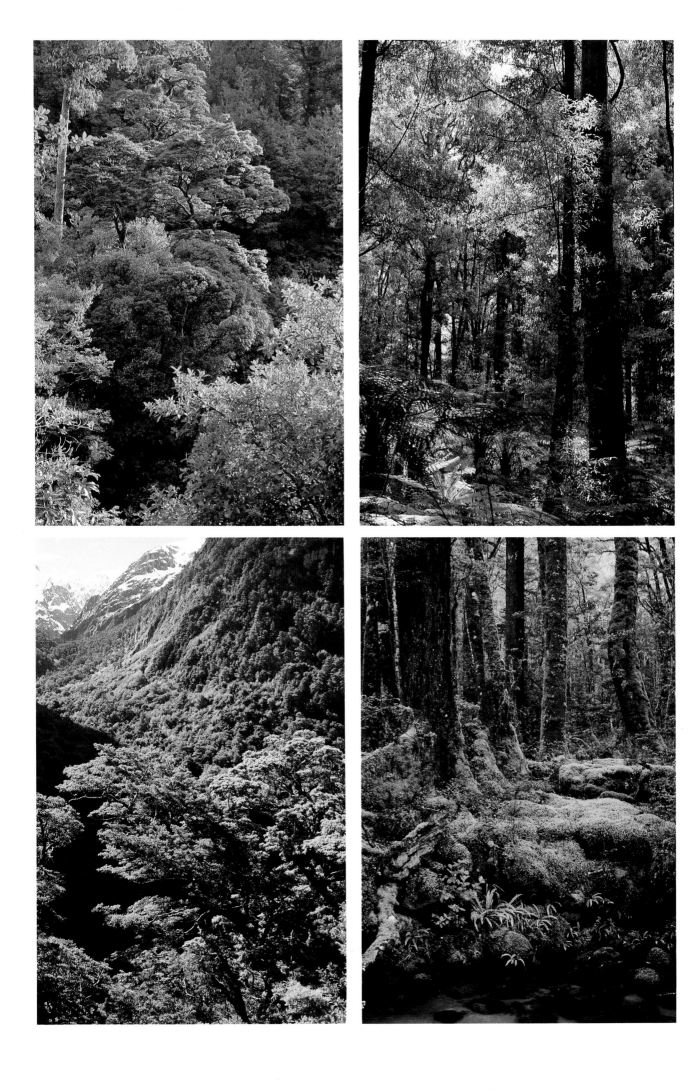

our larger rivers have been harnessed for hydro-electric power development. This has considerably altered the ecology of these environments, although newly created storage lakes sometimes offer fine sporting facilities and splendid scenic attractions.

Today, however, we have come to value our precious forest remnants with their diverse animal and plant associations, our majestic mountain landscapes and our spectacular and varying coastline where vast stretches of deserted sand and impressive rocky headlands remain untouched and unspoiled. And while our wetlands have been considerably reduced by drainage for agricultural development, they too still harbour many beautiful and interesting forms of plant and animal life.

Although some of the New Zealand landscapes today are quite different from those found here before human settlement, they retain their intrinsic nature. The countryside surprises with ever-changing shapes, patterns and lighting within a comparatively small land mass. It is not difficult to find complete isolation from the hustle of town or suburb and to experience firsthand the wildness and beauty of New Zealand's diverse landscapes.

In this book I have illustrated just a few of the subjects which, over the years, I have been stimulated to capture on film. I have always been fascinated by the mysteries of natural history, particularly those of animals and plants, as well as by the shifting moods of the sea and land. Here I can only offer some suggestions of the richness and variety of our wildlife and our landscapes.

In conclusion, I would like to acknowledge those people, too numerous to mention by name, who have helped me with advice or provided opportunities to photograph many subjects. Special thanks must go to my wife, Lynnette, and to David Bateman and Ray Richards who encouraged me to write this book. I would also like to express appreciation to Neysa Moss for her co-operation with the book design, and to Joy Browne for her editorial work.

GEOFF MOON
Auckland 1986

TOP LEFT Mixed rain forest.
TOP RIGHT Remnants of dense lowland podocarp forest have been preserved at Pureora, west of Lake Taupo, and at Whirinaki, adjacent to the Urewera National Park.
BOTTOM LEFT Montane beech forest in Fiordland.
BOTTOM RIGHT Typical beech forest near Murchison in the South Island.

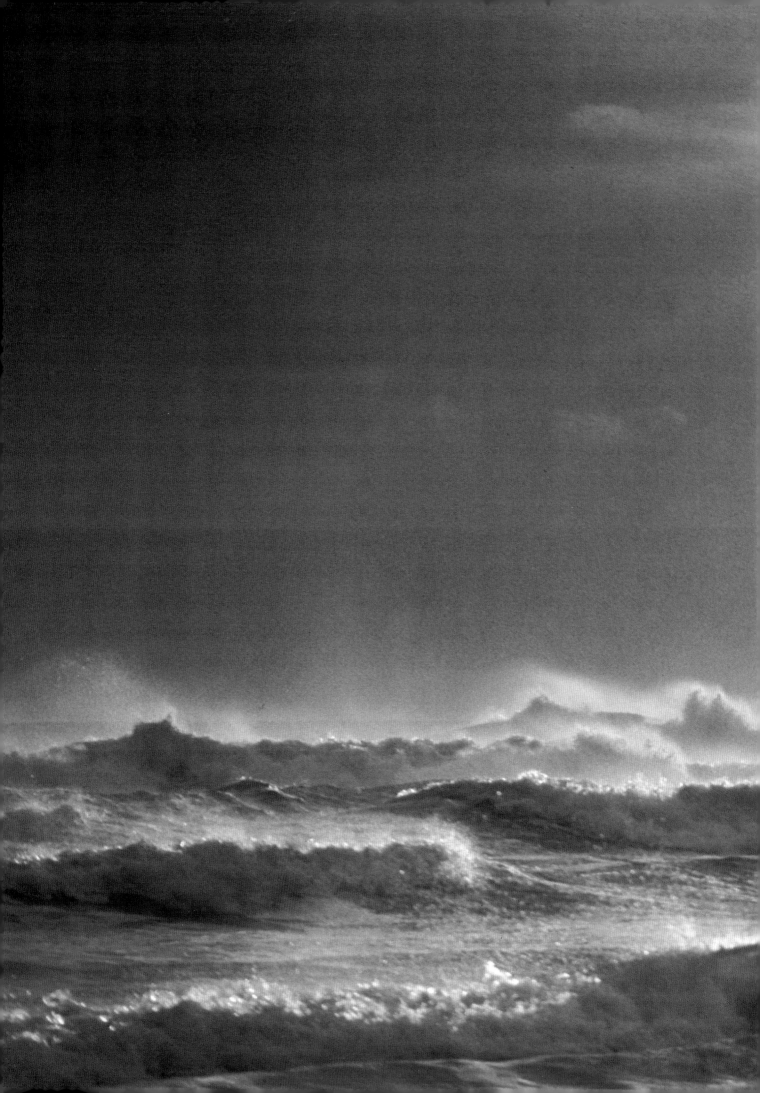

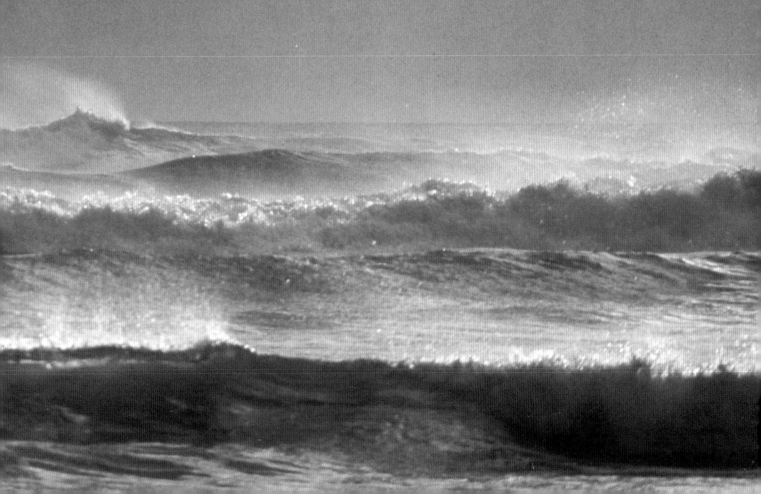

THE SEA AND OFFSHORE ISLANDS

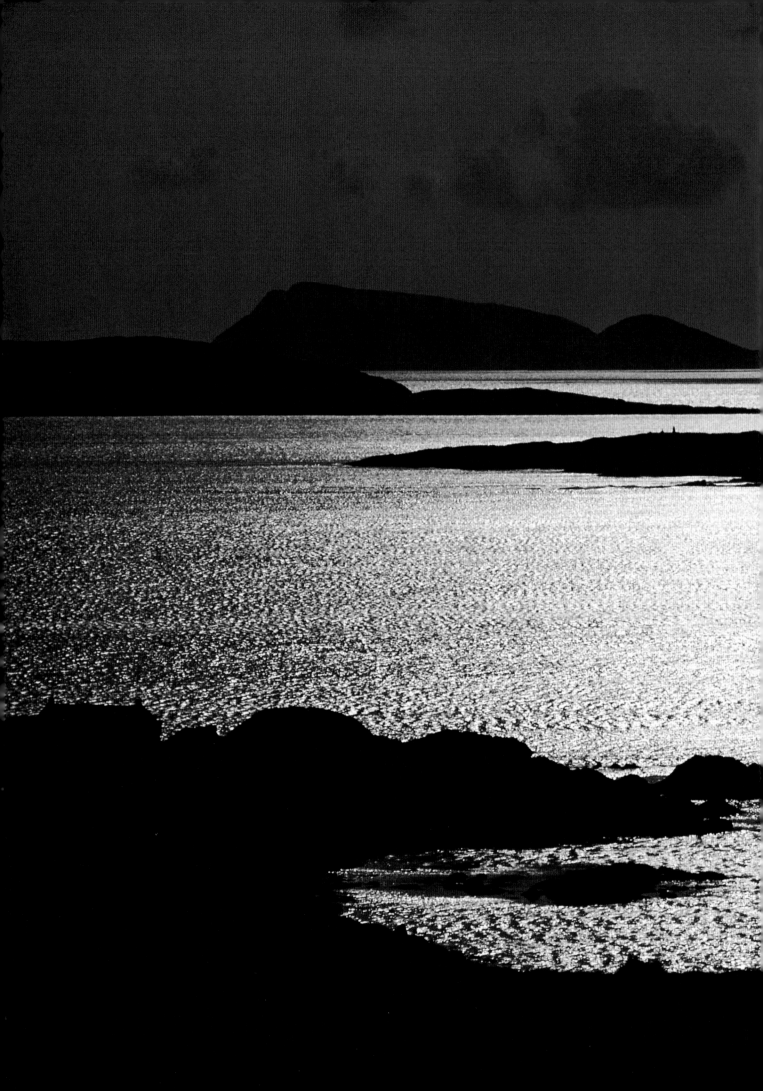

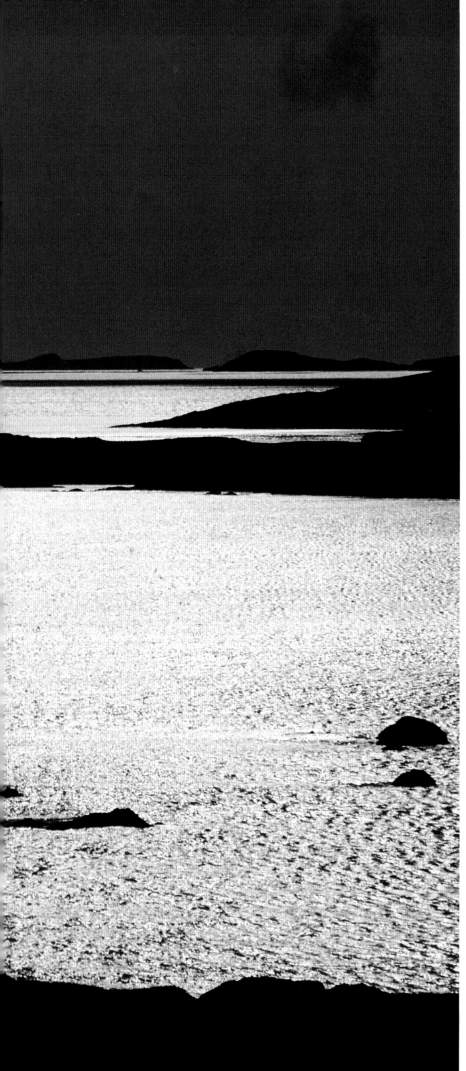

The seas surrounding New Zealand are probably the least modified of our diverse landscapes. Compared with those in many other parts of the world, our waters are relatively unpolluted, and their remoteness, with the vast expanse of the Pacific stretching away to the east and the Tasman Sea to the west, ensures that they will probably maintain this purity. However, the marine ecology in some areas is threatened, and in certain parts already affected to a major degree, by over-exploitation by the fishing industry. This could cause a chain reaction, upsetting the natural balance and eventually affecting all marine creatures dependent on the sea for their food.

New Zealand's position in the Pacific, the largest and most

ABOVE A royal albatross in flight.

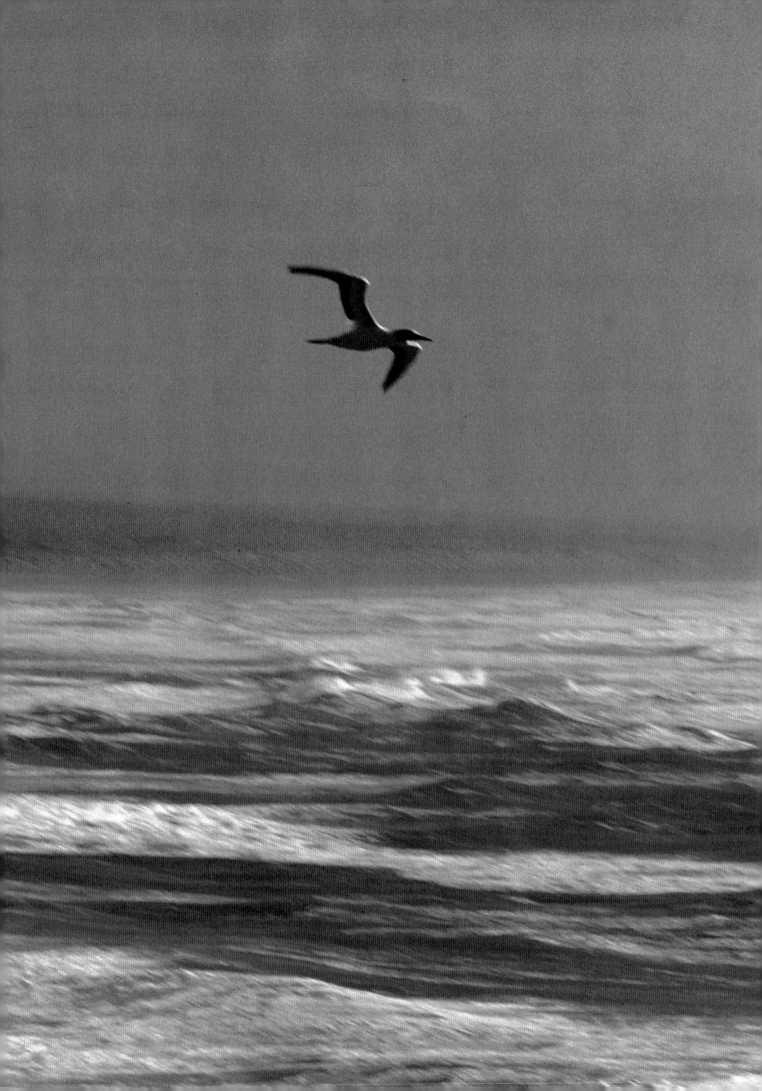

productive ocean in the world, has resulted in the country being endowed with a diversity of seabird species. By far the commonest of these birds are the pelagic tube-noses, thoroughly adapted to life at sea and distinguished by their tube-shaped nostrils which are peculiarly positioned externally on the bill. These Procellariiformes, the only order of birds composed entirely of marine species, spend their lives at sea and come ashore only to reproduce. Our many outlying and offshore islands provide them with ideal nurseries.

Apart from occasional sightings of whales or dolphins, these birds are the only conspicuous wildlife of the open seas. All members of this order, which includes albatrosses, mollymawks, shearwaters, petrels and prions, are gregarious. They nest in colonies, the albatrosses and some petrels choosing open ground, and the shearwaters and smaller petrels digging burrows or using rock crevices. All species lay only one egg per clutch. Some species, such as Hutton's shearwater and the Westland black petrel, still nest on the South Island mainland. Hutton's shearwaters nest in burrows over 1500 metres up in the Seaward Kaikoura Mountains, and the Westland black petrels choose low coastal hills near Barrytown on the West Coast in which to make their burrows.

The northern royal albatross has managed to maintain a small protected colony on Taiaroa Head on the Otago Peninsula, and other royals nest on southern outlying islands. The successful breeding of the albatrosses on the mainland at Taiaroa Head was entirely due to the persistent conservation efforts of Dr L. E. Richdale. The species had attempted to nest there from about 1920, but human interference and vandalism had frustrated their efforts. After strict protection measures were enforced, the birds finally hatched and reared their first chick in 1938, and since then the small colony has thrived.

As well as providing safe nesting habitats for the tube-noses and other species such as penguins, shags and gulls, those islands which are free from rats and other predators offer sanctuary for several species of endemic land birds, reptiles, insects and plants which once existed on the mainland. Most of the offshore islands were joined to mainland New Zealand during the last Ice Age, and when they became separated as the sea level rose with the melting of the ice, they still retained the indigenous flora and fauna. Some were later exploited for timber or for farming; goats, pigs and predators were introduced to others. However, certain islands managed to retain species of flora and fauna which had become extinct on the mainland and some outlying islands, such as the Chathams, and the Snares in the Southern Ocean, developed their own subspecies of birds in a predator-free

OPPOSITE A gannet surveys the surf for fish. Gannets dive for fish in deep water from a height of about 25 metres, making a near vertical dive. When fishing in surf or shallow water they make an oblique dive from a lower altitude.

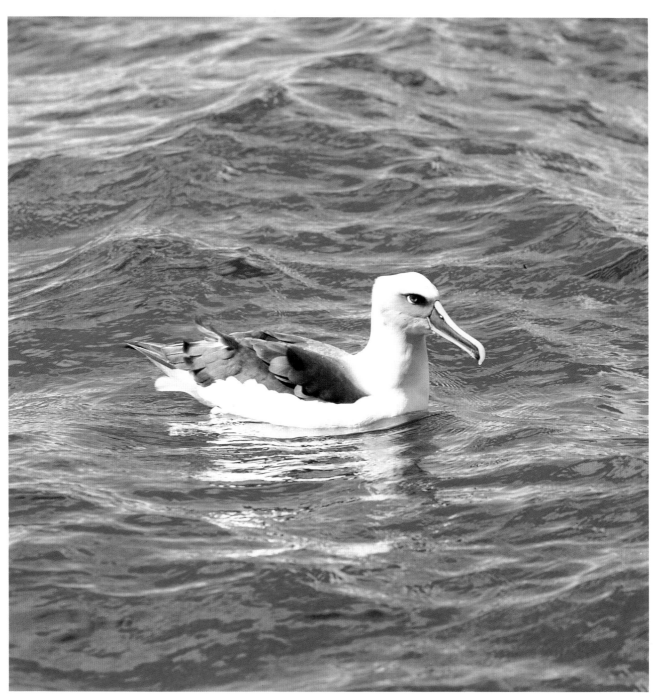

ABOVE A Buller's mollymawk, one of the
smaller species of albatross.
RIGHT A giant petrel. The prominent
nostril tube extends along two-thirds of
the length of the bill.

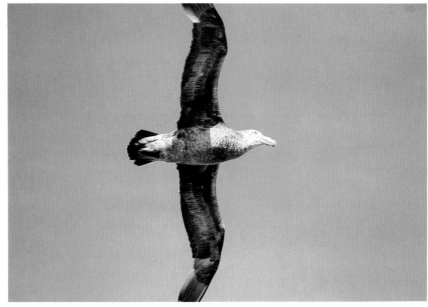

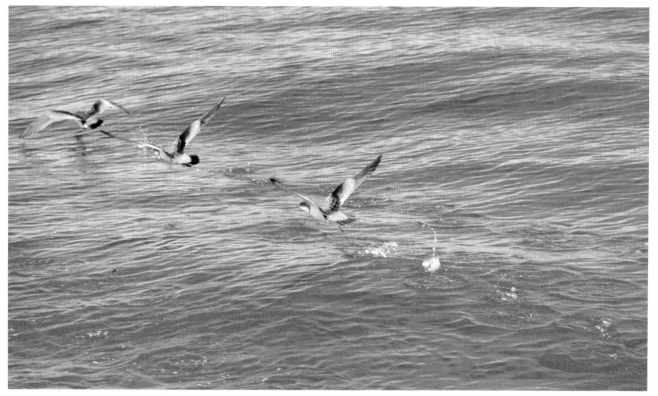

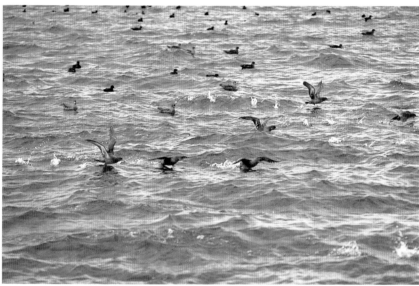

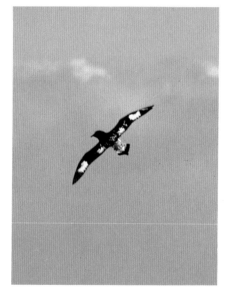

environment. These birds would face certain extinction today should rats be inadvertently introduced by visiting boats.

Having spent time on some of these offshore islands, I have come to appreciate and marvel at their isolation and tranquillity. I have vivid memories of my first visit to Taranga, or Hen Island, which is situated off the Northland coast. Immediately after anchoring, once the sound of the engine had died we were greeted by a tumultuous chorus of bellbirds and tuis coming from the rugged forested slopes above us. Next morning the dawn chorus was even more impressive as the voices of hundreds of birds rang across the calm water.

Taranga is a good example of a predator-free island whose existence prevented a species from becoming extinct. This island

TOP Buller's shearwaters. This species nests in large numbers on the Poor Knights Islands.

LEFT Sooty shearwaters are the commonest species of 'muttonbirds'. In the breeding season they come ashore at night to nest in burrows on many offshore islands. They are particularly numerous around Stewart Island.

RIGHT The cape pigeon. This medium-sized petrel is easily recognised by its distinctive black and white patterned plumage.

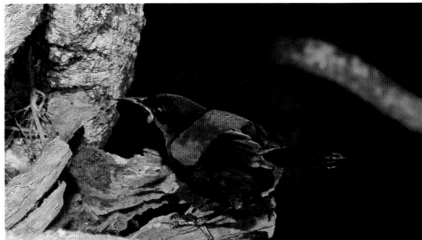

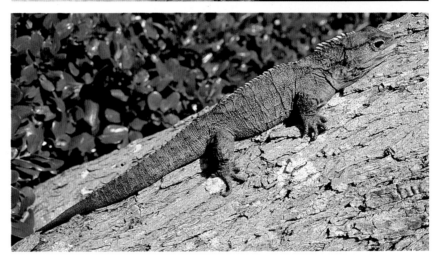

ABOVE The Poor Knights lily, raupo-taranga, is a relic of prehistoric tropical flora and grows naturally only on Taranga and the Poor Knights Islands.
TOP RIGHT A female North Island saddleback at its nest in a hollow limb. In the 1960s Taranga was the only remaining habitat of the North Island saddleback. Officers of the Wildlife Service transferred several birds from Taranga to various predator- free offshore islands where they now thrive
RIGHT The tuatara is now found only on predator-free offshore islands. It is the only living relic of a long-extinct order of reptiles which lived over 200 million years ago.

was the last remaining stronghold of the North Island saddleback, an ancient wattlebird related to the extinct huia and the endangered kokako, and once common on the mainland. I was privileged to be on the island in the early 1960s when officers of the Wildlife Service trapped several saddlebacks and transferred them to other predator-free islands. Here they thrived and bred so well that further transfers were made to other suitable islands with equal success.

A similar transfer operation was urgently carried out after it was discovered that muttonbirders had inadvertently introduced rats to Big South Cape Island off Stewart Island, and these were decimating the remaining population of the South Island saddleback. The saddlebacks were transferred to safety, but several subspecies of endemic birds, such as the bush wren and snipe, were exterminated by the rats. Although the saddleback transfers have proved so successful, it will not be possible to reintroduce the species to the mainland. The bird spends considerable time searching for insects in litter on the forest floor so it will always be vulnerable to predation.

Undoubtedly the most valuable of our offshore sanctuaries is Hauturu, or Little Barrier Island, one of the world's most important flora and fauna reserves. Covering some 2800 hectares

and rising to over 700 metres, the island has a rugged landscape clothed in dense rainforest. Earlier Maori occupation resulted in a certain amount of forest clearance, but as no deer or opossums were introduced, the island remains in a relatively pristine state. The coastline is precipitous except for an area in the south-west where a spectacular boulder beach fringes some flat land on which the resident ranger's house is situated.

Until 1978 Little Barrier Island was infested with feral cats which preyed on the rich birdlife, especially the ground-nesting

ABOVE Taranga or Hen Island is an important sanctuary off the east coast of Northland. Apart from the relatively harmless Maori rat, the kiore, it is free from mammalian predators. The island has good populations of kaka, parakeets, pigeons and North Island saddleback. Recently, stitchbirds were introduced from Little Barrier Island.

Hauturu, or Little Barrier Island, is the most valuable of our offshore island sanctuaries, and is one of the world's important flora and fauna reserves.

petrels. The endemic stitchbird, then found only on this island, was also severely threatened. Once the cats had been exterminated, after a difficult and sustained effort by the Wildlife Service, stitchbird numbers increased so remarkably that successful transfers have since been made to other predator-free islands, including Taranga. Little Barrier has now become an

extremely valuable sanctuary for the reception of other endangered bird species from the mainland, kakapo and North Island kokako being two recent transfers.

Another valuable sanctuary is Kapiti Island in Cook Strait. Although the island harbours rats, it is the last remaining stronghold of the little spotted kiwi which, apart from a few

TOP The boulder beach on the south-west coast of Little Barrier Island.
LEFT AND RIGHT CENTRE The kokako and kakapo are two endangered bird species which have in recent years been transferred to Little Barrier Island, which is now free from predatory mammals.
BOTTOM LEFT The little spotted kiwi survives on Kapiti Island. Apart from a few captive birds, it is now extinct on the mainland.
BOTTOM RIGHT The giant weta, with a body length of up to 75 mm, still survives on Little Barrier and the Poor Knights Islands.

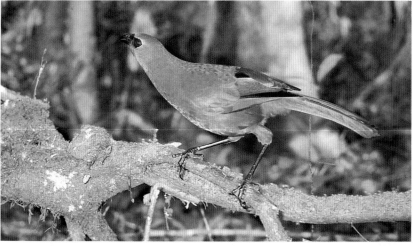

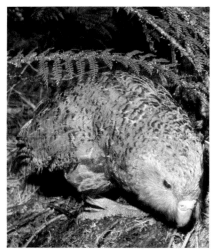

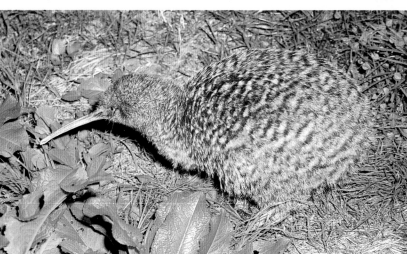

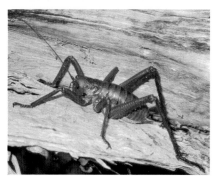

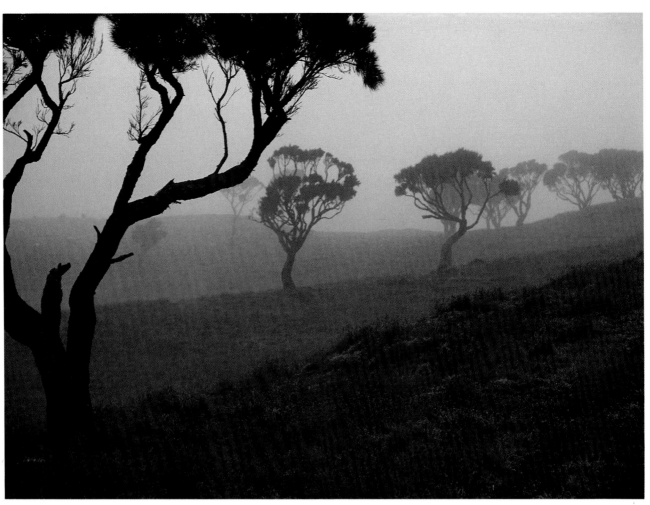
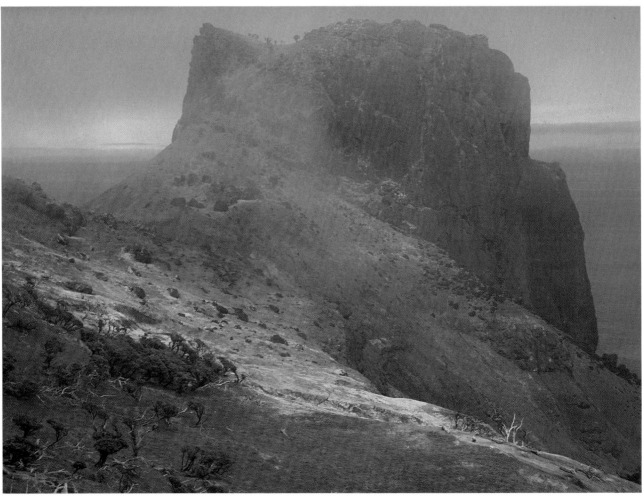

captive birds, is absent from the mainland. This small species of kiwi would now probably be extinct but for the introduction of a few birds to Kapiti Island early this century.

Many species of birds found on mainland New Zealand have evolved in isolation on some of our offshore and outlying islands to become subspecies with different characteristics. The Chatham Island black robin is an example and the story of the fight to save this bird from extinction is now well documented. Reduced to a population of only seven birds in 1979, their numbers have been dramatically increased by a careful process of cross-fostering. This was achieved by removing a robin's first clutch of eggs and placing them in the nest of a Chatham Island tomtit to incubate and foster. In this way the robins were induced to lay a second clutch which they themselves then reared.

Black robins now inhabit two small, predator-free islands close to the coast of Pitt Island in the Chathams, Mangere Island and South-East Island. The latter is also the home of other rare birds and plants, notably the Chatham Island snipe, the New Zealand shore plover and the magnificent Chatham Island forget-me-not.

There are many ecologically valuable small islands close to Stewart Island. One of the larger of these is the forest-covered

ABOVE Dense mats of the Chatham Island ice plant (*Disphyma papillatum*) growing on South-East Island.
TOP OPPOSITE Remnants of the akeake forest (*Olearia traversii*) which once clothed much of the Chatham Islands.
BOTTOM OPPOSITE Black Head, on the west coast of Pitt Island, which is the second largest of the Chatham Islands. Most of Pitt's original forest cover has been cleared to provide grazing land for farming. However, some areas have recently been reserved and fenced to exclude stock. This has resulted in rapid regeneration of many species of indigenous trees and plants.

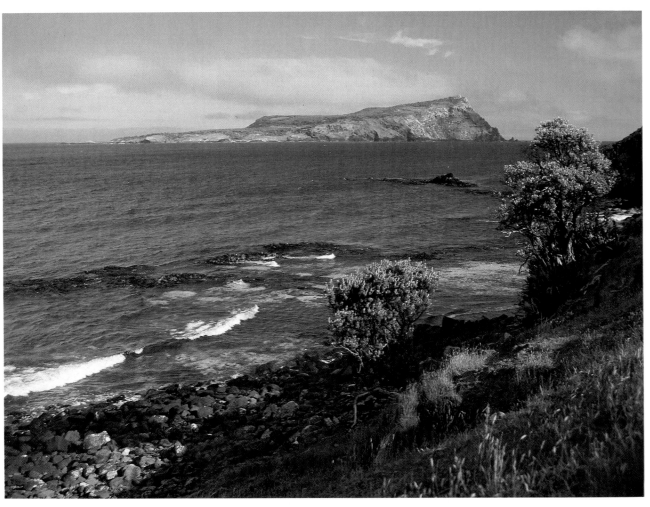

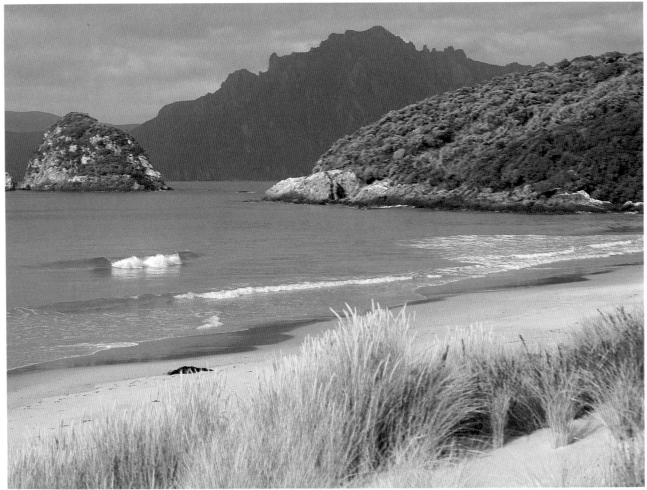

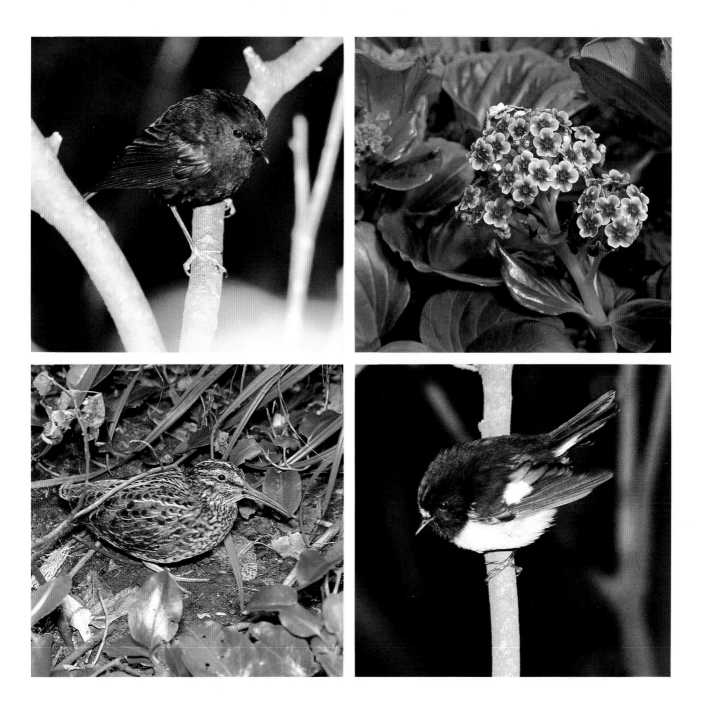

Codfish Island, off the north-west coast. Once the present operation to free it of wekas and opossums is completed, it will become a valuable sanctuary capable of sustaining several endangered species. Possibly one of these will be the kakapo which lives in the southern parts of Stewart Island, where its precarious existence is only made possible by the time-consuming control of feral cats.

Our seas are capable of producing some of the most powerful forces on this Earth. Their mood constantly changes from raging storm, when sky and water seem to merge, to complete tranquillity. In this environment the seabirds have evolved to live in harmony in this restless landscape.

TOP OPPOSITE South-East Island, off the coast of Pitt Island, provides sanctuary for several rare bird species such as the black robin (top left), the Chatham Island snipe (lower left) and the Chatham Island tomtit (lower right). BOTTOM OPPOSITE Codfish Island, off the north-west coast of Stewart Island, is another important wildlife sanctuary. TOP RIGHT The Chatham Island forget-me-not (*Myosotidium hortensia*) grows in its natural state only on the Chatham Islands.

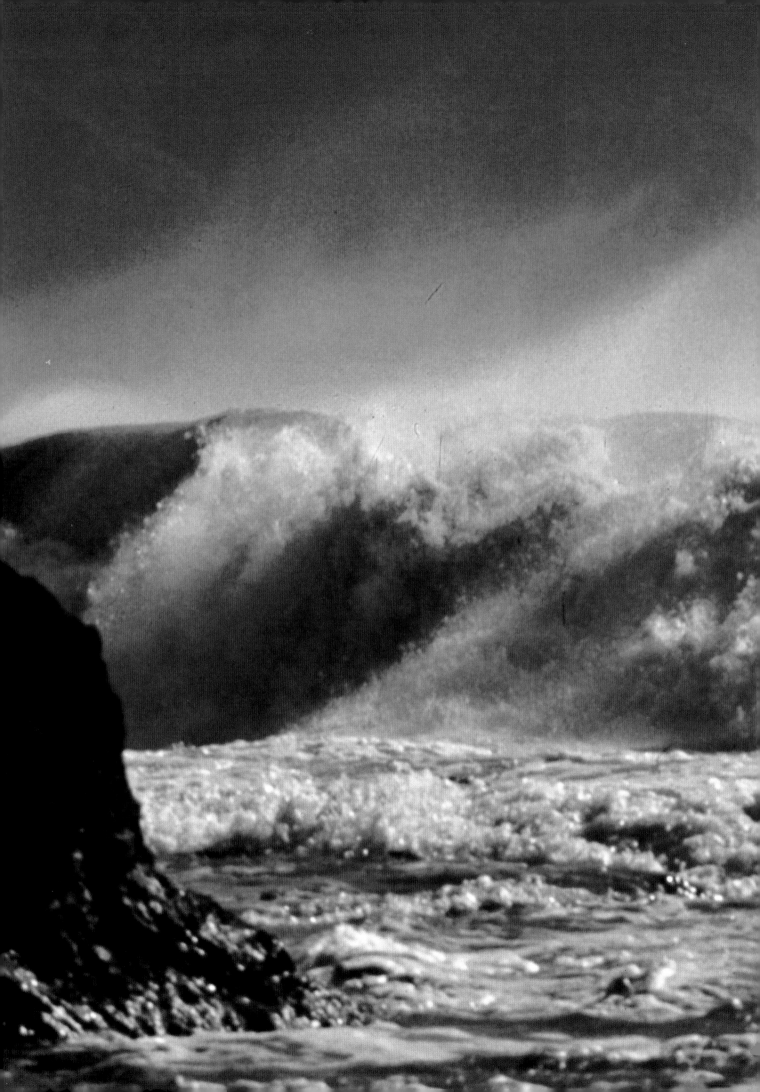

two

THE COAST

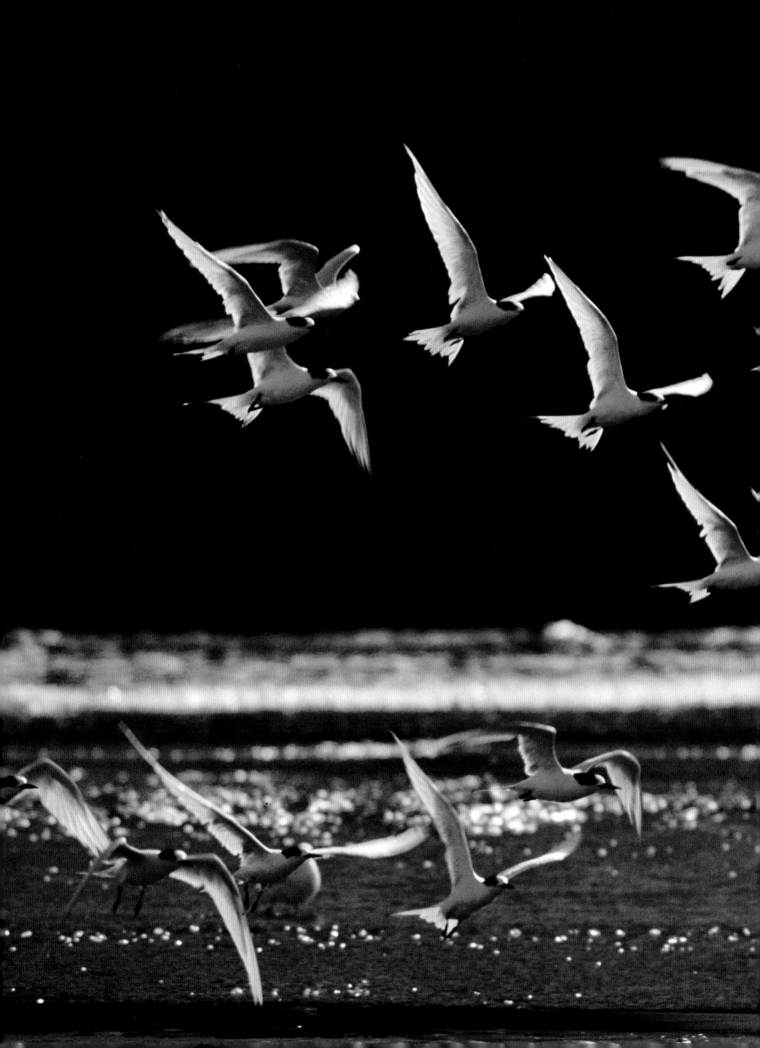

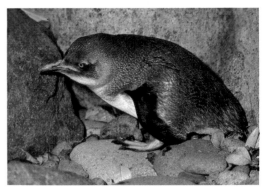

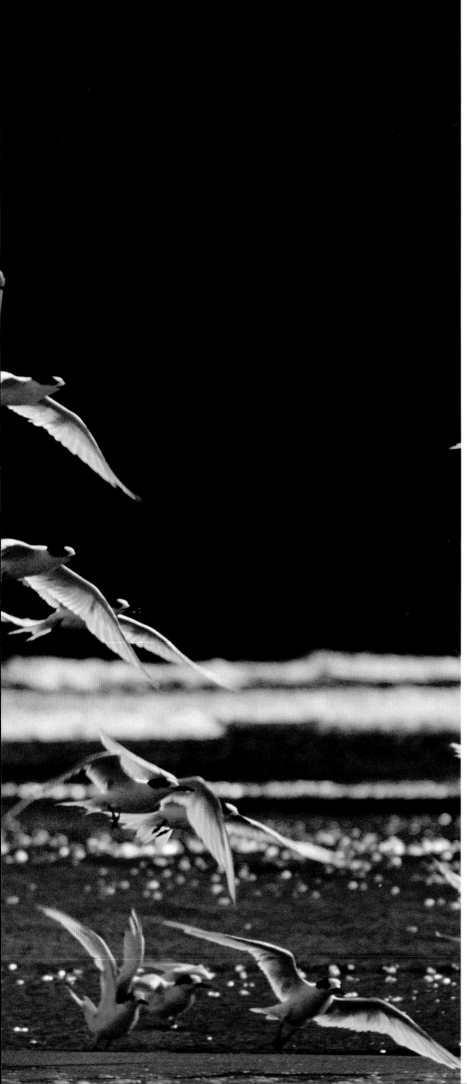

N ew Zealand's coastline is one of the longest in the world relative to the country's land mass, and no part of the land is further than 130 kilometres from the sea. The topography varies considerably, with long surf-washed sandy beaches along much of the west coasts. These are interrupted by rocky headlands, cliffs and rock and boulder beaches. The east coasts are more indented, with rocky headlands and small islets sheltering sandy or shingle beaches. Many of the larger sand beaches, particularly in the north, are backed by areas of dunes.

A distinct type of coastline exists in parts of the South Island. In the north a complex of islands and drowned valleys form the maze-like Marlborough Sounds, and in the South

ABOVE Little blue penguins come ashore after dark to visit their nests which they form in rock crevices and caves, or in earth burrows. They sometimes nest under seaside dwellings, where their nocturnal wailing calls make the birds unpopular.
LEFT A winter flock of white-fronted terns on a west coast surf beach.

Fiordland's spectacular, steep-sided sounds have been carved out by glaciation during the last Ice Age.

Most of these coastal landscapes support a wide variety of animal life, although gravel and shingle beaches are usually biologically unproductive. The sandy beaches provide a permanent moist environment for crustaceans, moluscs and marine worms, and these, in turn, provide food for fishes and birds. High-tide areas of these beaches are populated by sandhoppers and flies which inhabit the seaweed flotsam. The dunes backing some of these beaches are favourite nesting areas for many species of shore birds such as terns, variable oystercatchers, dotterels and stilts. However, in many areas marram grass has been planted to stabilise the dunes. This has resulted in the gentle dune slopes being transformed into low but almost vertical sand cliffs, and the marram-grass blanket covering the landward dunes creates a habitat unsuitable for nesting birds.

Most rocky shores have rich coverings of seaweed or bull kelp. This provides an ideal habitat for crabs, starfish, mussels and many other forms of marine life. Above the high-water mark these shores sustain growths of succulent ice-plants, grasses and prostrate vegetation, often backed by coastal flax and wind-tolerant taupata.

Boulder beaches are a feature on some coasts, and where wave action is moderate, the boulders retain an irregular shape and are stable, providing a safe haunt for crabs and many species of shellfish. However, on exposed shores small boulders and pebbles constantly move against each other with the surge of breaking waves, creating a habitat unsuitable for many forms of

OPPOSITE Toetoe growing on the white sand dunes on the seaward margins of the Parengarenga Harbour. This northern harbour is a favourite haunt for many species of wading birds.
LEFT Tuatua are a favourite food of shore-dwelling oystercatchers.

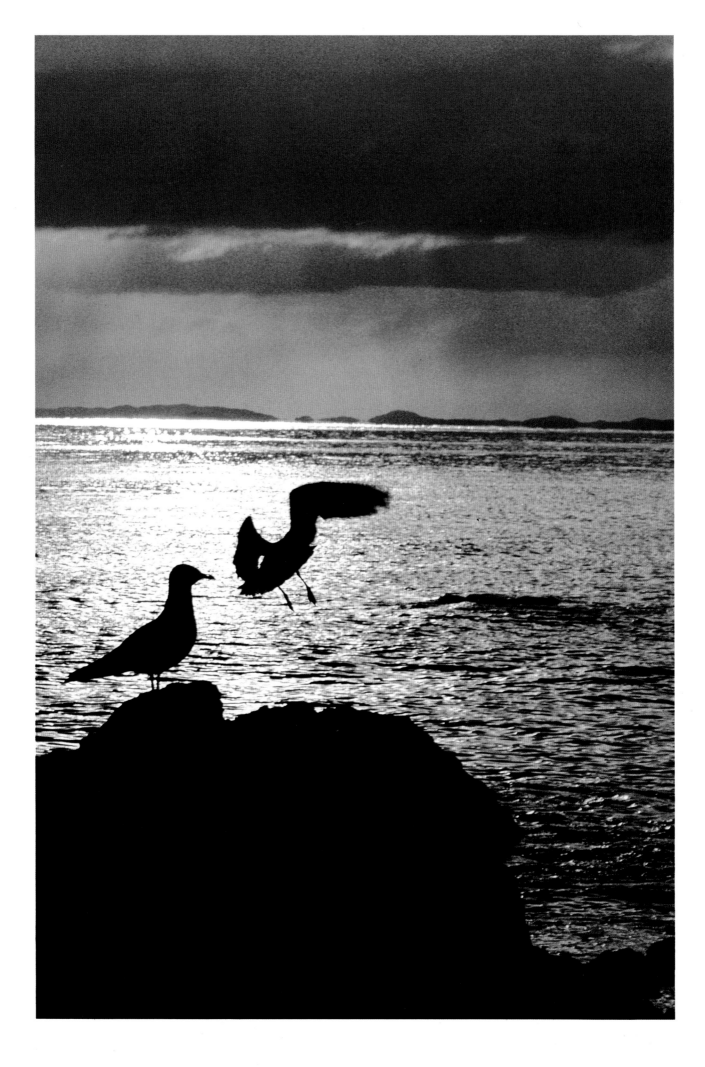

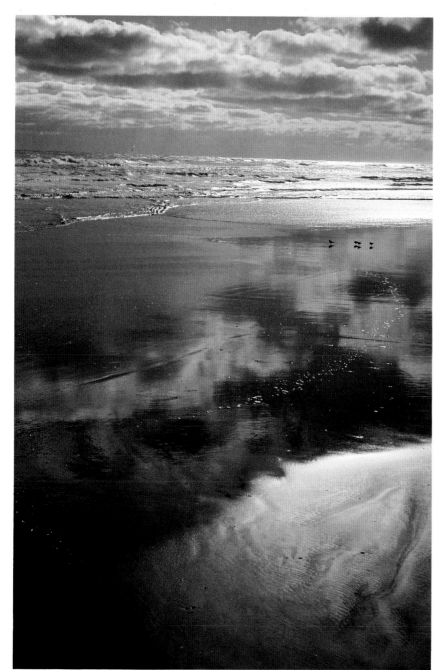

OPPOSITE Red-billed gulls silhouetted on a west coast beach.

LEFT Reflections in wet sand.

ABOVE In recent years land use for seaside dwellings has increased, especially in areas close to attractive beaches. In other districts sheltered bays and harbours have been developed for the fishing industry, with anchorage for boats and onshore buildings to provide processing facilities.

marine life. On other beaches large boulders form a more stable environment where many forms of marine life thrive. Excellent examples of such habitats are to be found at the southern end of St Clair beach in Dunedin, and on the spectacular boulder spit at Little Barrier Island. Beneath the boulders at these locations live a rich variety of marine organisms.

The early Polynesian and European settlers destroyed the forests which originally grew on the east coasts of both North and South Islands, although a remnant forest survives along the Catlins coast of Southland. Stewart Island, Fiordland and parts of the West Coast of the South Island also retain their virgin forests. Small areas of mixed forest, much of it second growth, still exist on some North Island coasts, with pohutukawa, karaka and nikau

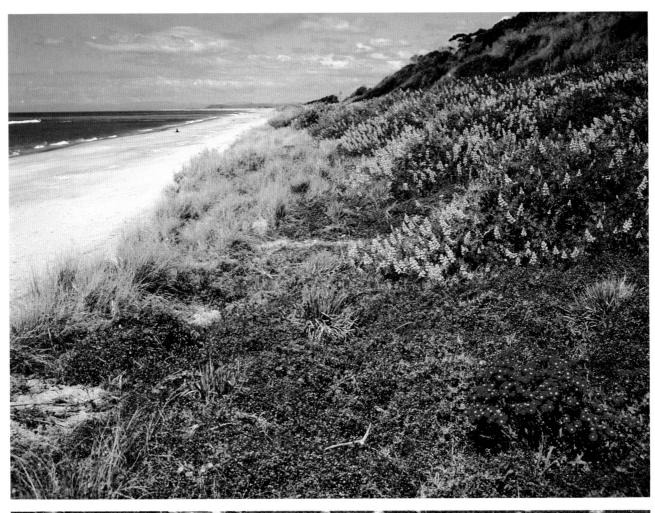

TOP Marram grass and lupins, planted to stabilise coastal sand dunes, have made these habitats unsuitable for nesting shore birds.
BOTTOM Bubbles left by the receding surf. The colours are caused by oleaginous plankton.

palms predominating. In parts of the South Island the southern rata may be seen in areas which have escaped browsing by opossums. It is not generally realised what severe damage opossums cause to rata and pohutukawa trees by defoliation. The illustration on page 53 was taken in 1949 on the south coast of Kawau Island. Today only a few live pohutukawa trees exist on

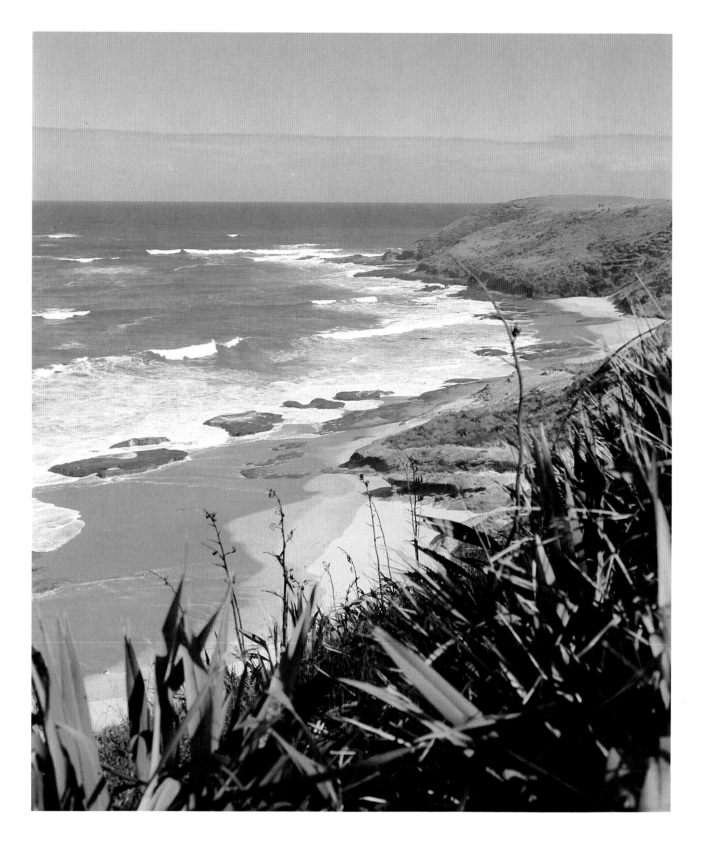

the east and south coasts of this island. By constant defoliation of shoots and branches, opossums have caused this widespread destruction. Similar damage has been caused to southern rata and mistletoe in the South Island.

In many coastal regions, farm pastures now extend to the water's edge and cattle stray on to the beaches and browse the

A sandy beach flanked by rocks on the west coast of Northland.

shoreline vegetation; on occasions they can even be seen eating kelp. These locations are now devoid of trees except perhaps for a few pohutukawa, ngaio or other species which are capable of withstanding salt-laden winds.

In recent years land use for seaside dwellings has increased, especially in areas adjacent to attractive beaches. Some of these developments have now grown to sizable settlements, with shops and other amenities for permanent residents.

Many of our coastal landscapes are rich in animal life. Again, birds predominate, but seals are not uncommon, especially on the South Island coasts, and skinks, geckos, spiders and various insects live near the shore. The exposed surf beaches often lack wildlife, except for the large black-backed gull and the smaller

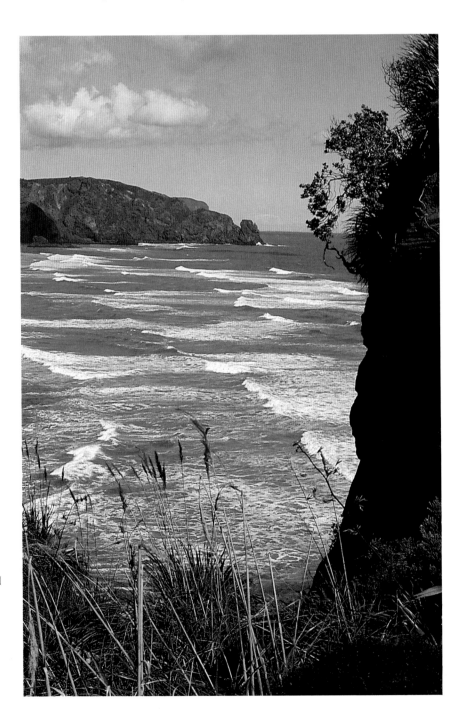

A typical surf beach on the west coast of the North Island. These surf beaches are mainly inhabited by gulls. White-fronted terns and spotted shags sometimes nest on the cliff ledges on the headlands overlooking the beaches, and variable oystercatchers and reef herons feed on the tide-washed rock platforms. The oystercatchers also feed on tuatuas dug from the hard sand and prised open with their powerful bills. Banded dotterels and pipits inhabit the dunes backing these beaches, where the pipits nest in the low ground herbage.

red-billed species. All gulls are scavengers, feeding on dead fish or stranded shellfish, unlike the terns, which feed only on live fish they capture by making shallow dives offshore.

The majestic gannet, with its near 2-metre wingspan, usually dives for its fish in the open sea, but sometimes cruises close to the breakers and feeds in the shallow water. Gannets nest in large colonies on certain offshore islands and stacks. Until comparatively recent times, the only colony nesting on the mainland was that at Cape Kidnappers in Hawke's Bay, but a few years ago, due to overcrowding of the colony on Oaia Island off Auckland's west coast at Muriwai, birds commenced nesting on a small stack close to the mainland cliffs. More recently some gannets have chosen to nest on the adjacent mainland, where they

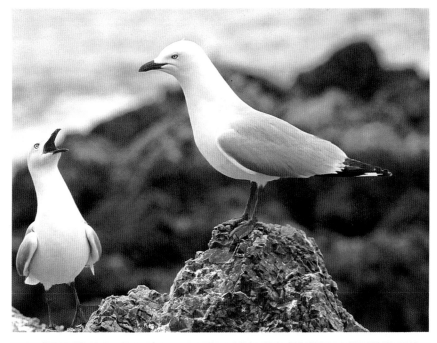

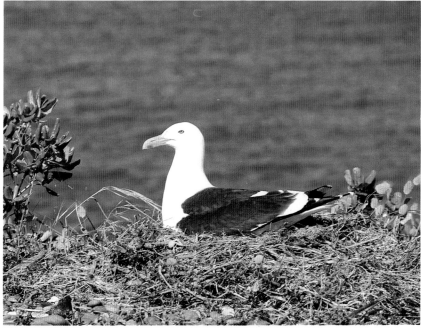

TOP Red-billed gulls are the commonest species of gull inhabiting our coasts. They nest in close colonies on rocky headlands and islets close to the shore.
BOTTOM. A black-backed gull on its nest close to the sea. This gull species also nests in inland regions, often at high altitudes.

The Coast 45

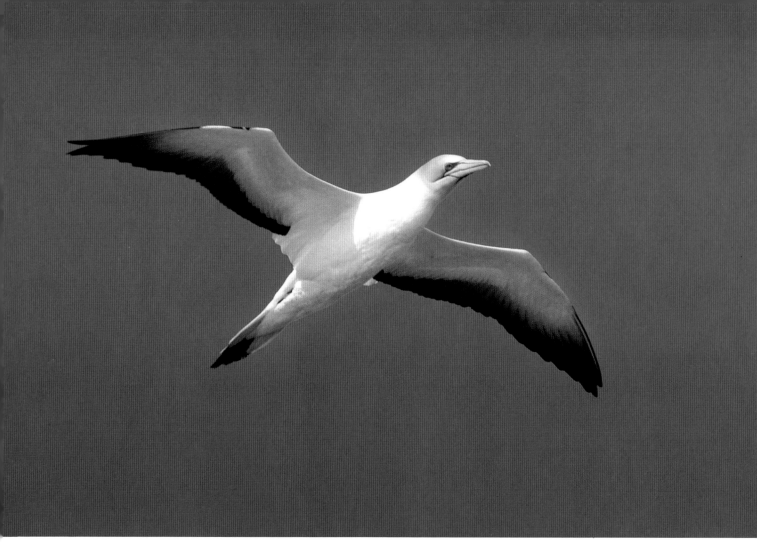

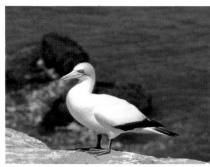

TOP The gannet has a wingspan of almost 2 metres.

ABOVE Gannets are easily approached when at their nesting grounds.

OPPOSITE It is estimated that well over 30,000 pairs of gannets nest around the New Zealand coast. The largest colony, of nearly 6000 pairs, nests on the shore of White Island, the active volcano off the Bay of Plenty coast. The colony on the mainland at Cape Kidnappers is the second largest.

are protected by a fence erected by the Auckland Regional Authority.

Sandy beaches and dunes, particularly on the east coasts, are favourite nesting habitats for other shore birds such as variable oystercatchers, dotterels and terns. The Caspian tern, a cosmopolitan species and the largest of the terns, nests in colonies among the dunes of certain beaches. Like the other terns, they use no nesting material. The two-or-three-egg clutch is laid in a mere scrape in the sand, and due to the effects of wind, the scrape may fill in, but is frequently reformed by the sitting bird rotating and kicking out the encroaching sand. The common white-fronted tern, or kahawai bird, also nests in colonies; sometimes these are congregated on sand dunes, but more often they choose such sites as rocky islets close to the shore, or shellbanks. In contrast, the rare fairy tern, the smallest of the terns and no larger than a blackbird, nests in isolation on a few east-coast beaches of North Auckland. It is probable that fewer than ten pairs nest in New Zealand.

Many species of shags or cormorants live round our coasts. Some strikingly beautiful species live only on inaccessible

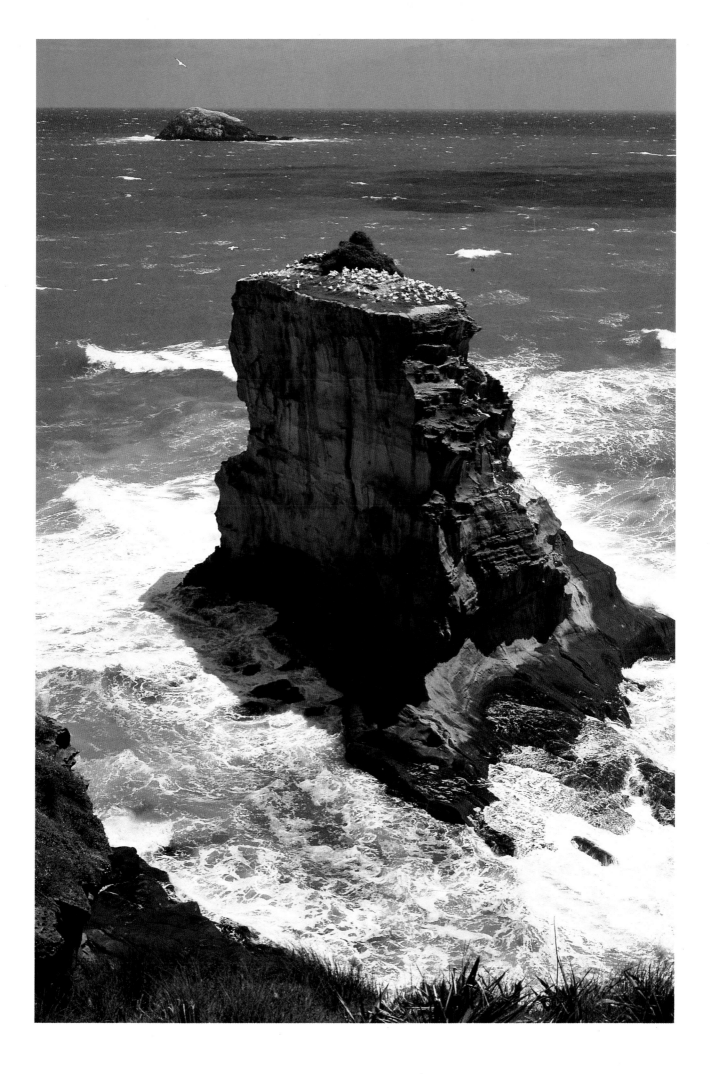

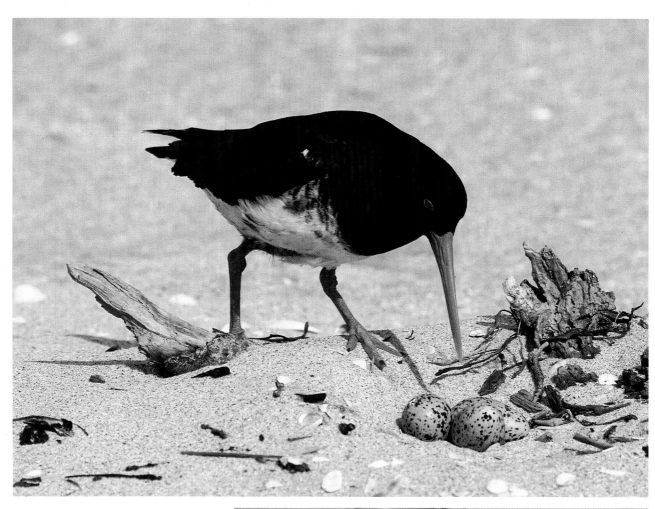

TOP Variable oystercatchers nest on the sand dunes.
CENTRE Caspian terns at their nest. They are the largest of the tern species.
BOTTOM Probably fewer than six pairs of the tiny fairy tern nest on ocean beaches in Northland.

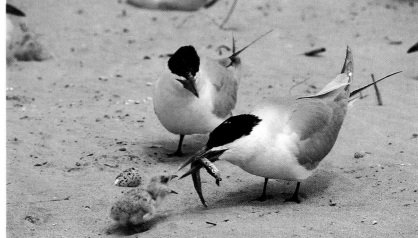

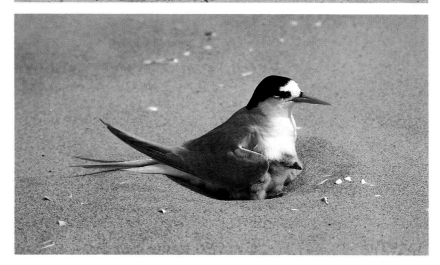

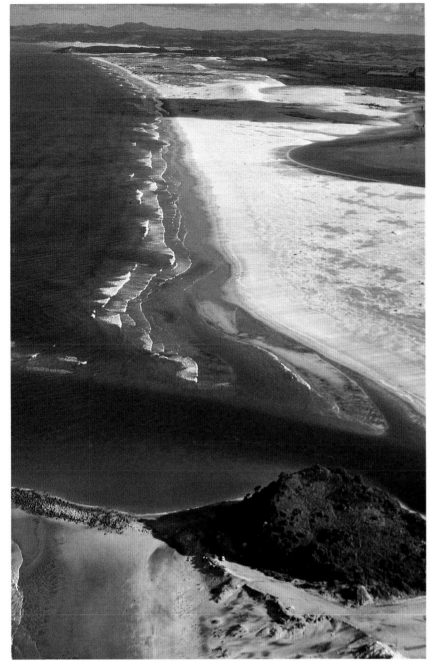

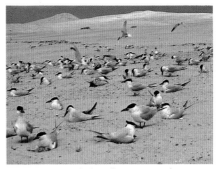

Caspian terns (ABOVE) nest in colonies among sand dunes.

LEFT Mangawhai Spit on the east coast of Northland is a valuable reserve where many species of shore birds feed and nest.

offshore islands, but the colourful spotted shag is easily seen around our rocky coasts, when, after the breeding season, birds congregate on rocks close to the shore to rest between spells of fishing.

The favourite nesting sites for spotted shags are on ledges of cliff faces near deep water, and in alcoves and fissures in volcanic cliffs, such as those on Banks Peninsula and Auckland's west coast. The large coast-dwelling pied shag prefers more sheltered shores than does the spotted shag. This species nests in trees overhanging cliffs; pohutukawas are a species commonly used for this purpose. The host trees are eventually killed, as the bird has the habit of defoliating the tree and scorching the leaves with caustic excrement.

ABOVE AND OPPOSITE These tidal rock platforms in the Chatham Islands provide ideal feeding habitats for the New Zealand shore plover and the Chatham Island oystercatcher. Both are endangered bird species.
RIGHT Sculptured coastal vegetation. This pattern of growth occurs in many plants exposed to onshore salt-laden winds.

Shags periodically dry their plumage by perching on a rock or branch with wings outstretched. Shag feathers are not fully waterproofed. This has the advantage of rendering the body less buoyant when swimming submerged in search of fish.

The little blue penguin is sometimes seen swimming close to the coast, but it only comes ashore during the breeding season to visit its nest in caves, rock crevices or in burrows beneath tree

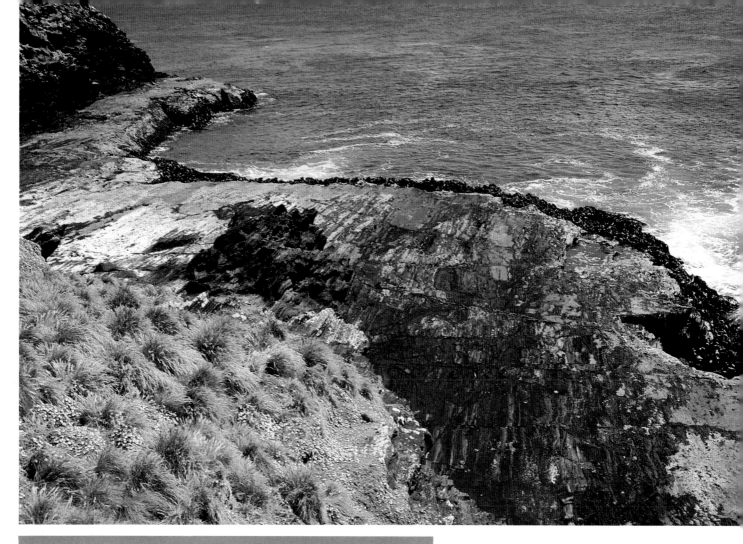

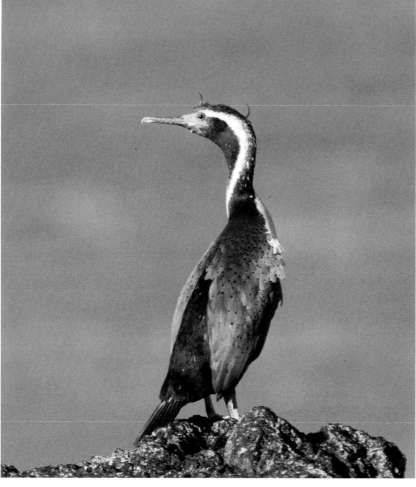

LEFT The spotted shag has increased its numbers following protection. This marine shag nests on ledges and crevices in cliffs on exposed rocky shores throughout New Zealand, but is absent from the Chatham Islands.

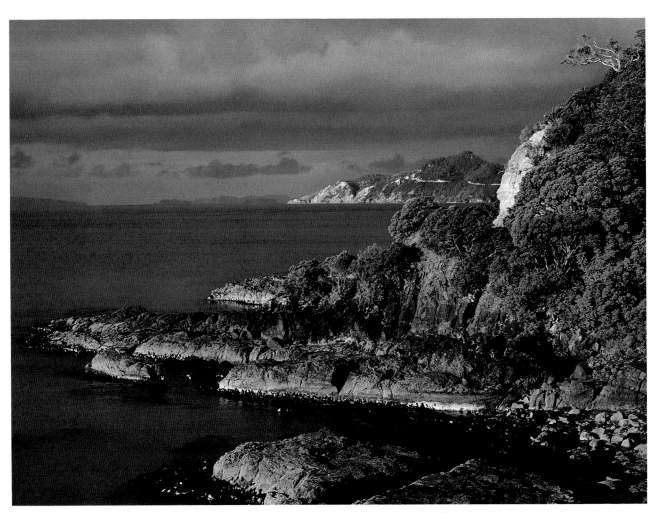
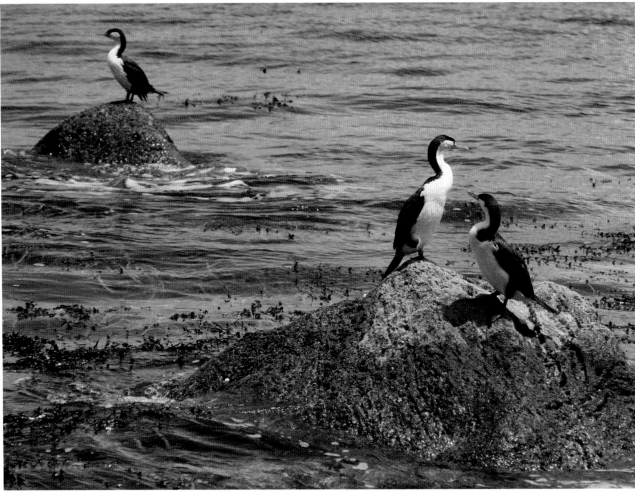

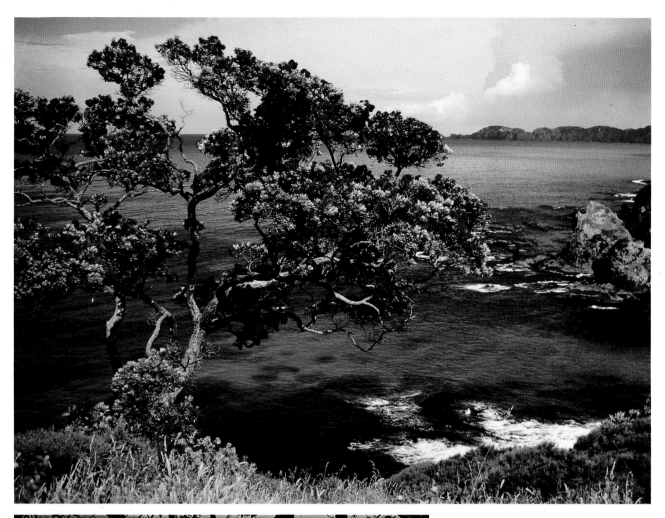

OPPOSITE ABOVE Part of the east coast of Coromandel Peninsula. The rocky shores are a favourite haunt of reef herons, white-faced herons and various species of shags.

OPPOSITE BOTTOM Pied shags are common in northern coastal waters, where they nest in pohutukawa trees overhanging cliffs. As with other shag species, they feed only on live fish which are captured by rapid pursuit under water.

TOP A lone pohutukawa tree stands on a Northland coast where once dense stands of these trees occurred.

LEFT This pohutukawa was photographed in 1949 on the south coast of Kawau Island. Today few such trees survive there, most having been destroyed by browsing opossums and wallabies.

roots. The rare yellow-eyed penguin is a much larger bird. Its distribution is restricted to the east coast of the South Island, from Otago to Stewart Island. This species may be seen ashore during daylight hours when it visits its nest in coastal scrub and flax.

The reef heron, slightly smaller and stockier than the familiar white-faced heron, is becoming much less common on our coasts.

It prefers to live on rocky shores where it feeds along the tideline or in rock pools. It builds a substantial nest of sticks in inaccessible caves or rock fissures.

Recently, while photographing on the Kaikoura coast, I was stalking a reef heron on a rocky headland when I almost stumbled over a seal which was basking behind a rock. It lumbered rapidly down the beach and after a disdainful backward glance dived under the waves and swam from sight. In many areas the New Zealand fur seal was hunted to near extinction by the early-nineteenth-century sealers, who slaughtered many thousands for their skins. Thanks to strict protection, seal numbers have rapidly increased. They prefer rocky shores and are now abundant on the coasts of Westland, Fiordland, Stewart Island and the nearby islands. They can also be seen in parts of the North Island, and a good colony exists not far from Wellington.

Although much of the New Zealand coastline has been modified in various ways, it is still possible to visit many secluded beaches, wild rocky shores and interesting wildlife haunts within a short distance of most of our towns and cities. Our small population ensures that this situation should continue.

OPPOSITE TOP Reef herons, unlike the common white-faced heron, remain on the coast and only rarely venture inland.
OPPOSITE BOTTOM A New Zealand fur seal resting on a rocky beach near Kaikoura. Last century these seals were ruthlessly slaughtered for their skins and soon became rare. With legal protection, their numbers have increased remarkably.
BELOW The Kaikoura coast on the east coast of the South Island. This rocky coast is frequented by gulls, terns, oystercatchers and reef herons.

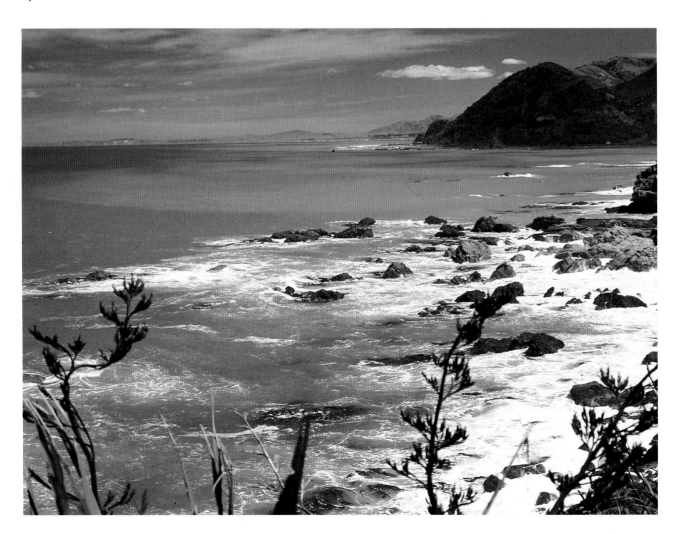

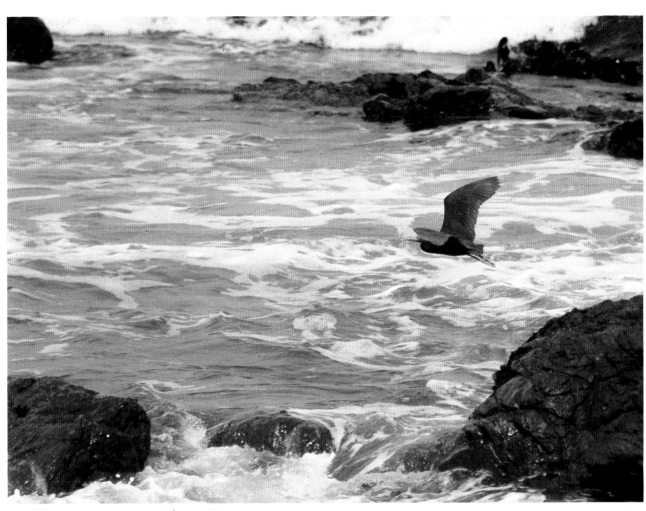

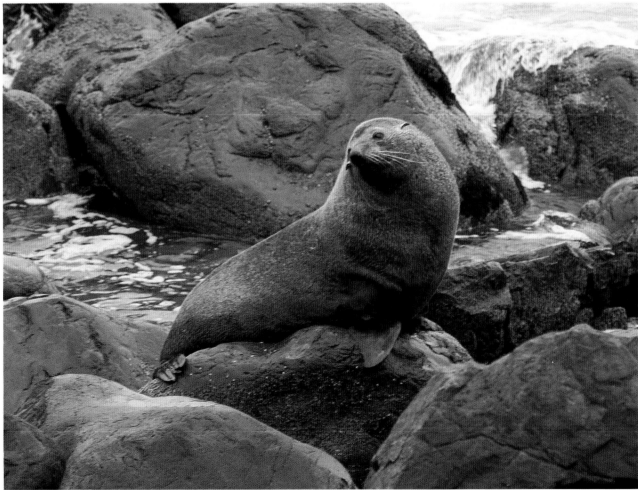

three

A WORLD
FOR WADERS

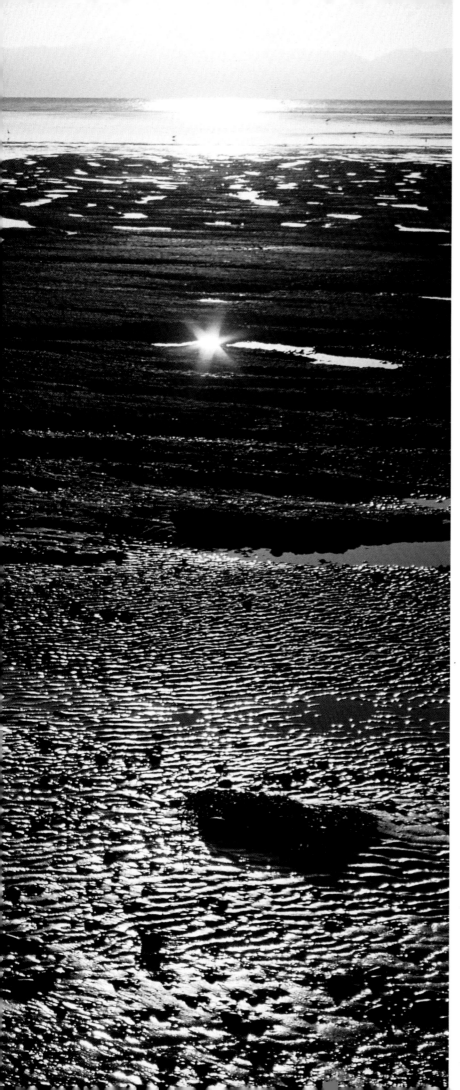

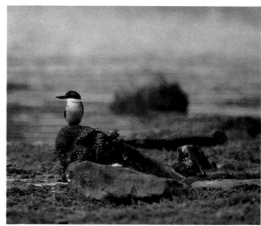

At first glance the wide muddy expanses of our harbours and estuaries at low tide present an uninviting and desolate landscape. Yet here is a habitat abounding in many forms of wildlife. A complete change of face occurs in these tidal regions every twelve or so hours. They are broads sheets of calm, glistening water at full tide, often fringed with dark green mangrove and salt marsh borders. As these waters recede, they reveal an expanse of mud or sand laced with a network of narrow channels and rivulets.

At high tide many species of fish invade these areas to feed on the bountiful supply of crabs, shellfish, worms and other marine organisms they provide, and the surrounding mangroves provide protection for their breeding and egg-laying. A

ABOVE The kingfisher is found in both coastal and inland habitats. Here one perches on the lookout for crabs and small fish.

complete transformation occurs as the mudflats become uncovered and many resident and migratory wading birds come to feed in these rich marine larders.

In the past, Man has often regarded the salt marshes or mangrove areas as convenient locations to establish dumps for the disposal of town and city rubbish, or reclamation sites for land-hungry developers. However, recently we have come to appreciate the importance of these natural environments, as research has shown them to be extremely valuable breeding grounds for many species of fish.

In 1973 the Auckland City Council proposed to use the Glen Innes spit area in the Tamaki Estuary as a site for a rubbish dump. However, a vigorous campaign by local residents and conservationists, led by the indomitable naturalist and writer Ronald Lockley, resulted in the area being saved from desecration. The spit has since been developed into a valuable nature reserve.

In New Zealand mangrove trees are found in the inter-tidal zones of sheltered shores. Only one species grows in our temperate climate; the southern limit of its distribution is Kawhia Harbour in the west and the Bay of Plenty in the east, where trees are small. In contrast, trees of up to 10 metres in height are found in the warmer northern regions. Mangroves are often associated with salt marshes which support certain low-growing varieties of succulents, sedges and rushes, and sometimes have a backing of flax plants on the landward side. During high spring tides salt marshes are inundated and many of the lower branches of the mangroves are immersed.

Several species of small birds, such as silvereyes, feed on insects in the foliage of the mangroves, and kingfishers can often be seen on a prominent perch waiting to dive on a small fish or mud crab. As the tide recedes, herons and other wading birds commence feeding along the exposed shore.

The sedges and rushes of the salt marsh provide good nesting sites for fernbirds, banded rails and occasionally bitterns. Fernbirds usually build a nest close to the base of a clump of sedge, and I have seen nests inundated by high tides when the birds have not made allowance for the rising water. Fernbirds' nests are also subject to predation by the rats which often forage in these areas.

Although fairly common in some estuaries and harbours, the secretive banded rail is seldom seen. This handsome little bantam-like bird may be glimpsed as it runs rapidly beneath the mangroves. I have sometimes flushed a bird when walking through a bed of rushes.

At low tide, estuaries and mudflats provide extensive and rich feeding grounds for a wide range of bird species. In winter months most of these are the resident ducks, shags, herons, gulls,

A mist-shrouded sun rises over the Firth of Thames.

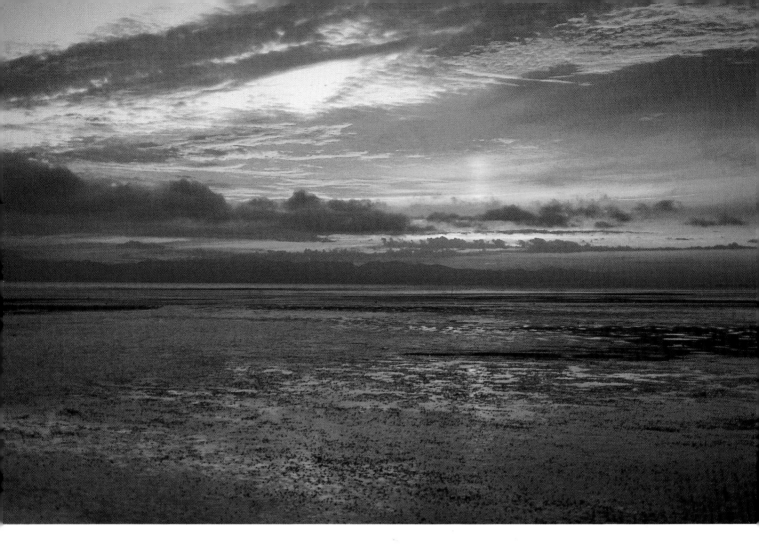

dotterels, South Island pied oystercatchers and pied stilts, with maybe a few Caspian terns flying overhead searching for fish.

The most spectacular feature of these landscapes is the annual visitation of thousands of migrant wading birds. These range in size from the long-billed curlew, with its 18-centimetre long curved bill, to the tiny red-necked stint, only fractionally larger than a house sparrow. Huge flocks of these migrants reach our shores in late September or early October, having made an incredible journey of thousands of kilometres from the tundra regions of Siberia, where they have fed and nested during the brief Arctic summer.

By far the best known and most numerous of these migrants is the bar-tailed godwit, usually seen probing for marine organisms in the mud, or resting in flocks on a shellbank or sand spit at high tide. Godwits, and to a lesser extent the smaller knots, far outnumber other species of migrant waders such as turnstones and several species of sandpipers.

It is amazing that tiny birds, such as the diminutive stint and the sandpipers, have the ability to navigate thousands of kilometres, much of the distance over ocean, to spend the summer months feeding in many of our harbours, and to then

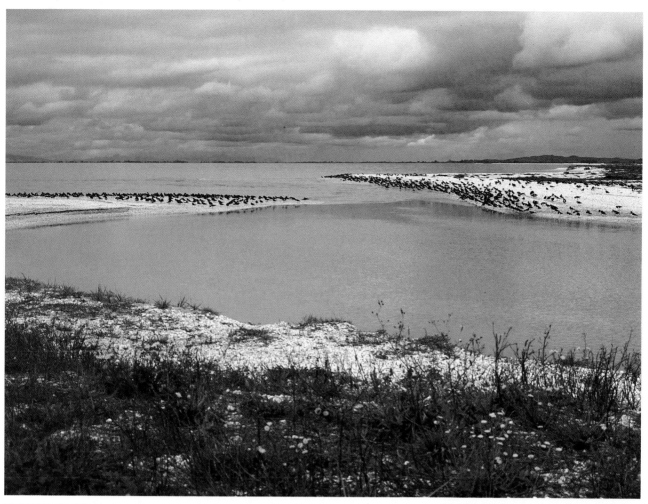

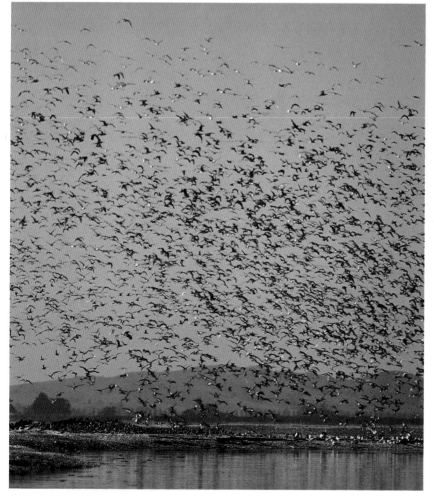

TOP Flocks of oystercatchers resting on the banks of a tidal stream.

ABOVE A New Zealand dotterel, one of our endemic waders.

LEFT A flock of godwits seek a resting place, having been driven from their mudflat feeding grounds by the rising tide.

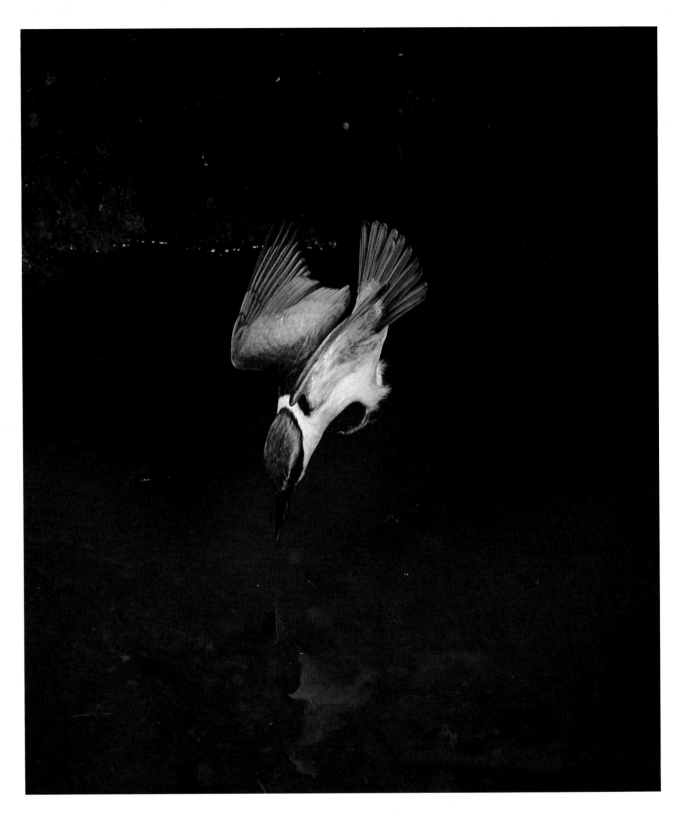

The New Zealand kingfisher dives for fish in shallow pools. Its main diet consists of mud crabs, insects and lizards.

repeat this journey to their breeding grounds. Most of these migrants reach our shores lean, hungry, and dressed in a drab grey or brown eclipse plumage. However, by February or March the birds have moulted and assumed a brighter and more colourful nuptial plumage.

Apart from these visitors, many of our indigenous wading birds use the tidal habitats as feeding grounds throughout the

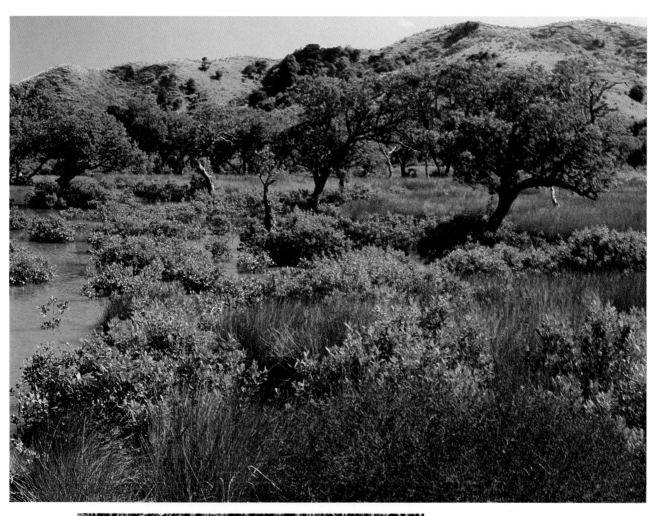

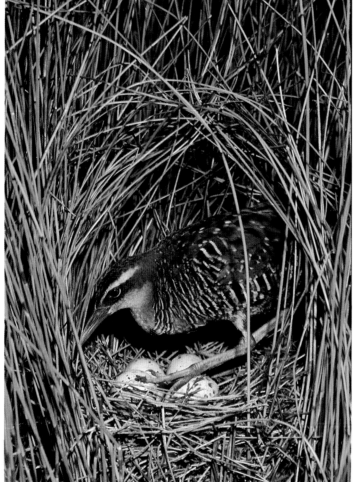

Mangrove swamps are found in the warmer sheltered estuaries and harbours of the North Island. They are an important feeding and breeding ground for many species of fish and provide a feeding habitat for birds such as herons, stilts and banded rails.

LEFT Banded rails obtain most of their invertebrate food from the mangrove swamps. They nest in the sedges which grow on the landward side of the mangroves, in areas which are only inundated by very high spring tides. They construct a nest of dry sedge stalks a few centimetres above ground, and pull down overhanging sedges to form a bower.

A World for Waders 65

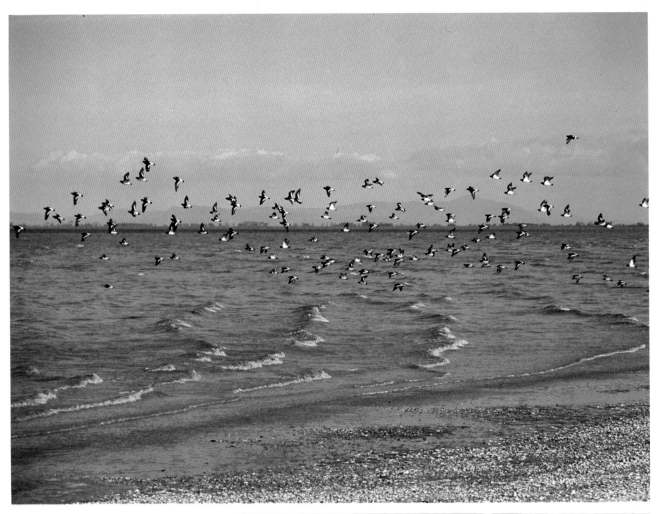

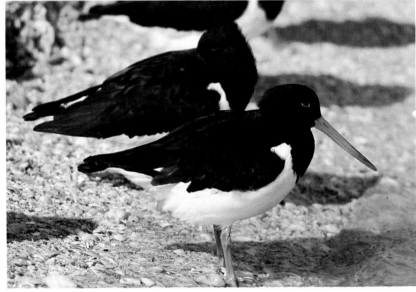

South Island pied oystercatchers nest only in the South Island, but large flocks spend the winter months on many North Island harbours and estuaries.

year. Of these, the conspicuous South Island pied oystercatchers are by far the most numerous. In lesser numbers are pied stilts, banded dotterels and the unique endemic wrybill plovers. All these species are migratory within New Zealand, and the banded dotterels travel also to Australia. Although the South Island pied oystercatchers occur in their thousands in North Island locations,

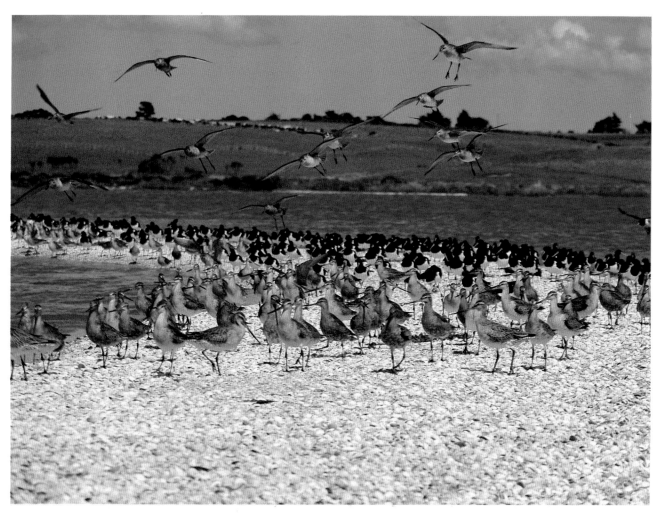

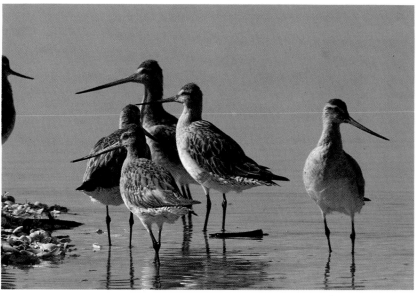

ABOVE South Island pied oystercatchers and godwits resting on a shellbank in the Manukau Harbour at high tide.
LEFT The bar-tailed godwit is the commonest of the migrant waders which spend the summer months in New Zealand. In late March and April they journey back to the Northern Hemisphere to nest in the tundra regions of Siberia.

they nest only in the South Island, choosing shingle riverbeds, pastures or ploughed land on which to lay their eggs in a mere scrape in the ground.

Wrybills are also seen throughout the year on many North Island estuaries and mudflats, but in early spring mature birds migrate to the South Island to nest on the shingle fans of certain

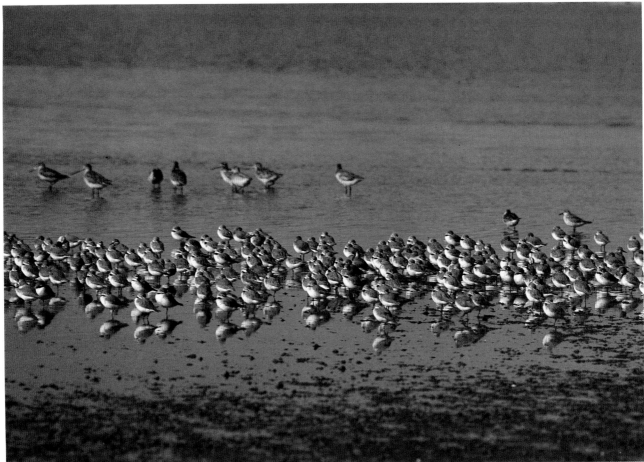

TOP LEFT The red-necked stint is the smallest of the migrant waders, being little larger than a house sparrow.
TOP RIGHT AND BELOW The unique endemic wrybill has its bill twisted to the right. It nests on shingle riverbeds in the South Island and migrates to North Island harbours in late summer to feed on the rich mudflat larders.

rivers. These small plovers, which are only found in New Zealand, are unique in having their bills twisted to the right; an adaptation which is thought to facilitate the capture of invertebrates when probing for food under river stones.

All waders are gregarious, active birds, feeding in loose flocks. As each tide rises, they are driven from their feeding

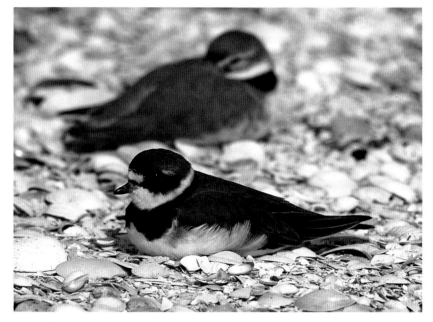

TOP The ringed plover is a very rare visitor to New Zealand. This one spent nearly two years in the company of wrybills in the Firth of Thames. BOTTOM A pied stilt at its nest on a sheltered shingle beach.

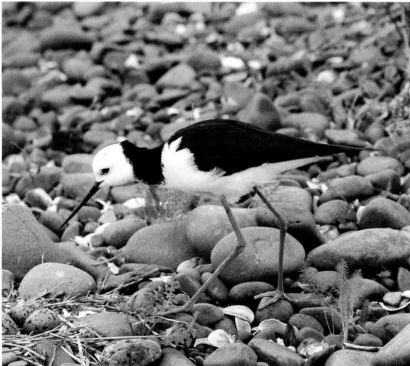

grounds to roost in large congregations on exposed shellbanks and sandspits. It is not uncommon to see flocks of several thousand birds massed on high-tide roosts in locations such as the Manukau Harbour, the Firth of Thames or Farewell Spit.

In some harbours roosting space is restricted, and birds constantly jostle for positions or fly off to seek an alternative resting spot to await the falling tide.

At times of high morning tides, I have sometimes camped overnight close to the water's edge in anticipation of early morning activity. As the dawn sky lightens and reflects in the still water creeping across the mudflats, small groups of birds in turn

take wing as their feeding is interrupted by the incoming tide. There is a certain excitement in the air as skeins of godwits and knots hurtle along just above the surface of the water, their wings rustling in the still air as they seek a place to rest.

White-faced herons are common in most of these habitats.

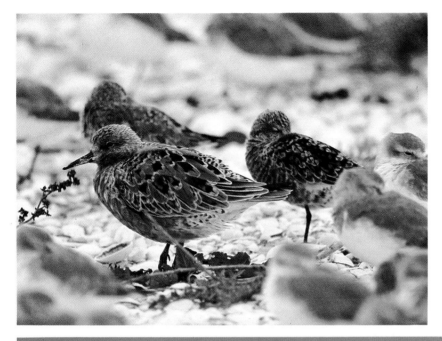

Knots are the second largest in number of the migrant waders, and vast flocks of several thousand birds can often be seen at Farewell Spit, the Manukau Harbour and the Firth of Thames. Knots are about half the size of godwits and have shorter legs and bills. Although they often fly and roost with godwits, they separate to feed by themselves. BELOW A flight of knots hurtles along, their wings rustling in the still dawn air.

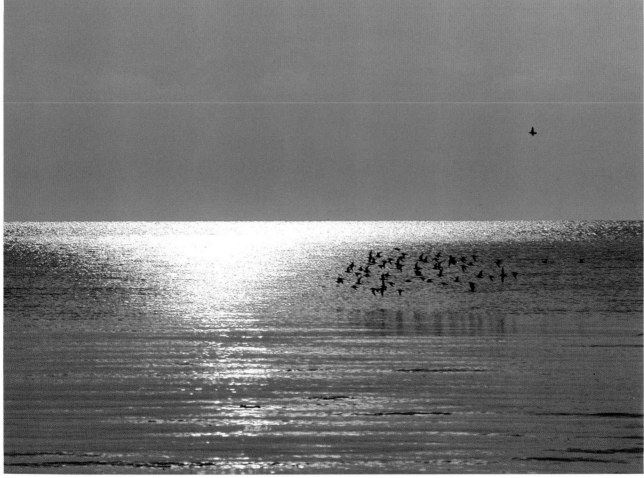

Large numbers of this Australian bird arrived in New Zealand about 40 years ago. They rapidly colonised marine and freshwater habitats in both the North and South Island. It is interesting to watch their varying methods of feeding. Sometimes they stand motionless, waiting for a fish to come within reach of a lightning jab of their rapier-like bill; at other times they move stealthily along the edge of the tide, searching for prey. When feeding in shallow tidal pools, they resort to raking the mud, one foot extended, to disturb marine organisms.

The white heron, or kotuku, has its only New Zealand breeding site in trees bordering the Waitangiroto Stream in south Westland. Following the summer nesting season, birds disperse throughout the country to spend the winter months in lagoons and tidal estuaries, where this strikingly large white bird may be seen.

Another conspicuous white bird, slightly smaller than the white heron, is the royal spoonbill. For many years these birds nested in tall trees close to the white heron colony in south Westland. Since 1978 several pairs have nested on the ground in

OPPOSITE TOP The white-faced heron is an Australian species which migrated to New Zealand in large numbers in the early 1950s. It is now our commonest heron and inhabits marine and freshwater habitats.
BOTTOM AND OPPOSITE RIGHT White-fronted terns or kahawai birds. This is our commonest tern species.

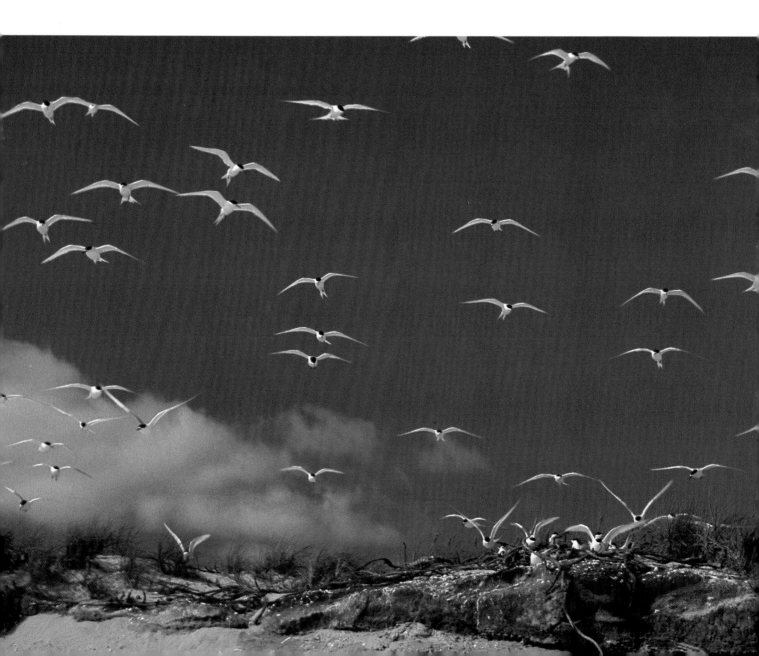

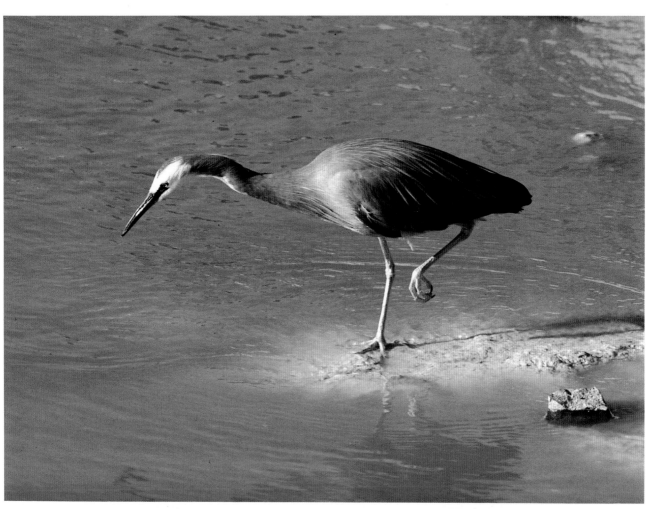

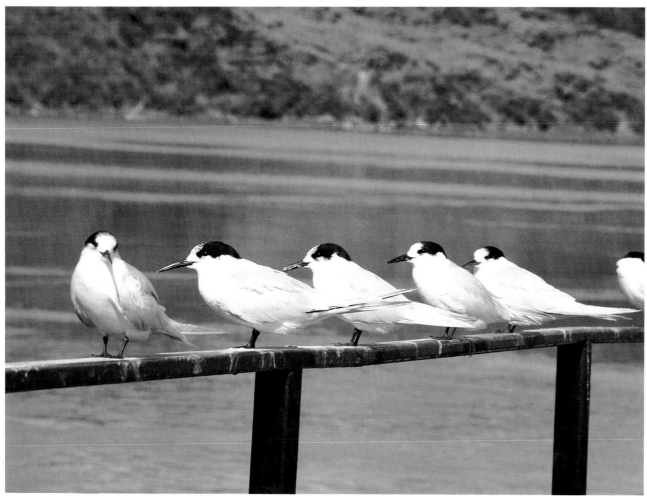

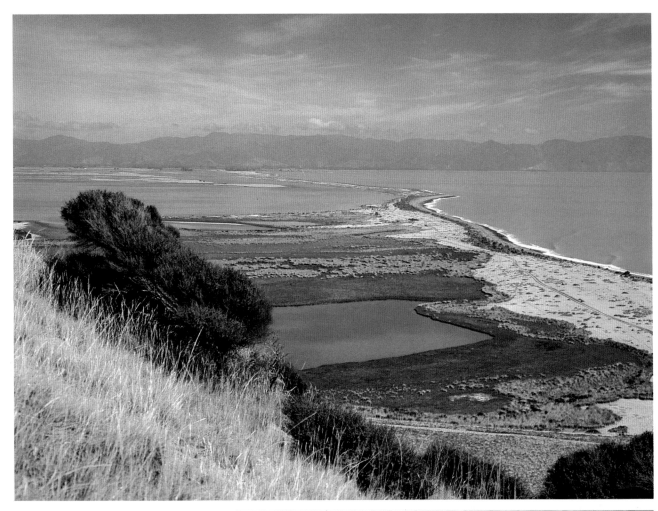

The Vernon Lagoons in Marlborough are bordered on the seaward side by a long boulder beach. This protects the extensive lagoons from the turbulent waters of Cook Strait. These lagoons are inhabited by black swans (right), various species of ducks, shags, gulls, terns and a wide variety of wading birds.

the salt marshes of the Vernon Lagoons in Marlborough. Unfortunately, nests have been flooded on occasions when high spring tides have coincided with floodwaters from the adjacent Wairau River. Spoonbills have an unusual method of feeding. Often in groups, they wade along in shallow water, swinging their spatulate bills from side to side to sieve out marine organisms.

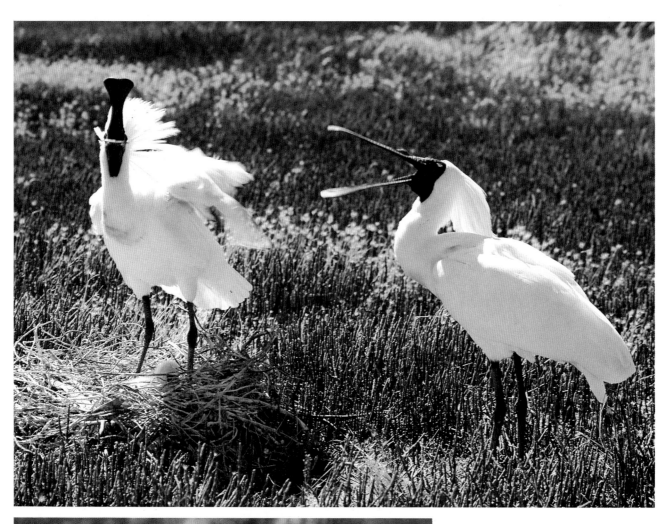

In recent years royal spoonbills have nested on islands in the lagoons.

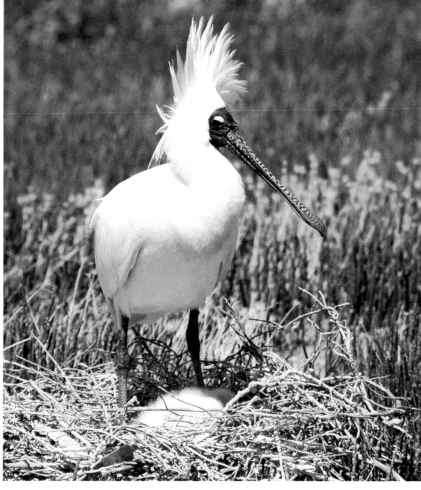

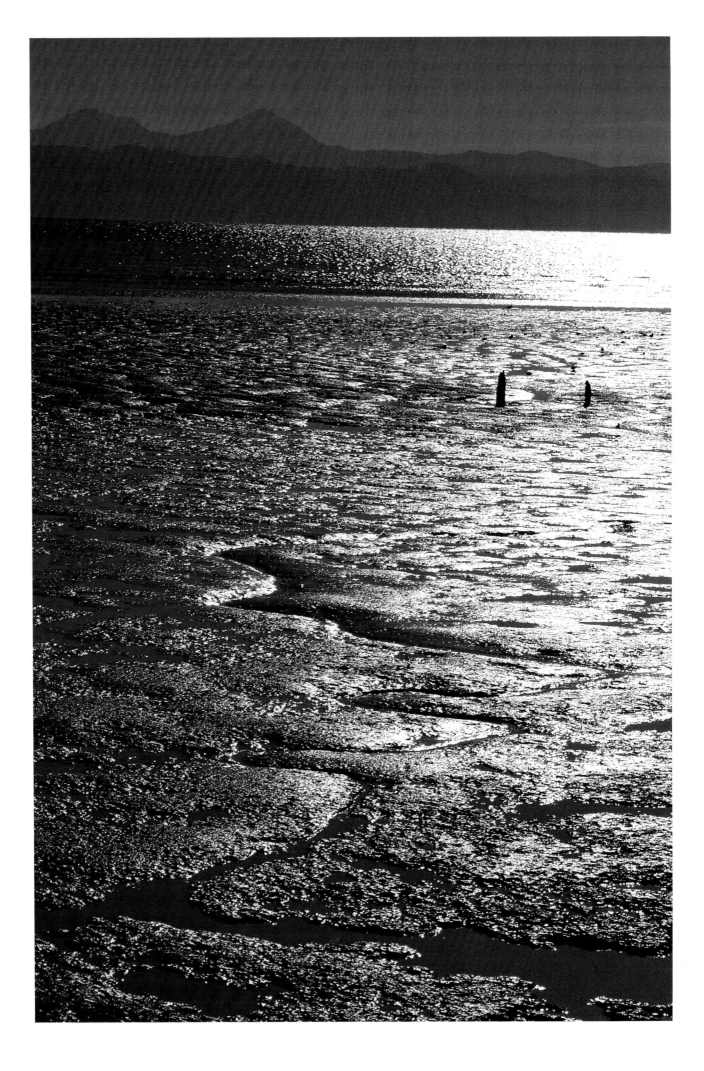

These familiar landscapes of harbour and estuary are common throughout New Zealand, and some of the most ecologically important of these are close to our towns and cities. Within comparatively small areas, these environments provide a constantly changing scene, activated by the movement of the tides and the needs of the dependent wildlife.

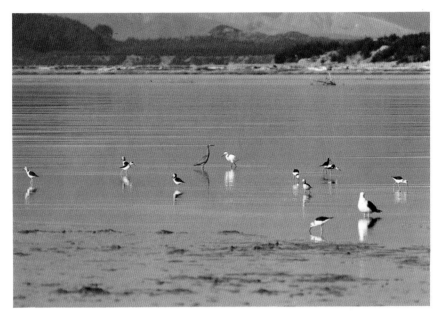

OPPOSITE The extensive mudflats of many of our harbours provide rich feeding grounds for many species of wading birds. Molluscs, crabs and marine worms abound in these habitats.

LEFT A little egret, a white-faced heron and a black-backed gull with a group of pied stilts.

BELOW Kowhai trees and flax growing on the coast of the Firth of Thames.

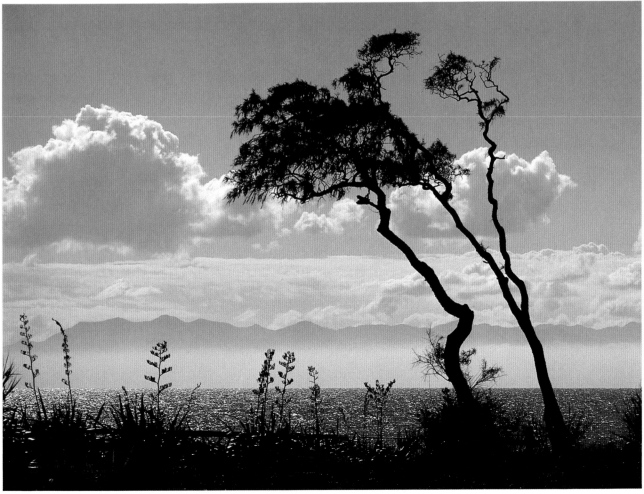

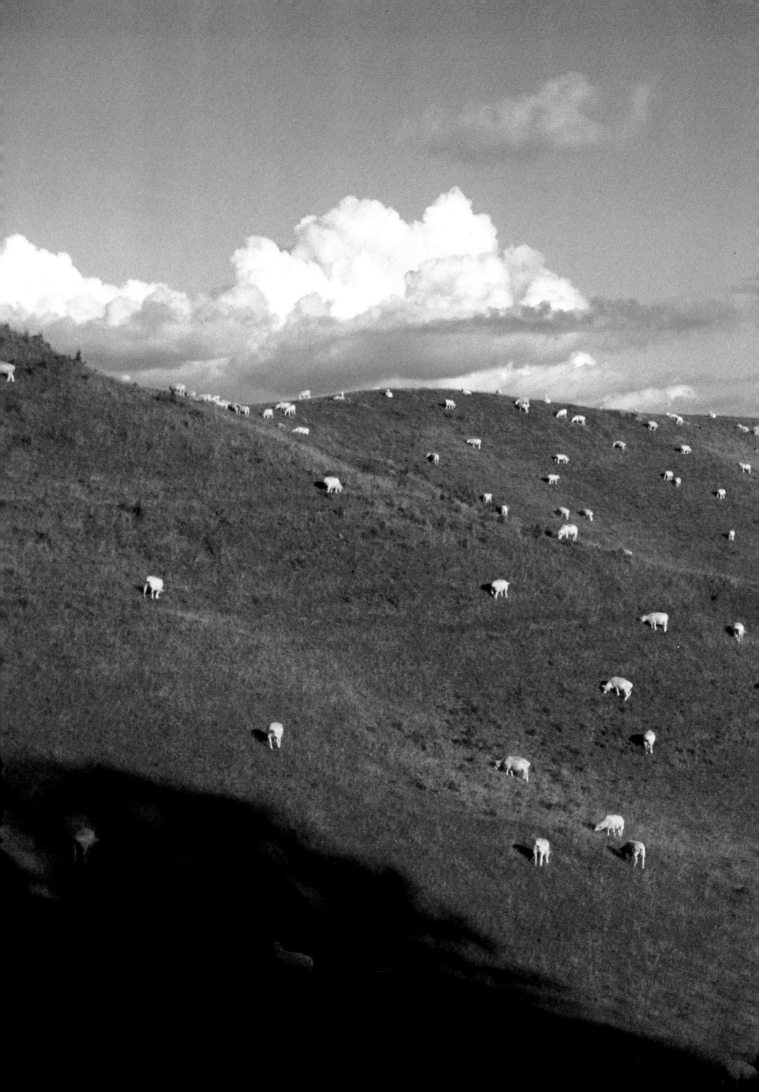

four

THE RURAL LANDSCAPE

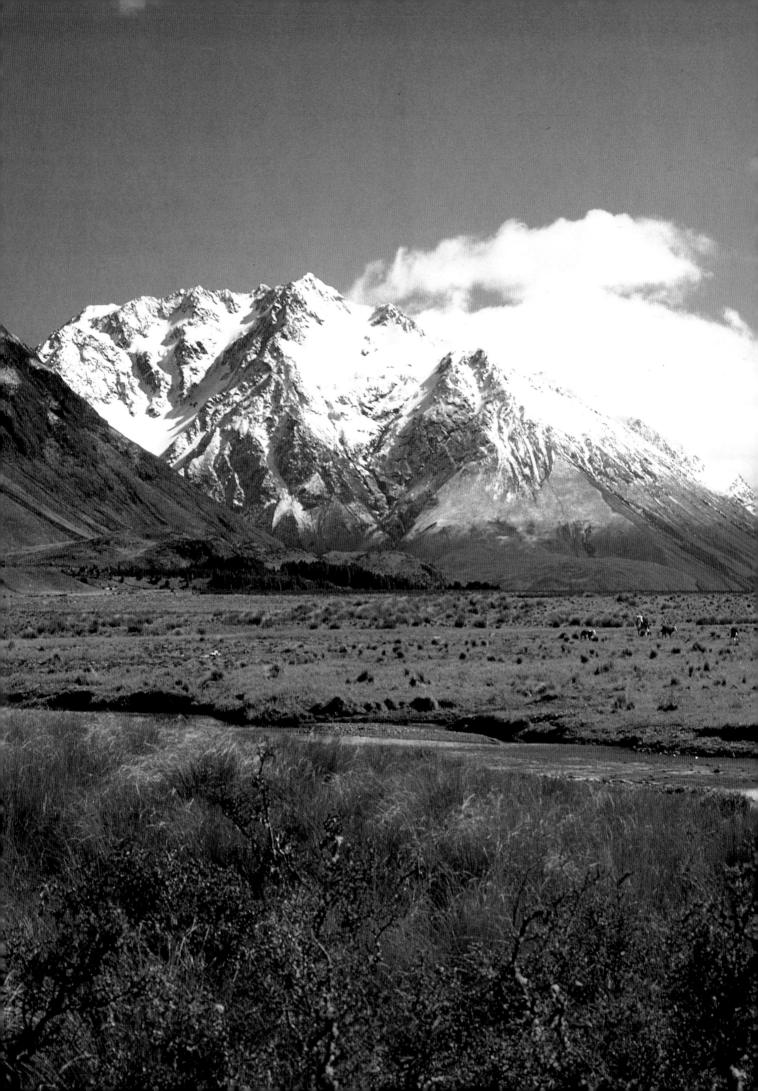

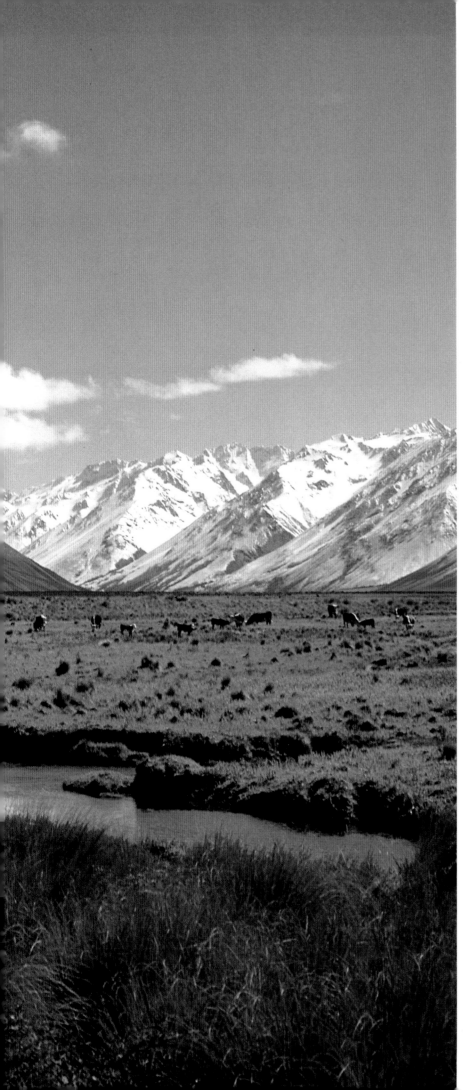

O f all this country's changed environments, the development of our present rural landscape from the original forest has undoubtedly been the most dramatic, and today farmed grasslands and arable lands occupy more than half of the New Zealand land area.

The early European settlers found many regions already denuded of the original forest. Much of this was scrub-covered and easily cleared and burned. Introduced species of grasses and clover readily germinated and grew in the ashes. In other parts, the tussock grasslands provided immediate grazing for stock.

Dual-purpose Shorthorns were the first cattle to be introduced, and Merino sheep brought from Australia were well adapted to survive on the

ABOVE Pheasants and other game birds were introduced for sport and are now common in many regions. Other game birds introduced are the Californian quail, which is now well distributed in drier regions of both the North and South Island, and the chukor, which prefers the eastern side of the Southern Alps.

tussock-covered hills of the Wairarapa and eastern slopes of the Southern Alps.

In other areas forest was cleared for pasture establishment and to provide timber for building. Forest clearance rapidly gained momentum to include steep hill country, with consequent erosion of soil and flooding of lowland regions, a phenomenon which frequently occurs to this day.

Arable farming for crops was mainly practised in the South Island and extensive grain-growing areas were developed, particularly on the downlands of Canterbury, Otago and parts of Southland.

Differing regional climates and soil types have today created a variety of pasture associations and the use of phosphatic and other fertilisers, now often spread by air on steep country, has created greatly improved grass growth. Today, due to a combination of fertiliser use and a favourable climate, areas in Northland, Taranaki and particularly the Waikato contain some of the most productive pastures in the world.

Now one can view wide expanses of open country, clothed in pasture or patched by crops, where not a single native tree is visible. Elsewhere the sight of rows of sombre macrocarpa windbreaks or clumps of pine trees is sometimes relieved by plantings of beautiful exotic deciduous trees. Lombardy poplars, (mainly in the South Island), also oak, ash, maple and silver birch are spectacular with their bright spring greenery or vivid autumn colourings. Hillsides and riverbanks, resplendent in brilliant yellow broom and gorse, likewise present a beautiful spring scene, but these shrubs, first introduced to form hedgerows, have proved a costly embarrassment and have spread uncontrolled in some regions.

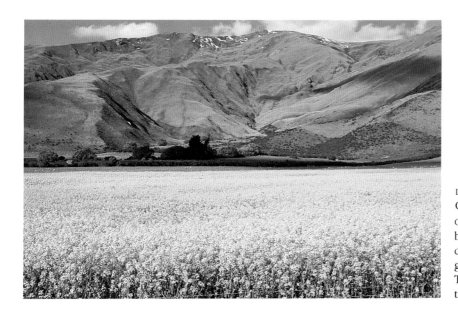

LEFT A field of mustard in flower, in Otago.
OPPOSITE Deciduous trees, first introduced by the early settlers, beautify the countryside with their bright spring greenery and vivid autumn colourings. These robinia have attractive twisted trunks.

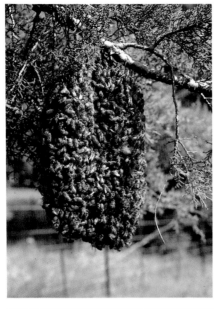

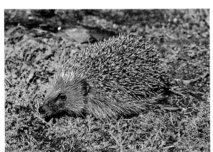

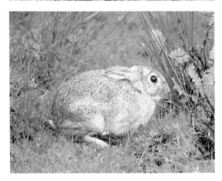

TOP LEFT Honey bees were originally introduced to New Zealand to pollinate white-clover flowers.

MIDDLE LEFT Hedgehogs feed mainly on insects, worms and snails. They also take eggs and young from ground-nesting birds such as skylarks.

BOTTOM LEFT Rabbits are a serious pest in drier regions and require constant control by poisoning.

TOP RIGHT In recent years kiwifruit farming has become popular in warmer districts.

MIDDLE AND BOTTOM Some farms have diversified to stock angora goats and red deer.

Orchards and vineyards have been established for many years in climatically suitable regions of both the North and South Island, and recent diversification has seen a rapid development of the kiwifruit industry and farming of deer and angora goats.

The open country provides suitable feeding habitats for many wild animals and birds. Rabbits are common in the drier areas, and in some parts of the country, particularly Otago, they have become a major pest, requiring constant control by poisoning. Hares do not breed as rapidly as rabbits and have not become a serious problem. Hedgehogs, also introduced from Europe, are most often seen as casualties on our roads. They are nocturnal in habit, feeding on a variety of insects, grubs and snails, and are also reported as taking the eggs or young of ground-nesting birds such as pipits and skylarks.

A South Island pastoral scene near the Maruia River. In this area much of the flats are farmed but magnificent beech forests still cover the hills in the background.

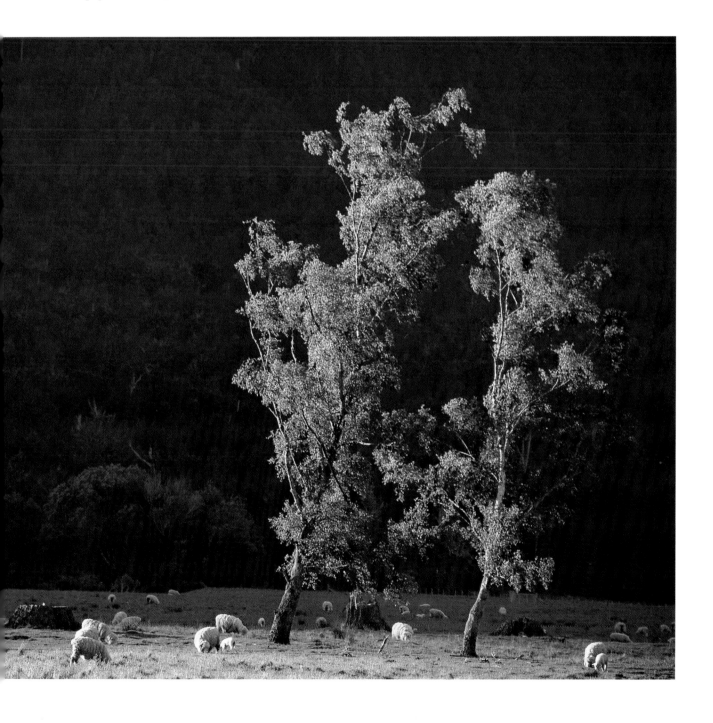

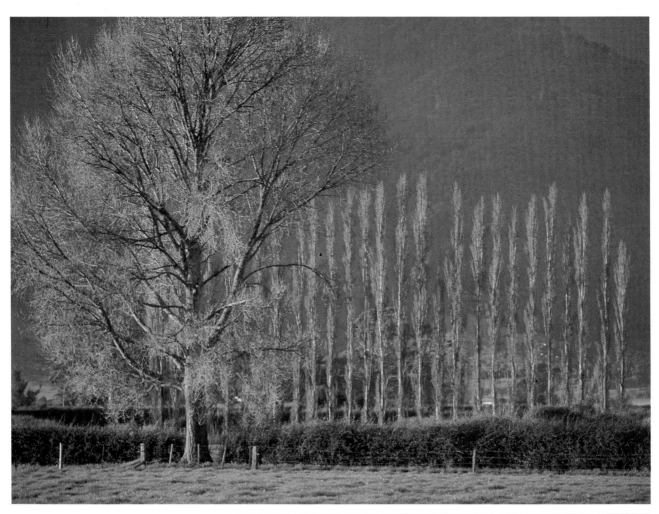

ABOVE Deciduous trees develop far more brilliant colours in districts where heavy frosts occur in autumn. In late summer these trees are just beginning to colour.

RIGHT Skylarks were introduced from Europe last century and now inhabit most pastoral districts, brightening the countryside with their lively trilling songs poured out as they soar skywards. Skylarks build their nests of dried grasses well concealed in a hollow beside a clump of grass.

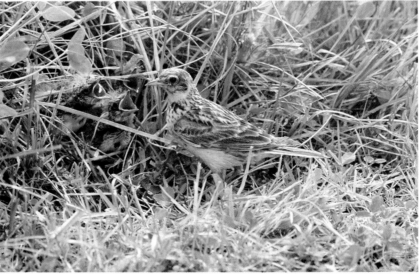

Undoubtedly the most readily visible wildlife of the open country and orchards are the birds. Many European species were introduced for nostalgic reasons by the early settlers, and most of these birds have thrived in their new environment.

Thrushes, blackbirds, starlings and chaffinches are a familiar sight in our gardens and parks. Blackbirds and the chaffinch have penetrated to the depth of our native forests and colonised most

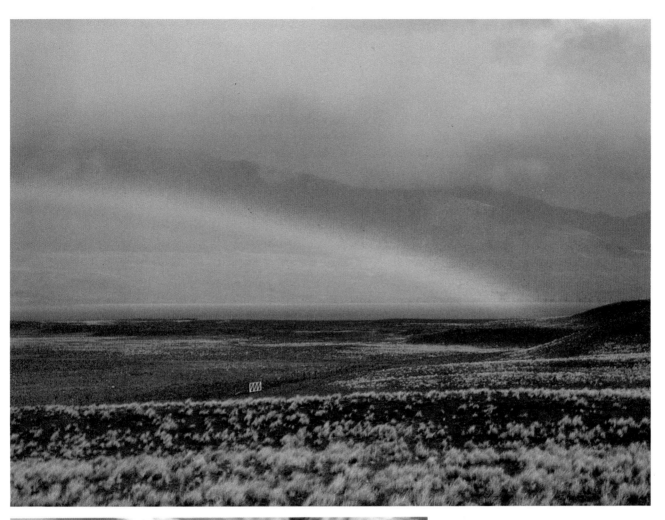

TOP Grazed tussock grasslands in the MacKenzie Country. Fires in pre-European times destroyed the forests and allowed the native tussock grasses to spread over wide areas. Today most of these native grasslands are grazed by stock, and exotic grasses and clovers have been introduced.

LEFT The small copper butterfly is very common around our coasts and in tussock country, especially where thistles and other weeds are flowering.

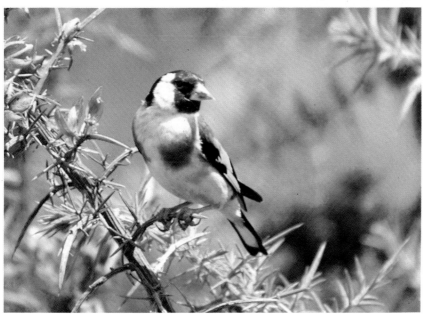

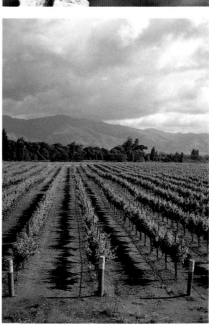

of the offshore islands. The attractive goldfinches have fared so well in New Zealand that they are considered to be more numerous here than in England, their country of origin. In winter, when they congregate to feed on seeds of grasses and thistleheads in open country, swarms of over a thousand birds are not an uncommon sight. Goldfinches build attractive nests composed of fine grasses, moss, lichens and cobwebs woven into a neat cup. A favourite site is in the branches of apple, plum, or other orchard trees.

There would be a dearth of birdsong in the open countryside but for the presence of the skylark, another European settler. As it soars into the sky the skylark's trilling, warbling song, poured out without pause, always fills me with a sense of exhilaration. Skylarks build a well concealed nest in a depression in the

OPPOSITE Introduced foxgloves grow in some areas of poor soil.
In winter months, many of the introduced finches such as the goldfinch (bottom left) form large flocks to feed on seeds in orchards, vineyards (bottom right) and pastures.
TOP RIGHT Starlings feed on various harmful pasture grass grubs. Farmers often encourage them to breed by placing nesting boxes on fenceposts.
TOP LEFT The introduced chaffinch is common in orchards and vineyards. It also inhabits native forests.

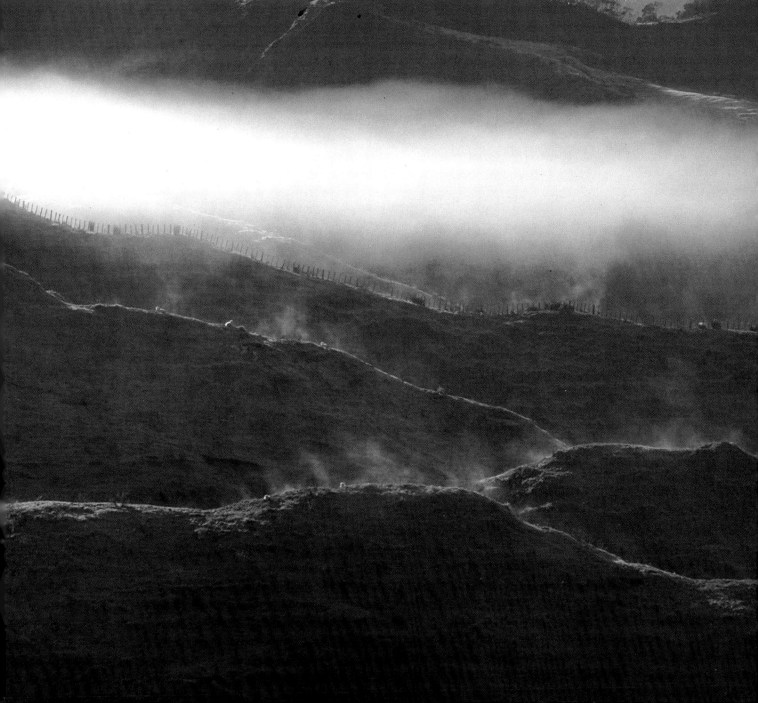

ground, usually beneath a clump of grass but often in very short grazed pasture. When sitting on its nest, the bird is very well camouflaged, but in spite of this, eggs and chicks are often destroyed by the introduced Australian white-backed magpie.

The magpie builds a substantial nest of sticks, grasses and leaves, and often lines this with wool gleaned from fences where sheep have rubbed. Some years ago I built a hide to photograph a magpie which was nesting in a pohutukawa tree. Magpies are wary and intelligent birds, and on no occasion did I see any sign of the bird each time I worked on completing the hide. However, when I used the hide for the initial session of photography, and had a friend walk away from the scene, within two minutes the magpie was back at the nest. She must have been keeping a close watch on me from a distance, yet assumed the coast was clear when my

Early morning mists rise from the hills and quickly dissolve as the sun rises.

'And all the distance shrouded into shapes
Dimly divined, the ghost of what we knew . . .'
— V. Sackville-West

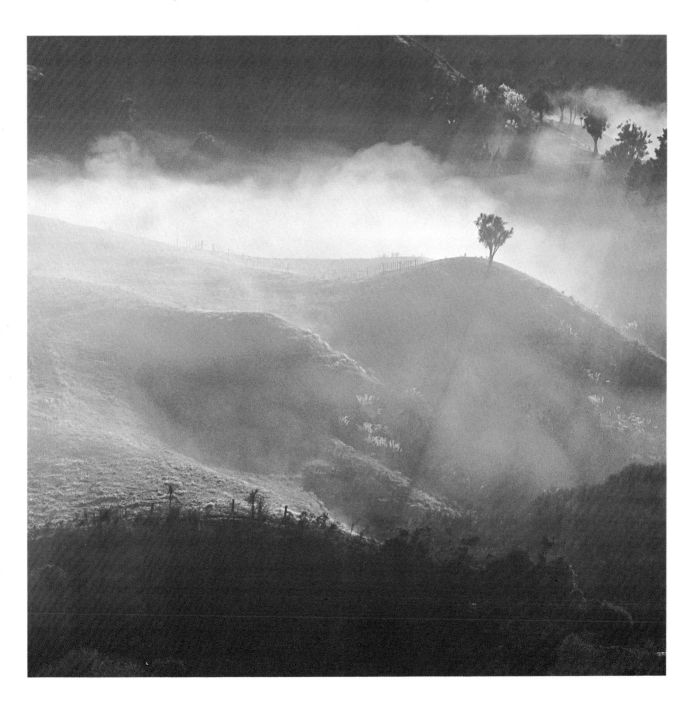

friend left the area. One day, from my elevated viewpoint, I watched the magpie foraging in the grass of a nearby paddock. She probed intently at one spot and then flew to the nest carrying a fledgling bird which she fed to her chicks. I have the incident recorded on movie film and it confirms the predatory habits of this species.

While pastures, arable land and orchards provide favourable

LEFT The introduced Australian white-backed magpie, although useful in destroying many harmful pasture grubs, also predates the nests of ground-nesting birds such as the skylark.
RIGHT Kahikatea swamp forests originally covered many low-lying areas. Today remnant clumps of these trees can be seen surrounded by pastures.
BOTTOM An isolated pohutukawa tree in the Coromandel district.

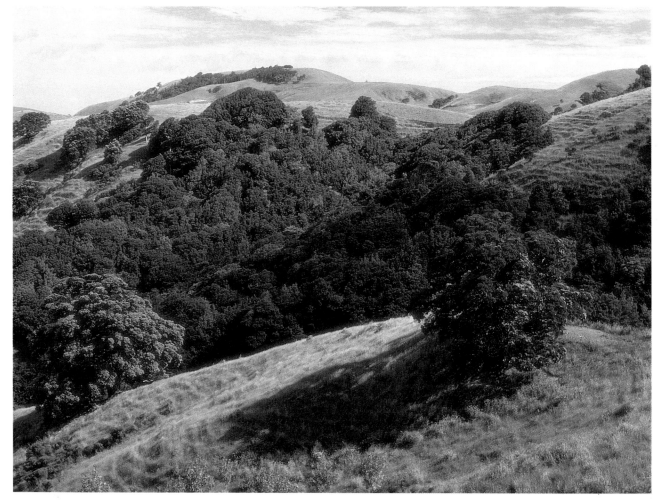

living conditions for most of the introduced birds, some of our native species have also found these open habitats to their liking. The pukeko favours the wetter paddocks and is often seen feeding on the grass verges of busy motorways. In the South Island, pastures and ploughed land are favourite feeding and nesting grounds for the conspicuous South Island pied oystercatcher. Here it is often joined by black-fronted terns and

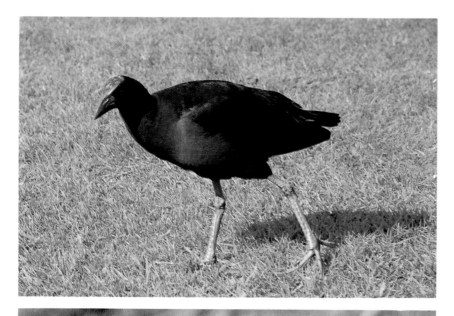

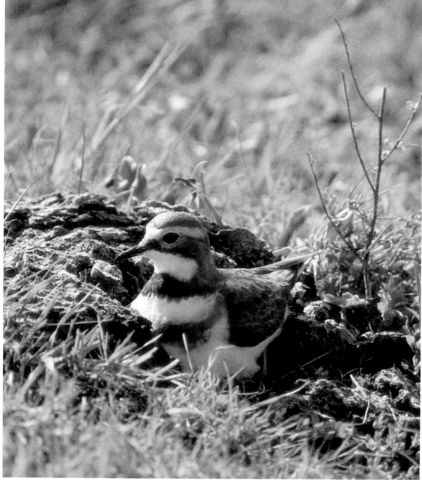

TOP The pukeko, essentially a swamp-dwelling bird, has adapted to feed on pastures and even along the grass verges of motorways.
BOTTOM This banded dotterel nested in the hollow of a dry cowpat in a pasture. These dotterels also nest on shingle riverbeds, sand dunes and sometimes at high altitudes on mountain slopes.

black-billed gulls searching for insects. Paradise shelducks are increasing in numbers and are now found more frequently in pastoral open country, and harriers are a common sight as they quarter the ground searching for insects, small birds and carrion.

From time to time, aided by the prevailing westerly winds, Australian birds cross the Tasman to settle in New Zealand. In past

RIGHT Introduced plants such as gorse and broom have spread rapidly in the favourable New Zealand climate.
LEFT Erosion occurs when steep hills are denuded of their original forest cover.
BOTTOM In many rural areas it is possible to view wide landscapes of pastureland where no native trees are visible. The area pictured was once forest-covered.

years some of the bird species accustomed to living in open country would not have found the original forest habitat to their liking and would not have survived. However, the expanded rural landscape has proved suitable for certain self-introduced species. A good example is the spur-winged plover. Birds were first seen in 1932 in Southland, where they settled and bred. Numbers

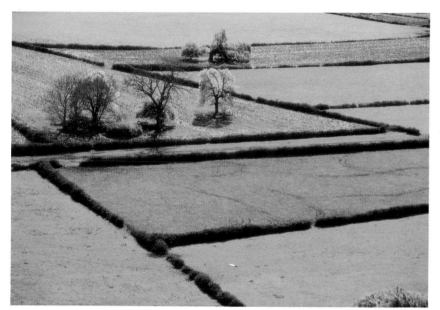

LEFT A pattern of pasture and arable land.

RIGHT The harrier preys on large insects and small birds in pastures and along forest margins and swamps. It also feeds on carrion such as hedgehogs, rabbits and opossums which have been killed by traffic.

BOTTOM The Waikato region is noted for its high-producing dairy herds.

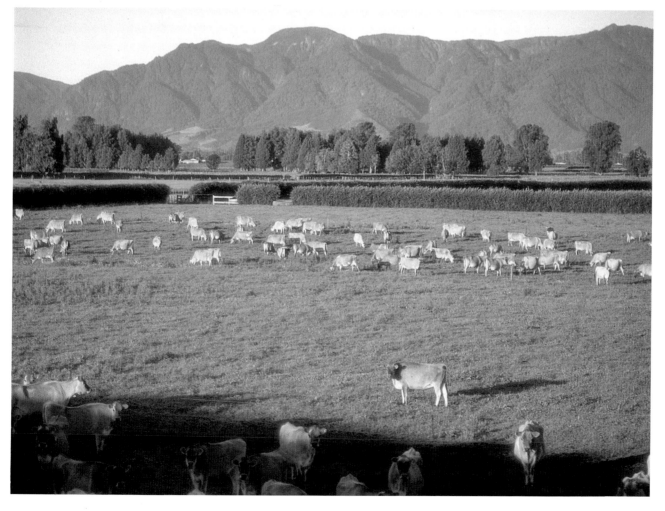

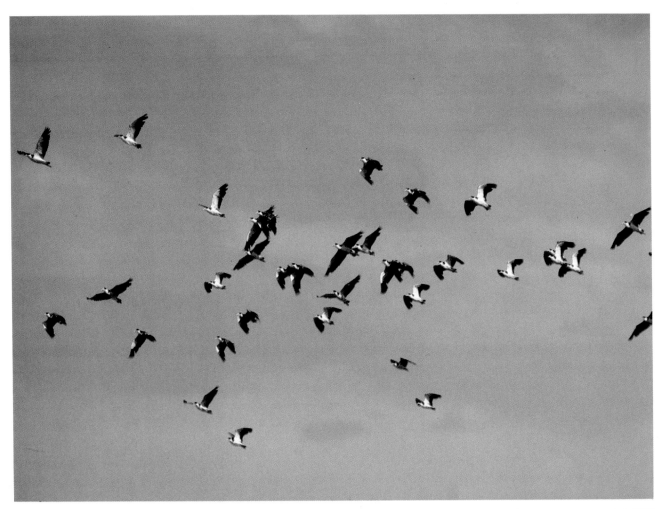

ABOVE Spur-winged plovers migrated to the South Island from Australia about fifty years ago. They have since spread throughout New Zealand and are common in many areas of rural and open country.

BELOW Kingfishers inhabit rural areas as well as the coasts and wetlands. They can be seen perched on powerlines on the lookout for insects and lizards. On occasions they prey on mice and small birds.

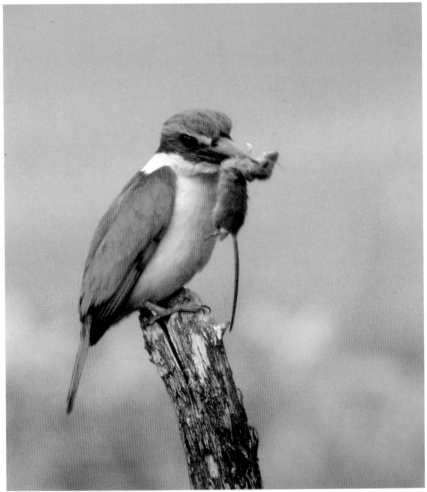

increased steadily over the years and birds invaded other suitable areas. They eventually spread to the North Island in the early 1970s, and today the bird is a noticeable inhabitant of open country throughout both main islands. Spur-winged plovers have a distinctive rattling call and a typical ploppy, lapwing flight. Out of the breeding season they often congregate in large flocks.

TOP A spring pastoral scene in southern Hawkes Bay.
RIGHT Remnants of a beech forest, now surrounded by pasturelands.
LEFT The yellowhammer was introduced from Britain for nostalgic reasons. It nests in roadside banks.

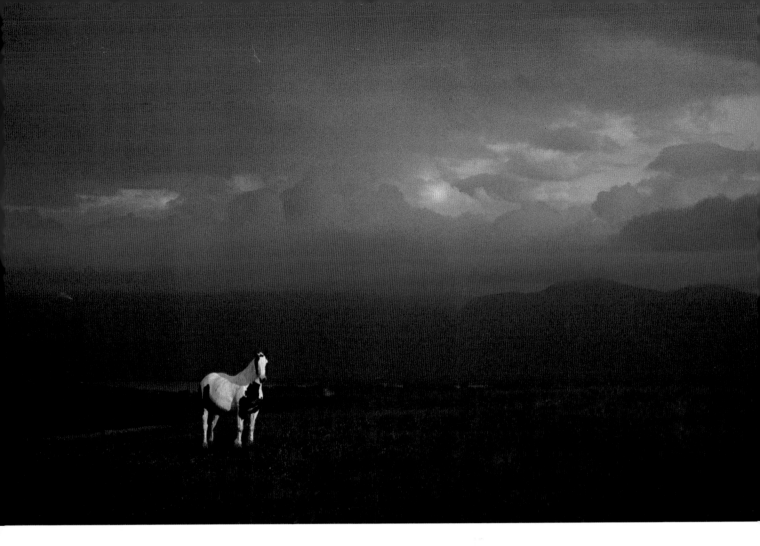

A shaft of sunlight breaks through storm clouds to spotlight a sentinel horse.

Other Australian birds which have recently settled in New Zealand open country are the white-faced heron and the welcome swallow. Both species arrived in large numbers in the 1950s and spread rapidly. Besides feeding in open pastures, the white-faced heron now occupies a variety of habitats and is quite at home in a marine environment or beside inland freshwater lakes. These herons usually nest high in pine trees.

In recent years, large flocks of cattle egrets have been arriving in New Zealand each autumn, presumably from Australia. They spend the winter and spring keeping company with the cattle and feeding on the grubs and insects which the animals disturb. In late October, having assumed breeding plumage, the egrets fly back to nest in Australia. It is hoped that these attractive small herons will one day remain to nest in New Zealand.

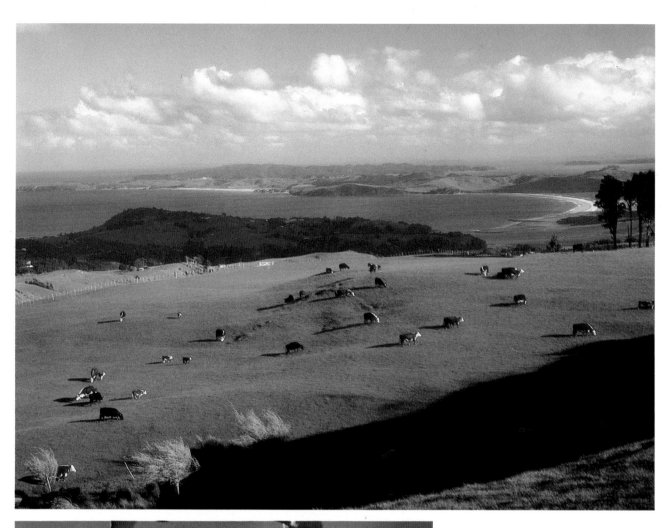

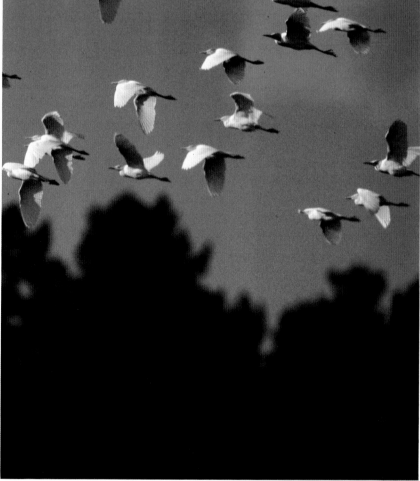

TOP In many parts of New Zealand farm pastures extend to the coast.

LEFT Cattle egrets are a cosmopolitan species of small heron.

THE WETLANDS

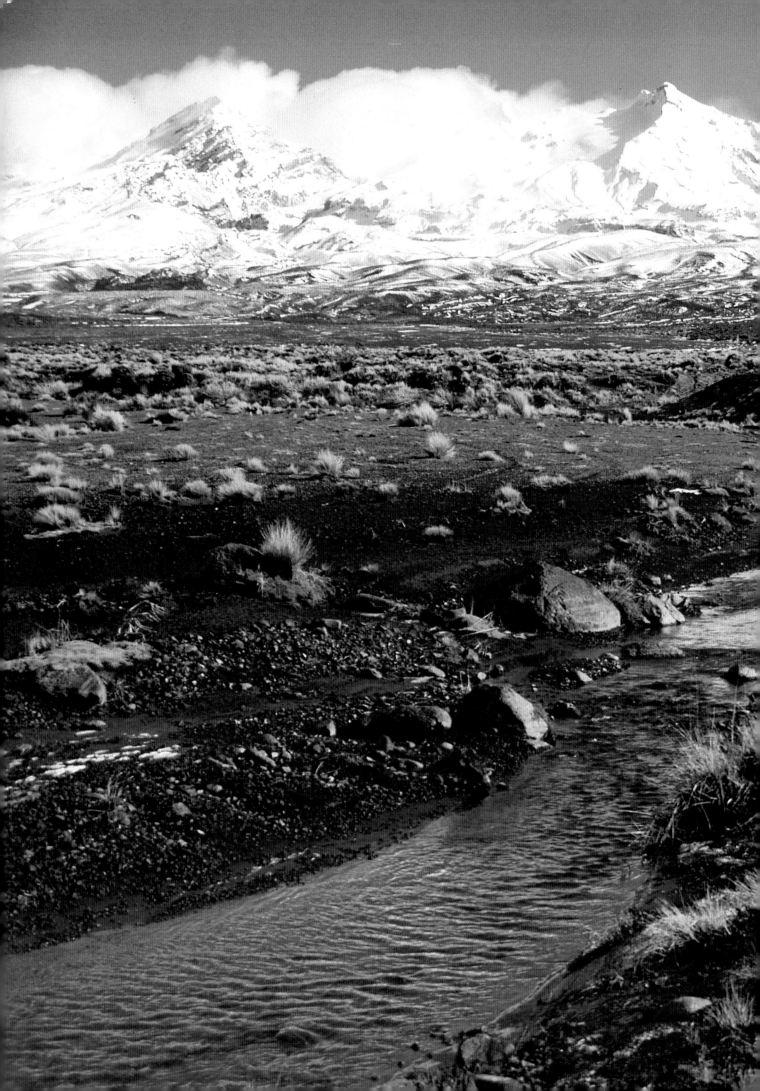

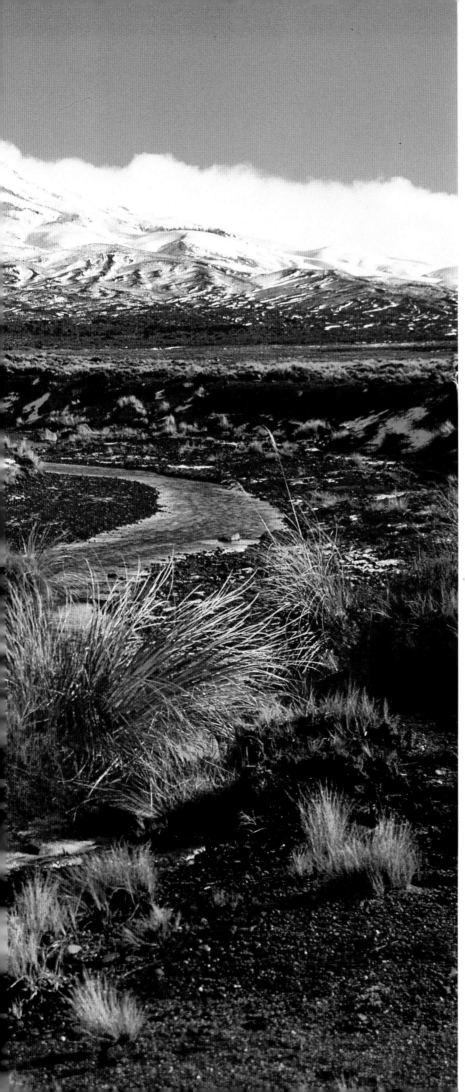

New Zealand's wetlands are well distributed throughout the country. They include numerous lakes, rivers, swamps and bogs.

Our lakes were formed in different ways. The largest, Lake Taupo and those of the central plateau in the Rotorua district, are of volcanic origin. Others have been formed by earthquakes which have uplifted the land to block off drainage from low-lying areas, or, as in the case of Lake Waikaremoana, by a massive earthquake-induced landslide which blocked the exit from a river valley. This occurred only 2200 years ago, a fact confirmed by carbon-dating of dead trees in the drowned valley. A lot of the South Island lakes were carved out by glacial action during the last Ice Age, and many of these are very deep.

ABOVE The blue duck still survives on many turbulent high-country rivers.
LEFT Our longest river, the Waikato, originates from small glaciers on the eastern side of Mount Ruapehu. The waters join the Tongariro River and flow on into Lake Taupo.

Some are a turquoise colour and have a milky appearance due to their content of 'rock flour' ground from alpine rocks by the action of glaciers.

Wind-blown sand has, by preventing drainage, created dune lakes in many coastal areas, and the sea's wave action has built up a long shingle bar to isolate Lake Ellesmere from the sea.

New Zealand has many manmade lakes. Most of these are long and narrow and have been formed by damming river systems to provide water storage for generating electricity. Lake Benmore, fed by rivers of the Waitaki catchment, is the largest of these manmade lakes, covering nearly 80 square kilometres. Many of the manmade lakes have been attractively landscaped with trees, and areas set aside for picnicking, boating and fishing. Smaller artificial lakes are used as water-supply reservoirs for town and city use. Access to most of these is restricted, and many are formed in fairly remote areas.

Fluctuating water levels due to water use of both reservoirs and hydro-storage lakes affects the aesthetic appearance of all these manmade lakes and may have an effect on their ecology by drying out the banks and consequently killing the vegetation. The hydro lakes, particularly the newer ones, are often too deep to encourage many species of wildlife, although some of those which have shallow fringes, with growths of rushes and other vegetation, are favoured habitats for ducks, shags, herons, stilts and other water birds.

Lake Whakamaru, which is the fourth manmade lake on the Waikato River, has stretches of rushes and weed-fringed shallow water. This attracts insects, frogs and many species of wetland birds; even the shy bittern feeds and nests here.

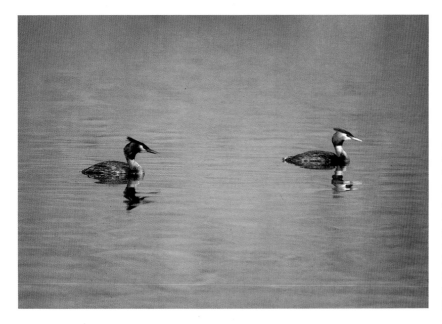

OPPOSITE Violent storms can arise quickly in mountain regions. Here the waters of Lake Alexandrina are whipped up by winds blowing from the Southern Alps. Lake Alexandrina, apart from its high reputation for trout fishing, has a greater number of resident southern crested grebes than any other New Zealand lake.
LEFT Southern crested grebes are now confined to the high-country lakes of the South Island and Westland.

Dawn on Lake Rotorua.

*'The sun aglow, and rising
flares a flushed-gold glaze that
glares life into another day.'*
— L.M.M.

Some of the South Island artificial lakes support populations of ducks, paradise shelducks and Canada geese. However, it is the natural lakes which generally support the greatest numbers of wetland birds. Lake Ellesmere and Lake Wairarapa are particularly rich in birdlife.

The natural subalpine lakes of the South Island are the remaining strongholds of the southern crested grebe, a species once living on some North Island lakes. The highest population of this strictly aquatic bird is found on Lake Alexandrina in South Canterbury. A close relative, the New Zealand dabchick, a much smaller bird, now appears to be absent from its former haunts in the South Island. However, it is still reasonably common on many North Island lakes, particularly those of the central plateau and on the northern dune lakes.

The major rivers of the North Island radiate to the coasts from the central mountains and the volcanic plateau. New Zealand's longest river, the Waikato, nearly 450 kilometres in length, flows from its source on the eastern side of Mount Ruapehu into Lake Taupo via the Tongariro River. From the lake's outlet it reaches the Tasman Sea at the Waikato Heads.

Many South Island rivers are fast flowing as they originate

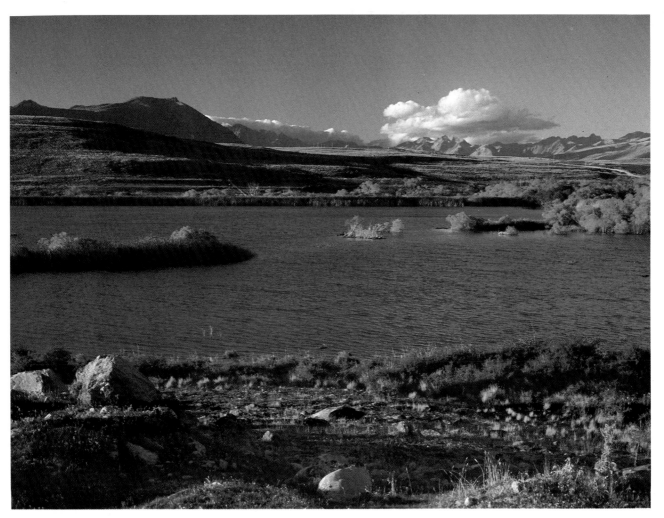

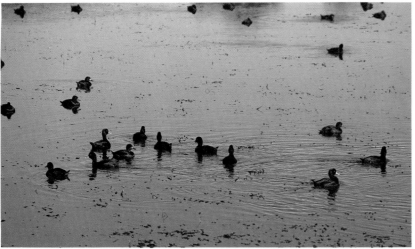

ABOVE Lake MacGregor, a small high-country lake in South Canterbury, supports three pairs of southern crested grebes.

LEFT The New Zealand scaup, or black teal, is our only true diving duck. It is found in small flocks on many lakes throughout the country.

from high country or from the Southern Alps. Lakes are also the source of some rivers. The fast-flowing Buller River commences its course to the West Coast from Lake Rotoiti. Further south, the Waiau River flows from Lake Te Anau into Lake Manapouri and then to the Southland coast. Its volume has been adversely affected by the use of Lake Manapouri water to supply the power station which releases its water into Doubtful Sound.

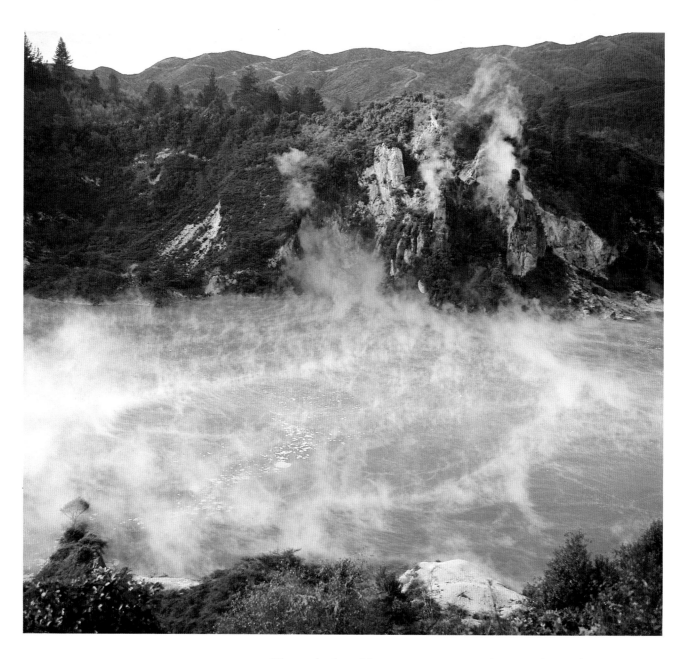

The Waimangu Cauldron, a small thermal lake on the North Island's central volcanic plateau.

The turbulent blue Kawarau River drains Lake Wakatipu and joins the turquoise-coloured Clutha River at Cromwell. The Clutha already supplies the generators of the Roxburgh power station, and its waters will soon be further harnessed at the Clyde Dam, which is now under construction.

Some of the most ecologically interesting rivers are the braided shingle rivers of Canterbury and the Waitaki River catchment. All arise on the eastern side of the Southern Alps. Braided rivers are those which have interwoven channels and shingle islands, the channels often changing their courses with fluctuations in the water flows. Internationally, braided rivers of the type found in New Zealand are uncommon, and the specialised avifauna which has evolved and adapted to live and breed in these habitats is found nowhere else in the world.

These rivers, which are subject to rapid fluctuations in level, provide more extensive habitats for the resident birds than do

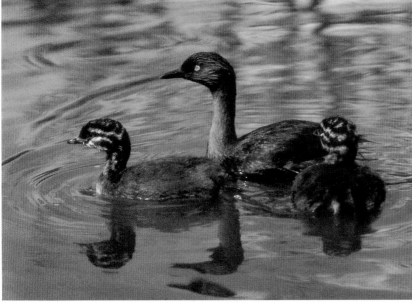

LEFT The New Zealand dabchick, a small grebe, is now found only in the North Island. It is quite common in the southern parts of Lake Taupo (above) and on the Rotorua lakes.

single-channel rivers. Typical of the birds feeding and nesting on these rivers is the unique wrybill, previously mentioned as visiting North Island feeding grounds out of the breeding season. The wrybill's cryptic colouring exactly matches the stones of its riverbed habitat, and unless it is moving, it is difficult to see.

Similarly, the eggs, laid in a hollow among stones on shingle fans in the river, are also extremely well camouflaged.

Other endemic bird species found on these braided rivers are the black-fronted tern, the black-billed gull, and the banded dotterel. The wrybill nests only on certain braided rivers, but the other species may nest in other localities.

TOP Lake Wakatipu is a deep glacial lake, and the source of the Kawarau River. In the South Island, only Lake Te Anau is larger in area.

BOTTOM Introduced briars have spread in many of the drier areas of the South Island. In spite of being a noxious weed, their delicate summer flowers and bright red hips in autumn, add colour to many bare hillsides. These flowering briars were growing at Glendhu Bay, Lake Wanaka.

The endemic black stilt, now the rarest wader in the world, uses the Waitaki River catchment as its only nesting habitat. Its survival is threatened by the presence of a high number of predatory mustelids and feral cats in the area. These predators were originally attracted to prey on the numerous rabbits which live in this part of the country. Some of the black stilt's former

TOP Large flocks of Canada geese inhabit the high-country lakes of the South Island, where they cause damage by grazing and fouling adjacent farm pastures.
BOTTOM Introduced lupins and broom growing along the shores of Lake Tekapo.

RIGHT Broom and willows have spread to many rivers such as the Waiau thus making them unsuitable nesting habitats for certain bird species. LEFT The Ahuriri River, in the Waitaki catchment, is a valuable ecological habitat. Many species of birds feed and nest on its islands and shingle fans, and it is one of our finest fishing rivers. BOTTOM The braided shingle rivers which flow from the eastern slopes of the Southern Alps are subject to rapid fluctuations in levels. These rivers provide more extensive habitats for the resident birds than do single-channel rivers.

habitats have been severely modified by the colossal schemes to harness water for power generation in the Waitaki River catchment. Wide canals now divert water from the Tekapo, Pukaki and Ohau rivers to power stations, and then to supply water to Lake Benmore. These rivers now have extremely low flow rates,

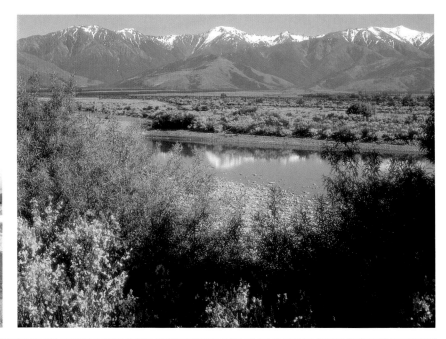

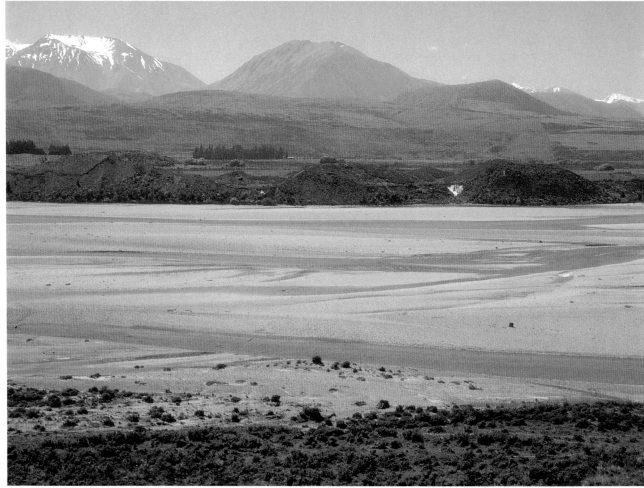

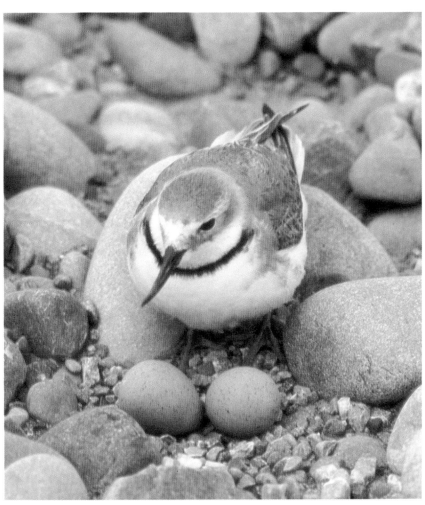

LEFT The wrybill nests in isolation on a few selected braided rivers flowing from the eastern side of the Southern Alps. Their cryptic-coloured eggs are laid in a depression among the river stones.

BOTTOM Black-fronted terns nest in loose colonies on many shingle riverbeds in the South Island. They are essentially an inland bird but often migrate to the coast during winter months.

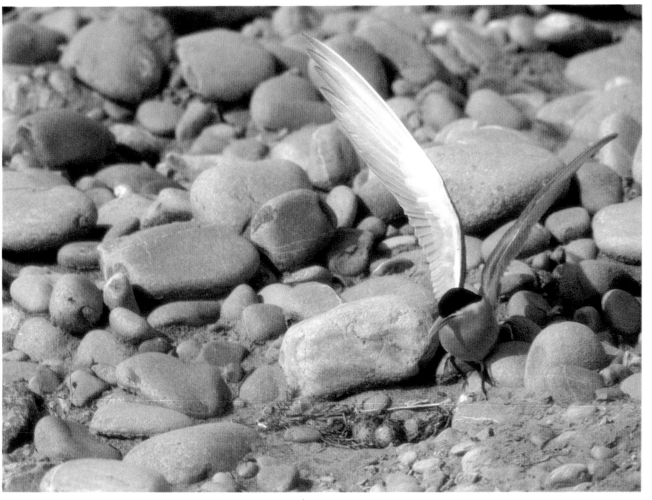

Introduced willows have spread along the courses of many rivers and streams, in many cases causing blockage of the flow and flooding. The spring green of the willows brightens the banks of the Hamurana Stream.

and are no longer attractive habitats for black stilts. Fortunately, the ecologically important Ahuriri River, apart from some use of water for farmland irrigation, has not been exploited for power generation.

Many South Island shingle rivers have been modified by

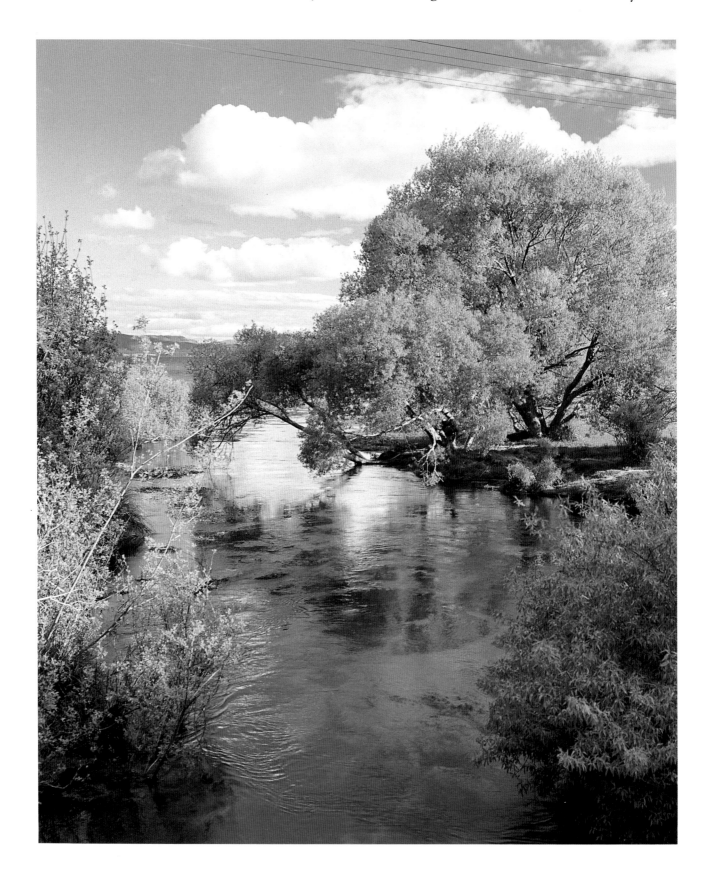

infestation with exotic vegetation such as broom, lupins and willows. Some North Island rivers have also been affected, but not to the same extent. These plants bring colour and beauty to these wetlands, but deny large expanses of shingle to river birds for both their feeding and nesting. Willows in particular, with their low-sweeping branches and exposed roots, cause problems by restricting water flows.

Some famous waterfalls are found on our major rivers and the Huka Falls on the Waikato River are probably the best known of these. In fact many of our most beautiful waterfalls are to be seen on some of our smaller rivers and streams, especially in the high country and in Fiordland and other high rainfall regions, although here a number of waterfalls only function after periods of continuous heavy rain. Not all waterfalls are river-fed. The famous Sutherland Falls in Fiordland, the highest in New Zealand, are fed by Lake Quill, a small alpine lake.

Our landscape originally included large expanses of swampland, some of it interspersed with swamp-forest trees such as kahikatea. Much of the Waikato basin and Hauraki Plains consisted of this type of vegetation. Today few large areas of swamp and bog remain, most of it having been drained for agricultural use. A classic example of drainage occurred in 1864,

The Papakorito Falls, just one of the many beautiful waterfalls on the Aniwaniwa Stream in the Urewera National Park.

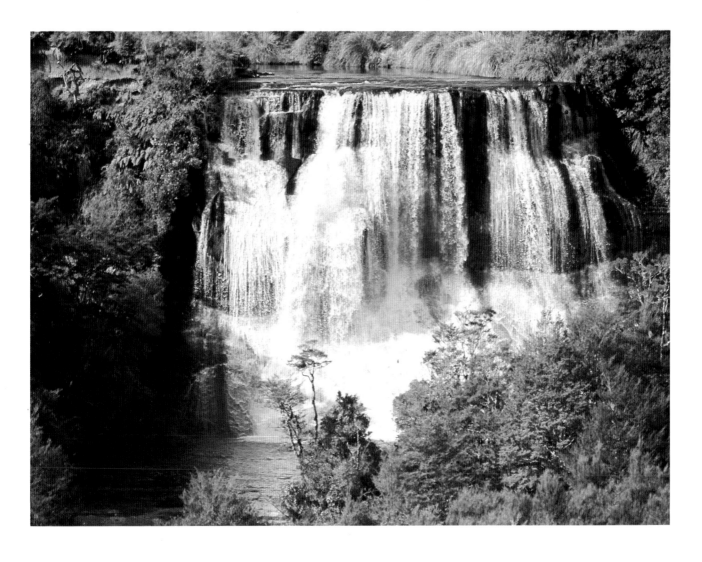

Mistletoe growing on beech trees on the shores of Lake Ohau.

when a huge portion of Canterbury swampland was drained to form the Longbeach Estate. Altogether, 250 kilometres of open drains were excavated to produce a highly productive farm.

The type of vegetation growing in a swamp is dependent on the nutrient content of the soil and water. Where fertility is high, flax, raupo and carex sedges will flourish, whereas in low-fertility regions the only tall plants may be the jointed and rush-like sedges.

All swamps which have not been modified provide a home for many insects, spiders, frogs, fish and birds. Welcome swallows are now a common bird in these habitats. These attractive, lively birds have a swift, irregular flight, skimming just above the surface

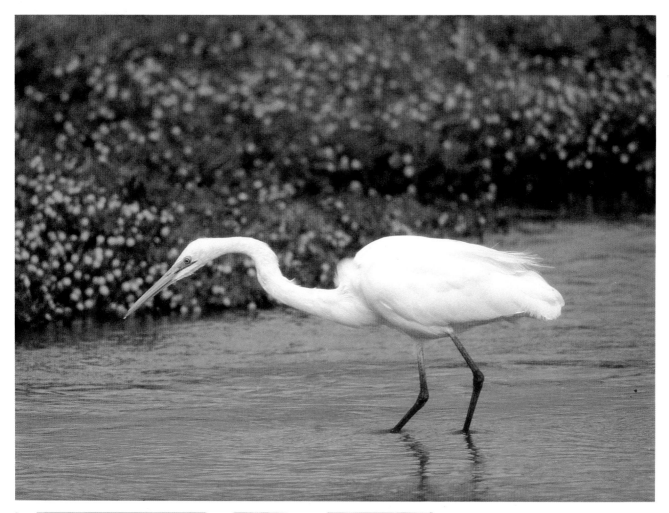

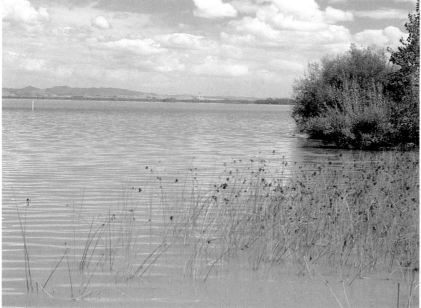

ABOVE The only known nesting site of the kotuku, or white heron, is near Okarito in south Westland. Many birds migrate to spend the winter months feeding in North Island swamps and estuaries.
LEFT Lake Waikare. This shallow lake has many resident waterfowl. It is used as a ponding area to contain waters from the Waikato River in times of flood.

of exposed patches of water to collect insects on the wing, or sometimes circling and wheeling high in the sky. Welcome swallows are an Australian species. They were first seen in Northland in the mid 1950s, where they fed and bred around Lake Omapere. In subsequent years they spread throughout New

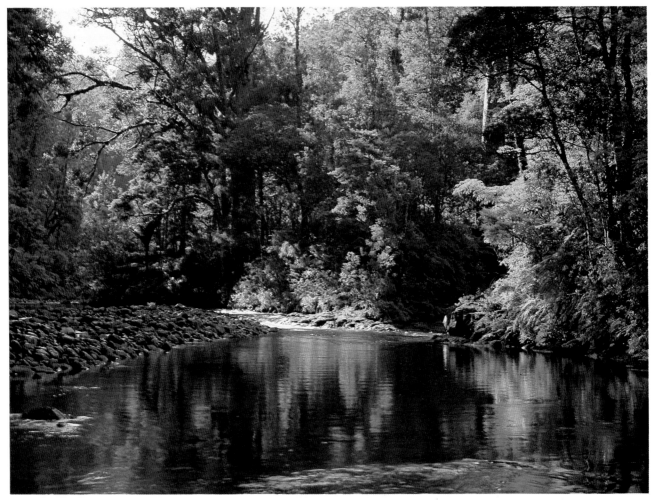

TOP The Waipoua River in Northland, flanked by kauri trees.

ABOVE Dragonflies. Their larvae live under water and are an important food source for blue duck and trout. The larvae take about five years to reach maturity.

RIGHT The Tongariro River, which feeds Lake Taupo, is famous internationally for its trout fishing.

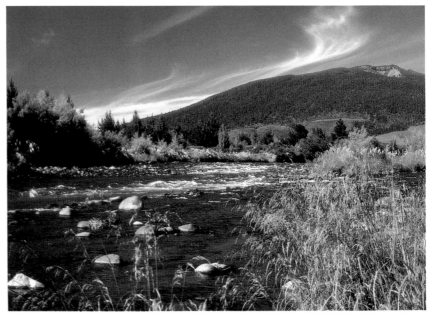

Zealand, making their nests of mud, reinforced with grasses, under road-bridges and culverts, or in outhouses, cowsheds and, sometimes, boats. Flying insects are scarce in inland areas during winter, and at this time of year welcome swallows migrate to the milder areas on the coasts, where they can be seen catching flies

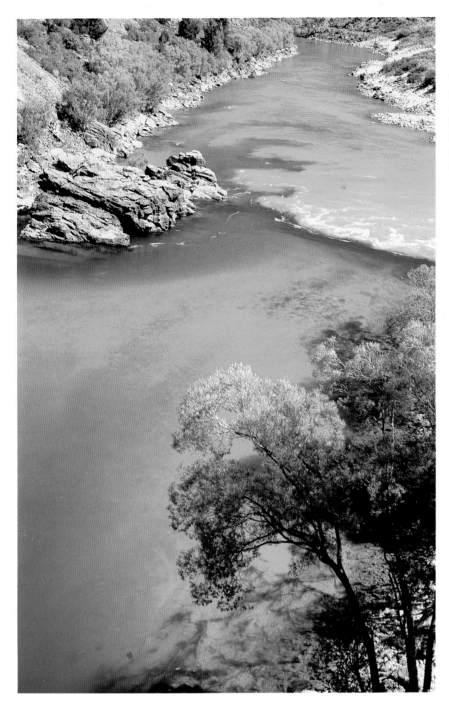

Where the Clutha and Kawarau rivers meet at Cromwell, their different coloured waters mingle, and continue to the sea as the Clutha River. This river is the longest in the South Island and discharges the greatest volume of water of any river in New Zealand.

which have been attracted to flotsam seaweed.

Little shags frequently search for fish in very narrow channels separating the swamp vegetation, but they also frequent slow-moving rivers and the larger lakes. In the breeding season they often associate with little black shags to nest in colonies in riverbank and lakeside trees.

The large black shag, or cormorant, a cosmopolitan species, is more often seen on the larger lakes or in tidal harbours. It is a shy bird, having been persecuted by anglers because of its competitive fish-feeding habits.

Another conspicuous bird seen in swamps and on riverbanks is the pukeko. Its favourite nesting sites are clumps of rushes or

beds of raupo, but it often feeds in open country and farm pastures.

Kingfishers find a niche to live in various types of country. Although sometimes inhabiting forests, they are most likely to be found near water and are a common sight on the shores of many lakes, on riverbanks and near swamps. They choose the branch of a tree, or stump protruding from the water, as a commanding perch from which to dive for fish or insects. Like most birds, they possess acute eyesight. From my hide I once watched a kingfisher, perched on his lookout, suddenly swoop down and fly at least 90 metres over a lake to pluck a dragonfly from the surface.

It is common to see harriers quartering the swamp, gliding effortlessly in search of small birds, frogs or carrion. Harriers also use swamp vegetation as communal roosts and usually nest in these locations.

All the species just discussed are the wildlife most likely to be seen in these wetland landscapes. However, some birds which are quite common are also so secretive that they are seldom observed. The spotless crake and the marsh crake are two of these

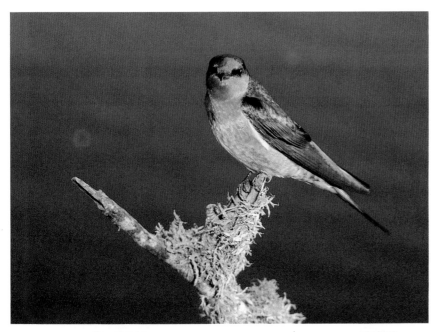

OPPOSITE Lake Okareka, in the Rotorua district, is a favourite haunt of many water birds. Welcome swallows (left), white-faced herons (bottom left), and Australian coots (bottom right) are some of the species found here.

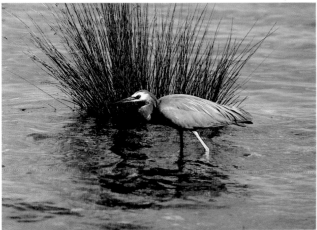

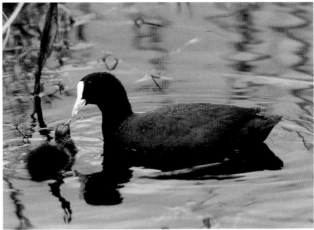

Fernbirds are common in many swamps, although they are seldom seen. They are weak fliers and remain hidden in the swamp vegetation, where they feed on insects and spiders.

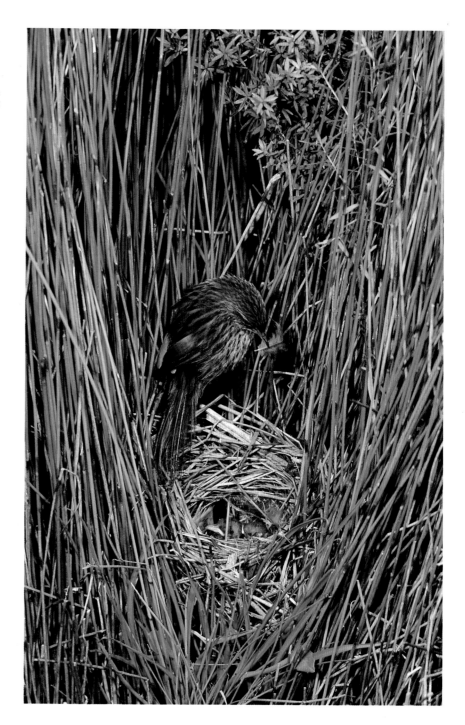

species. They are no larger than a blackbird, but have longer legs and a short tail. They are crepuscular, feeding at dusk along the edges of channels in the swamp, searching for insects and grubs.

The fernbird is a small endemic warbler which lives among swamp vegetation and in raupo beds. It is also found in some areas well away from water, being quite common in flax, scrub and heather in the Tongariro National Park. Fernbirds, of which there are several subspecies living on some outlying islands, are very weak fliers. When flushed from a reed bed, they will fly rather laboriously with rapid wing-beats for only a short distance before flopping into cover.

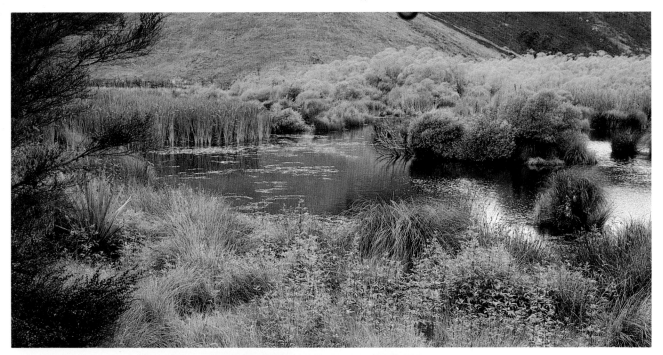

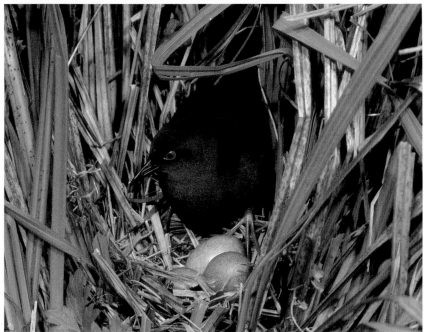

TOP Typical lowland swamp vegetation.
LEFT The spotless crake, a small rail not
much larger than a common blackbird,
is fairly well distributed in many North
Island swamps, but as it is crepuscular
and secretive, it is seldom seen.

Pied stilts and several species of ducks frequent these
wetland landscapes, sometimes accompanied by herons and
occasionally the brown bittern.

Related to the herons, the bittern is becoming increasingly
uncommon with the reduction of its favourite wetland habitats.
Bitterns have wonderfully cryptic plumage, and when standing
motionless among rushes with bills held skywards, they are often
unnoticed. During the breeding season, male bitterns can be
heard making their booming calls, a sound which can be imitated
by blowing across the top of a large bottle.

I was once attempting to photograph bitterns from a hide

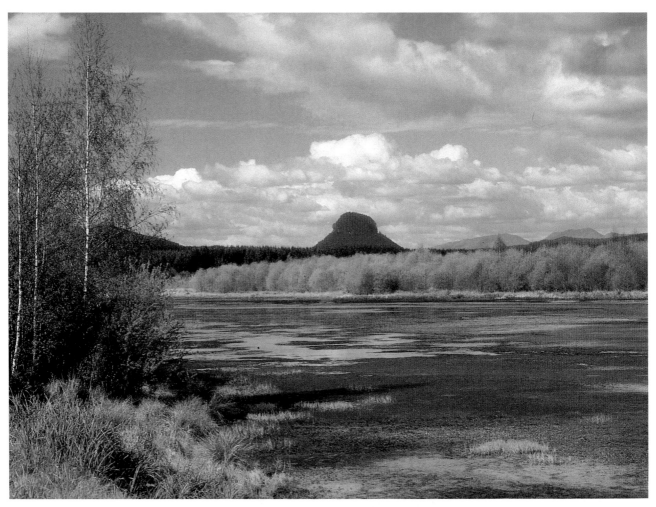

Lake Whakamaru, formed by one of the Waikato River hydro-electric dams, is an excellent habitat for many species of swamp birds.
RIGHT The brown bittern is becoming scarce in many districts because its swamp habitats are being drained to produce land for agricultural use.

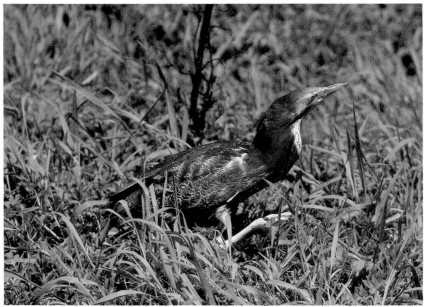

built on the edge of a swamp near Lake Taupo. Several hours passed without a bittern coming within camera view, then suddenly I was thrilled to hear a bittern begin to boom just behind my hide. He was so close that I could hear him draw in his breath prior to uttering each call. Considering our close

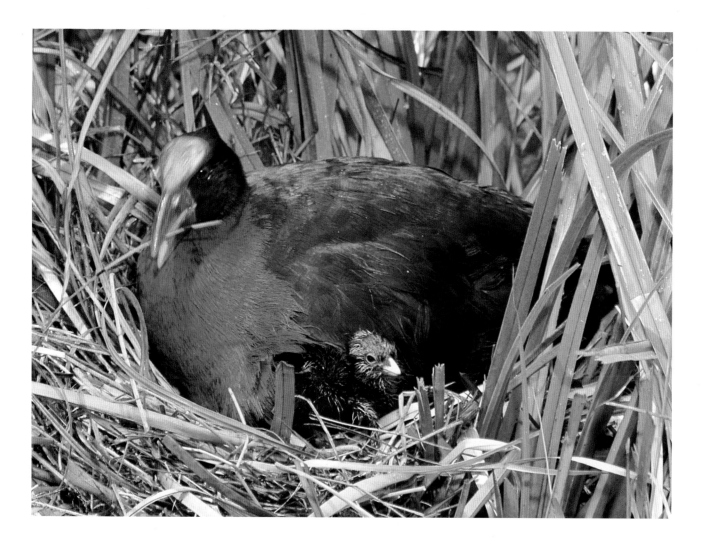

proximity, the call seemed surprisingly low in volume, yet on a still day the booming can be heard well over a kilometre away.

Our valuable wetland habitats, especially swamplands, will probably continue to be exploited or drained for agricultural use, but in some localities concerned landowners and conservation groups are creating new wetland habitats to attract and preserve our interesting and important wetland fauna.

A pukeko's nest at the edge of a raupo swamp. Pukekos have a protracted nesting season in the North and nests can be found during many months of the year, although most birds nest between July and February.

six

THE
FORESTS

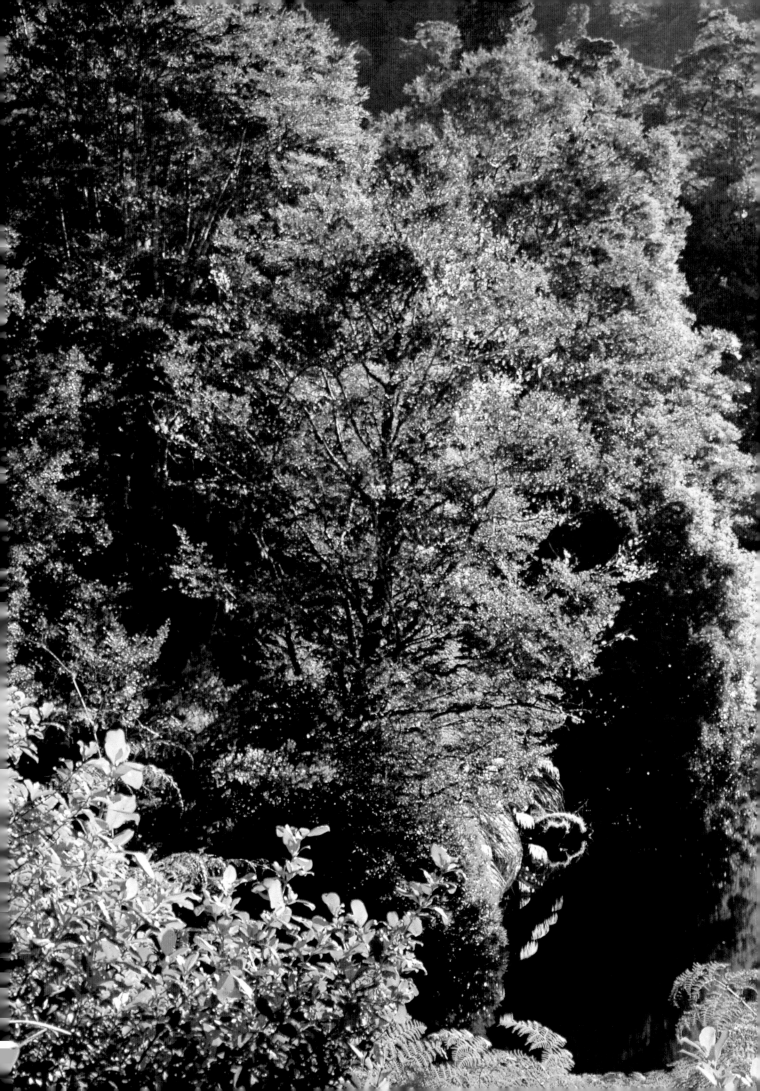

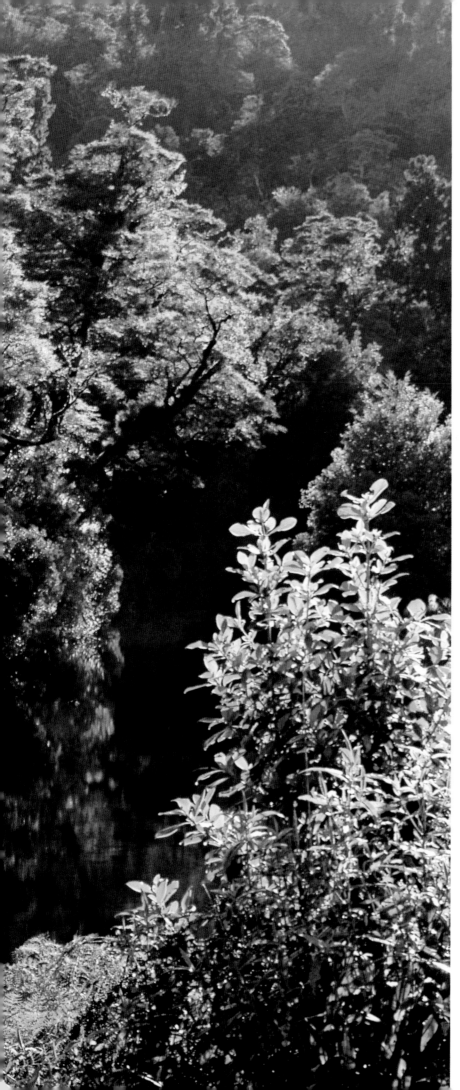

In its primeval state New Zealand's landscape consisted principally of forest, interspersed with tussock grassland, wetlands and alpine vegetation. The early Polynesian and European settlers drastically modified the land, felling trees and burning vegetation to clear the land for agricultural use and to provide timber. Throughout the country today, most of the areas of lowland forest now visible have at some time been exploited for their timber. For this purpose the preferred trees were the native conifers — kauri in the northern regions, and elsewhere the podocarps such as rimu, totara, kahikatea, matai and miro. Species of beech and hardwoods (tawa, rewarewa, pukatea and kamahi) were not so sought after. However, with the development of the pulp and

Mixed podocarp, hardwood and beech forest in the Urewera National Park. ABOVE Supplejack is a tall climbing plant commonly found in mixed rainforests. The bright red fruits are eaten by pigeons, kokako, kaka and parakeets.

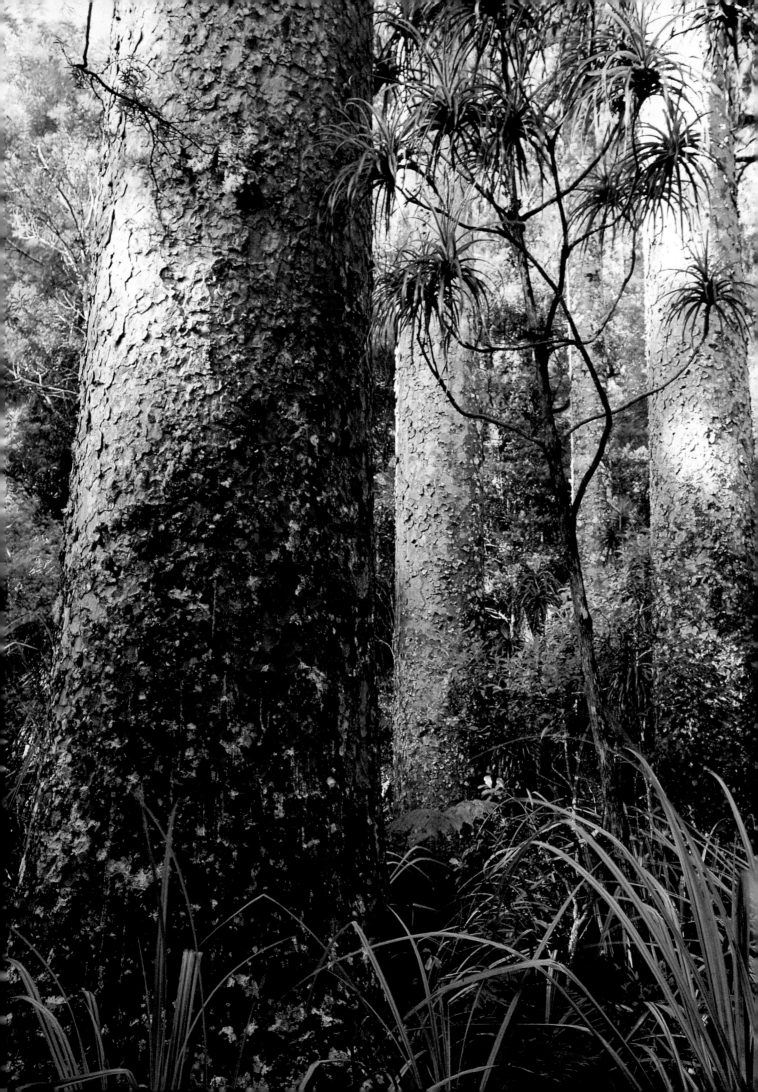

wood-chip industry, there is increasing pressure to use these hardwoods, especially beech.

Much of this lowland forest is now regenerating, in spite of browsing by opossums and, in some regions, by deer, goats and feral pigs, which destroy the regenerating seedlings. This forest regrowth can be very attractive and provides a favourable habitat for many species of invertebrates, lizards and birds. Beneath the canopy grow interesting and beautiful shrubs, ferns, mosses and fungi. Most New Zealand trees are evergreen, losing a few leaves at a time throughout the year. Very few are deciduous, fuchsia, kowhai and some lacebarks being the exceptions.

Areas of unlogged virgin forest still survive in parts of both the North and South Island, but even these are not in their complete pristine state, as all have in some way been modified by browsing animals and introduced predators.

In Northland a relentless campaign, led by the late Professor W. R. McGregor, resulted in the preservation of an area of virgin kauri which now forms the Waipoua Forest Sanctuary. Other pockets of kauri forest have now also been protected. However, these are pitifully small remnants of the majestic mixed kauri and broadleaf forests which once covered Northland, the Waitakere Ranges and the Coromandel Peninsula.

The lowland podocarp and hardwood forests of the Waikato, Taranaki and Hawkes Bay have now gone, but again, due to efforts by conservationists, remnants of magnificent, dense podocarp forests have been preserved at Pureora, west of Lake Taupo, and at Whirinaki, adjacent to the Urewera National Park. Extensive stands of mixed rainforest, consisting of podocarps, hardwoods and beech, remain in the Ureweras, and to the east in the Raukumara Ranges, as well as in the southern Tararuas.

Large expanses of unmodified forest, particularly beech species, survive in the South Island. In north-west Nelson, the upper Buller valley, Matakitaki and Maruia areas there are continuous tracts of beech forest, extending in many parts into subalpine altitudes, and in Fiordland and the south-west, stands of pure beech forest are predominant.

Mixed podocarp forest still survives in parts of Westland, where the canopy of rainforest is penetrated by tall rimu and kahikatea. This type of forest also once existed in the wetter regions east of the Southern Alps. Today a remnant can be seen in the Peel Forest, where a few large totara trees survive in this small reserve.

Although early Polynesian settlers cleared practically all forest cover from the east coasts of both main islands, a few remnants of coastal forest can still be found. In Fiordland, extensive beech forests grow to the water's edge; in the Catlins and on Stewart Island, southern rata flourishes and blooms close to the shore.

Kauri forests once covered much of Northland, the Coromandel Peninsula, the Waitakere and Hunua ranges. They were plundered for their valuable timber, and today the Waipoua Forest is the only large stand of virgin kauri forest.

'Ancient of days in green old age they stand . . .'
— William Pember Reeves

TOP LEFT A North Island robin and (below) a male tomtit — two familiar forest birds.

RIGHT A silvereye on a tanekaha branch. Large flocks of silvereyes migrated to New Zealand from Australia in the mid 1850s. They are now common in forests and scrub and frequently visit suburban gardens in winter.

The North Island contains a different kind of coastal forest: pohutukawa trees backed by karaka, kohekohe, puriri and nikau palms. All these species are valuable producers of food for nectar and fruit-feeding birds.

Exotic pine forests are now a prominent part of our forest landscapes. The preferred species for timber production in New Zealand is the radiata pine, which was first introduced from its native California in 1860. However, it was not until 1922 that the first commercial plantings were made, mainly on the North Island's volcanic plateau. In the 1960s commercial planting was accelerated, and today exotic pine plantations thrive in many parts of the country. As well as introduced species, many insectivorous native birds now inhabit these pine forests, which provide a rich

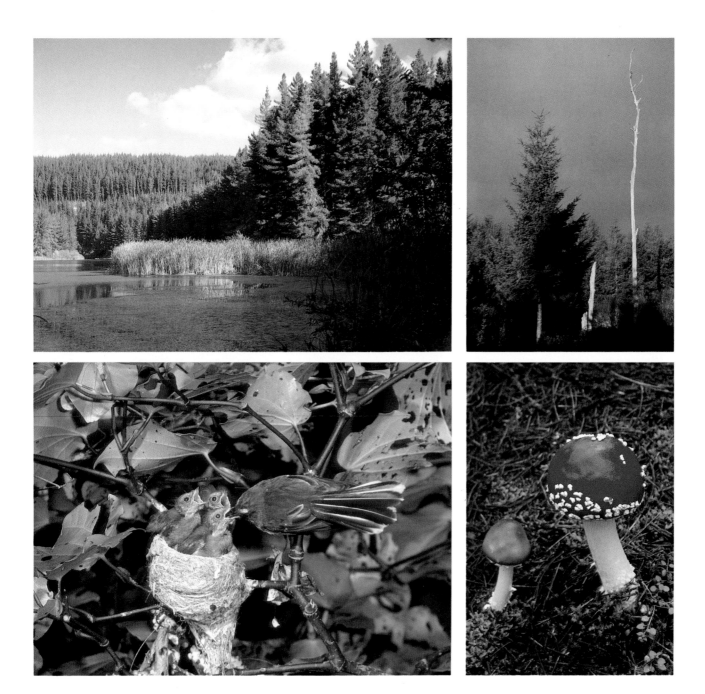

source of insect food. However, it appears that the presence of pockets of native forest within, or adjacent to, the pine plantations is essential for the year-round survival of native bird species.

Before the arrival of European man, with his introduced predators such as cats, rats and mustelids, a very rich fauna existed in all our forests. Early naturalists and explorers were enthralled by the abundant and diverse forms of birdlife, many of them unique, such as the nocturnal kiwi, with its complete absence of wings, its hair-like feathers, weak eyesight and nostrils situated at the tip of a long, probing bill.

Some of the bird species common in the forests at that time — for example, the huia, piopio and bush wren — are now extinct. Others, such as the kakapo, saddleback and stitchbird,

TOP LEFT The exotic radiata pine is the preferred tree for commercial timber production.
TOP RIGHT The skeleton of a native tree is a stark reminder of a forest which has been replaced by exotic pines.
LOWER LEFT A fantail at its nest. Some insectivorous birds such as fantails, robins and tomtits inhabit pine plantations.
LOWER RIGHT Poisonous *Amanita muscaria* toadstools are common in pine forests.

survive only on predator-free offshore islands, and the North Island kokako lives precariously in a few scattered remnants of our once luxuriant rainforests.

Birds are an essential part of the forest cycle, and many trees and shrubs depend on them for dispersal of their seed, or for pollination of their flowers. The small seed of many of the podocarp trees is attached to a tasty, fleshy fruit and, when eaten by a bird, the undigested seed is voided with the excreta, and often at a considerable distance from the donor tree. Tuis, bellbirds, kokako and saddlebacks all feed on the smaller fruits and, in addition, the nectar-feeders help to pollinate the flowers

BELOW The tui thrives in many of our podocarp and hardwood forests. It has also adapted to feed on introduced nectar-producing trees and shrubs growing in urban districts.

RIGHT The comparatively small areas of lowland podocarp forests which have been saved from milling are valuable habitats for many bird species, notably kokako, kaka and parakeets. To thrive and breed, these birds require large areas of unmodified forest containing mature trees.

OPPOSITE TOP A massive rata vine climbing a large rimu tree.

OPPOSITE CENTRE Flowers of the northern rata (*Metrosideros fulgens*).

OPPOSITE BOTTOM Flowers of the rare carmine rata, *Metrosideros carminea*. This species flowers for a short period in late spring.

of a variety of trees and shrubs including those of the kowhai, pohutukawa, rata, fuchsia and flax. Surprisingly, the insignificant tiny clusters of flowers which grow directly from the main trunk and branches of the kohekohe are favoured by bellbirds, as the sugar content of the nectar is higher than in most other flowers.

Pigeons are most important in the seed-dispersal chain. Besides feeding on the smaller fruits of many tree species, they are able to swallow larger fruits such as those of karaka, puriri, miro, titoki, pigeonwood and nikau. They also feed on the fruits of vines such as supplejack and kohia.

Some forests appear silent and devoid of life, yet other forests

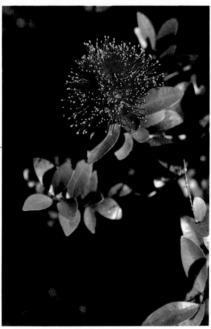

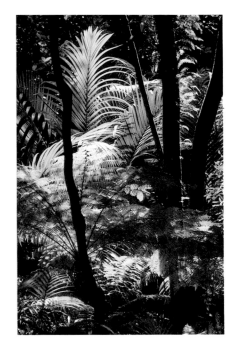

TOP Dense groves of nikau palms thrive in warmer regions such as Northland, Auckland's Waitakere Ranges and the north-west coast of the South Island.

RIGHT Named for their resemblance to the dragon plant, dracophyllums occur in many forms, ranging from tiny alpine plants to small trees.

of similar structure have an abundance of birds. The reason for this is unknown, and does not appear to be related to the availability of food.

Little, isolated patches of bush support only a few bird species, and these are usually the smaller birds such as fantails, silvereyes and grey warblers. Research has shown that the number of resident bird species in a particular forest is related to its size. Larger birds such as kaka, kokako and the parakeets will not survive in isolated patches of bush of less than about 2000 hectares. Some of the strong fliers — pigeons and kaka in particular — will migrate to areas of forest which have seasonal flowering or fruiting trees. Even tuis will fly some distance to feed on flowering flax, kowhai and pohutukawa.

LEFT Regenerated coastal forest on the east coast of the North Island. This forest type usually consists of pohutukawa, karaka, kanuka, kohekohe and sometimes taraire and puriri. In moist areas nikau palms and various species of tree ferns also occur.

TOP RIGHT A totara, one of the important podocarp species growing in Pureora Forest.

BOTTOM The flower of the rewarewa tree, also known as the New Zealand honeysuckle.

Birds are usually least active and vocal during midday hours. They are also quiet in late summer, when moulting after nesting. Although rather inconspicuous, and much smaller than a tui, the bellbird has a remarkably powerful voice. It is one of the few species of native bird that sings at intervals throughout the day, and during any month of the year.

Many of the smaller forest birds can be attracted for closer viewing by rubbing a small glass bottle with a wet cork to make a squeaking sound. Bellbirds, fantails and grey warblers will stay close for some time; others such as tomtits, whiteheads and yellowheads are initially inquisitive but soon depart.

RIGHT The bellbird feeds mainly on nectar and fruits. The volume of its melodious song is remarkable for such a small bird.
BELOW Native clematis.
BOTTOM LEFT A species of perching tree orchid, *Dendrobium cunninghamii*.
BOTTOM RIGHT The small prostrate *Fuchsia procumbens* grows in some coastal areas of the North Island, but is now rare. The flowers are less than two centimetres in length.

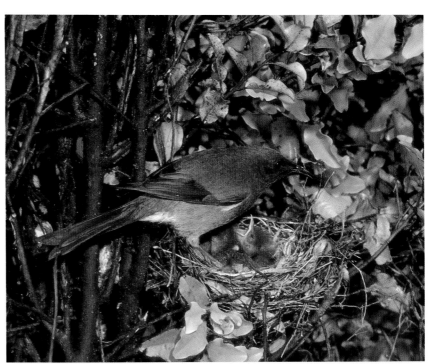

Kakas will sometimes respond to a loud whistle and fly low, uttering a harsh cry, or perch on a high branch and drop twigs on the onlookers. Kakas are dependent on mature forest for nesting. They can find suitable food supplies in regenerating forest, but they have specific nesting requirements, selecting the dry cavity of a large tree in which to lay their eggs on a bed of dry wood chips. The entrance hole to these nests is often surprisingly small. I recall one nest hole in a puriri tree which was only 5 centimetres in width at its widest point — only the length of a matchbox! I had a hide near this nest and noticed that the bird encountered a certain amount of difficulty each time she squeezed through the hole. Mature forests also provide kakas with dead and rotting trees. These are favourite feeding sites, where they use their powerful beaks to tear away wood as they search for insects and huhu grubs.

Kakarikis, the small red-crowned and yellow-crowned parakeets, also require large stands of mature native forest for feeding and nesting. They too nest in cavities in trees. The red-crowned parakeet is becoming scarce on the mainland, but is still abundant on offshore islands.

Perhaps the most confiding forest bird is the robin. One is often unaware of its presence as it perches silently close by,

The kokako is one of New Zealand's ancient wattlebirds, related to the saddleback and extinct huia. It now survives in small numbers in podocarp hardwood forests north of Taranaki and in the Puketi kauri forest of Northland. Recently some birds were rescued from a forest near Rotorua which was being felled. Over twenty birds were transferred to Little Barrier Island where they are now breeding.

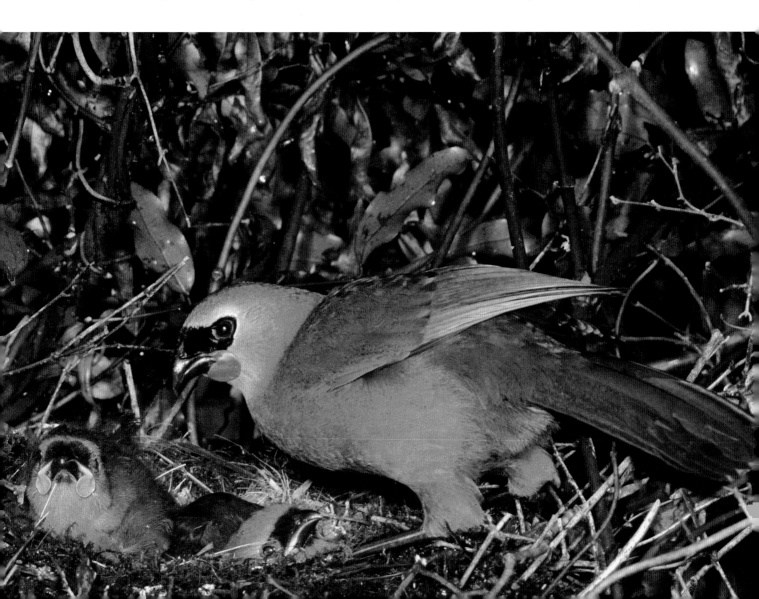

Red crowned parakeets outside their nesting hole. These birds live in large forested areas and are common on many offshore islands, but are becoming scarce on the mainland. Like the kaka (opposite below), they require large trees to provide dry cavities in which to lay their eggs.

watching for food, its dusky grey body blending with the dim forest background. If leaf litter is disturbed on the forest floor, it will dart down to pick up invertebrates which are often too small for us to detect.

Kiwis are unlikely to be seen during daylight hours, except on Stewart Island. There they often emerge from their burrows on dull days or well before dusk. The rather plaintive calls of the

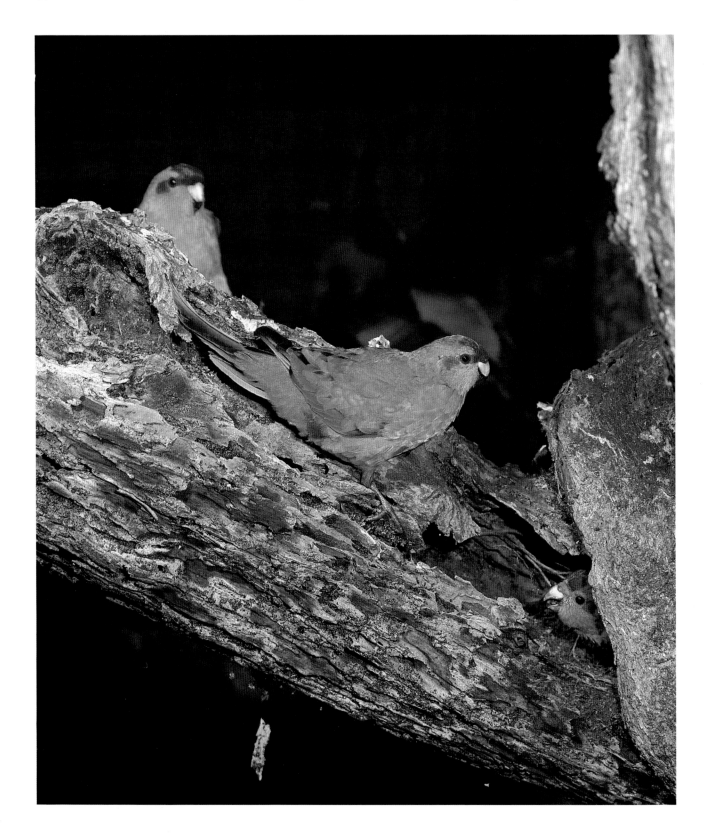

male kiwi can be heard at night in many forested regions, and in Northland scrub country. The call of the male bird consists of a series of ascending and descending whistles. In contrast, the female kiwi utters a shorter, hoarse cry.

Kiwis eat a variety of invertebrates, especially cicada nymphs. They also eat berries which have fallen to the ground. In their search for earthworms, they probe deeply into the soil, leaving

LEFT Fruit of the native passion vine or kohia.
CENTRE Fruit of the karaka tree.
RIGHT Dead trees provide larders for kaka. They use their powerful beaks to rip off wood to expose insects and huhu grubs.

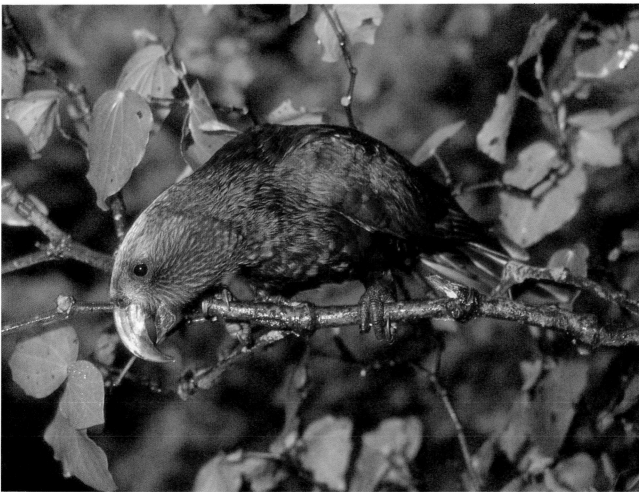

The morepork is our only surviving native owl, the larger laughing owl being now considered extinct. Moreporks feed mainly on insects, especially on moths and wetas, but they also take mice, lizards and small birds. Moreporks lay two eggs per clutch, usually choosing a hollow in a tree or a cavity in a clump of astelia. They use no nesting material and the white eggs are laid in a depression in the rotting wood. OPPOSITE A brown kiwi. In their search for earthworms, kiwis probe deeply into the soil, leaving telltale conical-shaped holes in moist ground. They also eat a variety of berries and insects, especially cicada nymphs.
LEFT The flightless weka or woodhen.
BOTTOM LEFT A wolf spider with egg sac. These common spiders can be found under logs in the forest.
BOTTOM RIGHT The mamaku is our tallest tree fern.

conical-shaped holes which can be seen in areas of moist earth.

Another well-known nocturnal forest bird is the morepork, our only surviving native owl. The larger laughing owl, sadly, is now thought to be extinct; it was last reported from a sighting in the South Island.

Although normally a forest dweller, the morepork has adapted to the changed environment and now inhabits parks and farmland, provided that these include clumps of trees suitable for roosting and nesting. During daylight hours moreporks hide themselves in the forest in deep shade, under tree-fern fronds or beneath clusters of vines. If their roost is discovered by smaller

OPPOSITE TOP LEFT The epiphytic astelias are members of the lily family. They often form large clumps which provide nesting sites for moreporks.

OPPOSITE TOP RIGHT Kidney ferns grow in moist areas, often on moss-covered fallen tree trunks.

OPPOSITE BOTTOM The large tree nettle or ongaonga (*Urtica ferox*) can cause a painful sting. It is host to the caterpillars of the native red admiral butterfly.

TOP The three species of ancient frogs of the genus *Leiopelma* are found in moist habitats, often well away from water. These native species have primitive characteristics and do not develop a tadpole stage.

BOTTOM Stick insects are harmless vegetarians and are usually well camouflaged on the outer foliage of plants, so that only a movement will betray the insect's presence.

birds, the morepork is harassed by a cacophony of alarm calls until it is forced to seek a more secluded resting place.

I have been particularly interested in the nesting habits of moreporks, and have spent many hours in hides near their nests. These are usually in tree hollows or in cavities under clumps of perching astelia. Soon after dusk the first food is brought to the nest by the male bird. This usually consists of large prey, such as a lizard, mouse or small bird. Subsequent feeds appear to consist entirely of insects such as moths, beetles, stick insects and wetas.

Our handsome native pigeons are still common in many of the larger forests. They favour the mixed podocarp habitats which provide them with a wealth of fruits and foliage; they are uncommon in pure beech forest where their food is scarce.

Pigeons usually make their presence known by the low whistling sound of their wing-beats, or by noisily feeding in the forest canopy and dislodging fruits. They only lay a single egg per clutch. When the chick is about a week old it is left unattended during the day, and I was curious to discover when and how the chick was fed. On one occasion I spent the whole day, from 6 a.m., in my hide without seeing or hearing the adult pigeon in the vicinity. The chick had not fed all day, yet, when the parent finally arrived at the nest just before dusk, it made no demand to be fed, and as the adult settled, it just buried itself under her breast. Subsequently, by observing several other pigeon nests, I found that chicks were fed soon after dawn by each parent, and unless they are perhaps fed during the night, this would appear to be the only feed they receive each 24 hours.

Many other creatures inhabit our forests. New Zealand's only endemic mammal, the bat, of which there are two species, is now rarely seen. During the day, bats roost in colonies, hanging upside-down in certain selected hollow trees. They leave these trees at dusk and, with an erratic flight, hawk insects along the forest margins or above the canopy. The short-tailed species of bat also hunts insects by crawling along branches and over the forest floor.

Looking towards Mount Whitcombe, with remnants of Westland forest in the foreground.

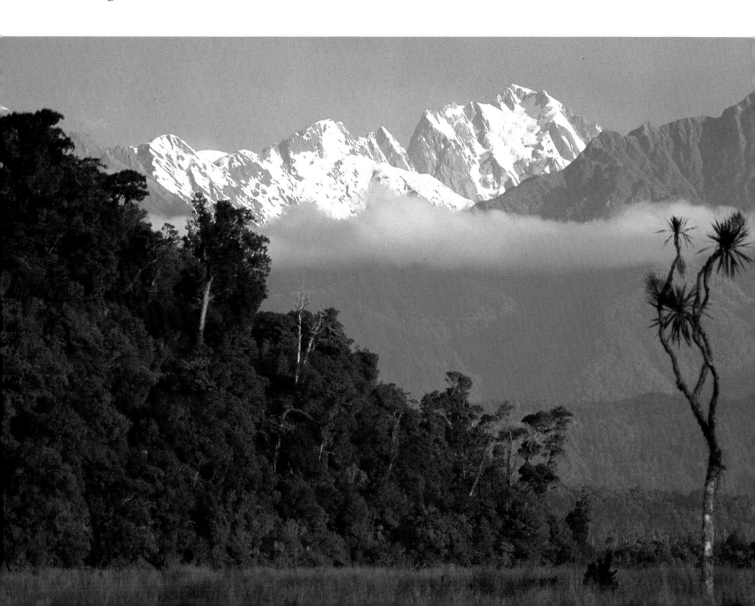

All other mammals found in our forests have been introduced to New Zealand. Rats, stoats and other mustelids are widespread, as are foliage-destroying Australian opossums. Red deer, goats and feral pigs live in some forests, and although they are rarely seen, signs of their browsing and rooting are often evident. The damage caused by the larger of these mammals is gradually being reduced by trapping and hunting, and the present high commercial value of deer in particular will ensure that their numbers are controlled.

Many New Zealanders have yet to explore their forests and experience their wonder and majesty. No botanical knowledge is needed to appreciate the massive dimensions of kauri trees when

Mistletoe growing on a beech tree in the South Island. Introduced opossums have eliminated mistletoe from many beech forests in both the North and South Islands. It is no longer seen growing in the beech forests of the Tongariro National Park, where it was common twenty years ago.

New Zealand has two species of bats, our only native mammals, and both are now rare. The long-tailed bat, which is also found in Australia, has small ears. The short-tailed bat (BELOW) which has only a stump of a tail, has large ears, and is endemic to New Zealand. By folding the forepart of its wings, this species is able to climb and walk on the ground. Both species feed on insects which are caught on the wing; they are nocturnal, roosting in cavities of hollow trees by day.

TOP LEFT A fallen tree has let in light to stimulate vigorous regeneration of beech seedlings.

BOTTOM LEFT Green geckos are nocturnal, but can often be found well camouflaged in manuka or other foliage. They feed on insects and nectar.

TOP RIGHT Skinks are smooth skinned and usually remain hidden under stones or logs. They are often preyed on by kingfishers when they come out to sun themselves.

BOTTOM Many species of fungi grow on rotting logs or moist ground on the forest floor.

OPPOSITE A South Island beech forest.

met face to face, or to experience the impressive grandeur of towering trees in a dense podocarp forest, and the sense of tranquillity one feels when in the silent depths of a mossy, southern beech forest is not easily forgotten.

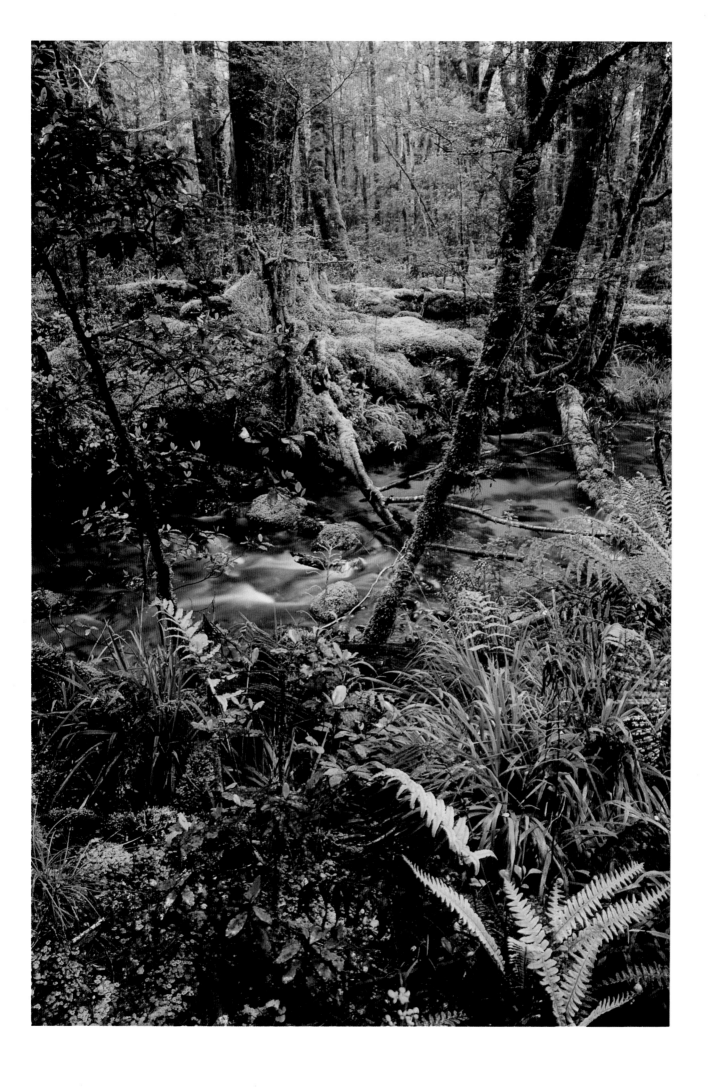

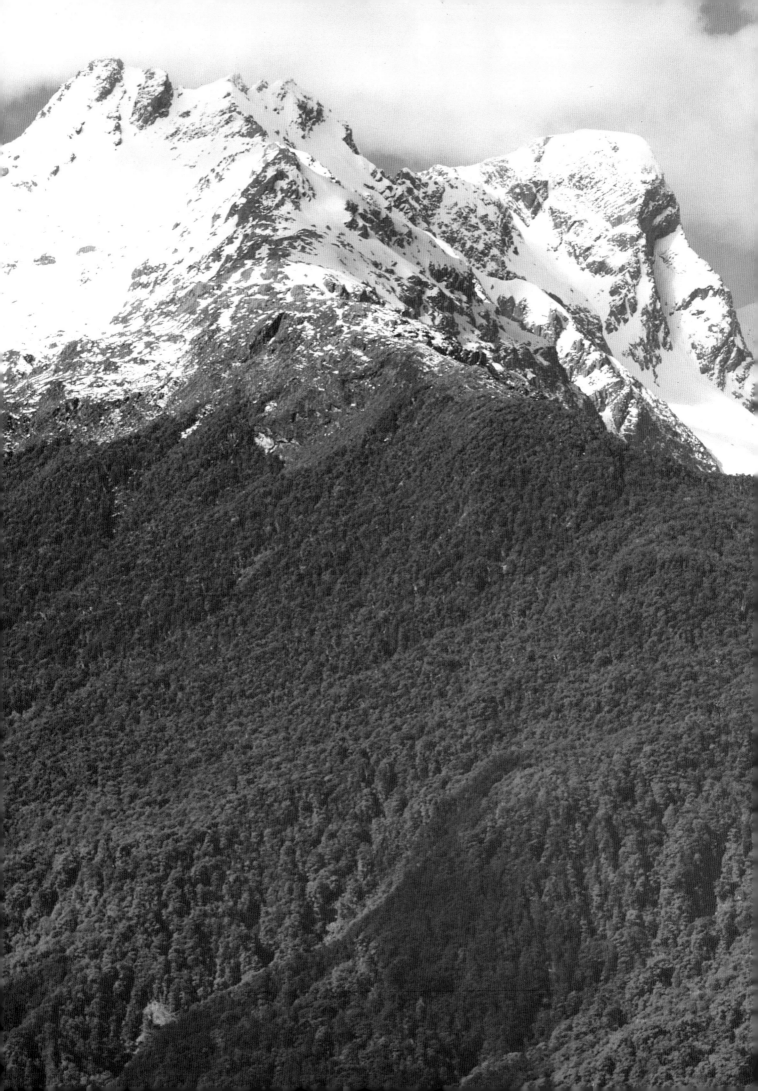

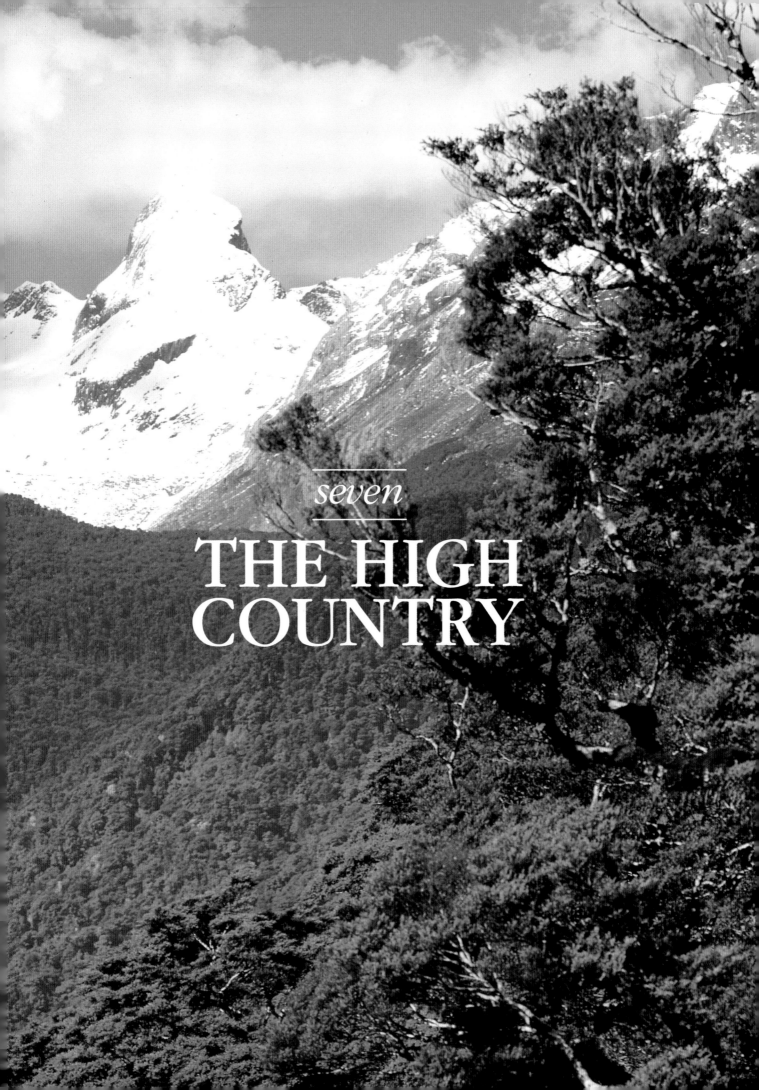

seven

THE HIGH COUNTRY

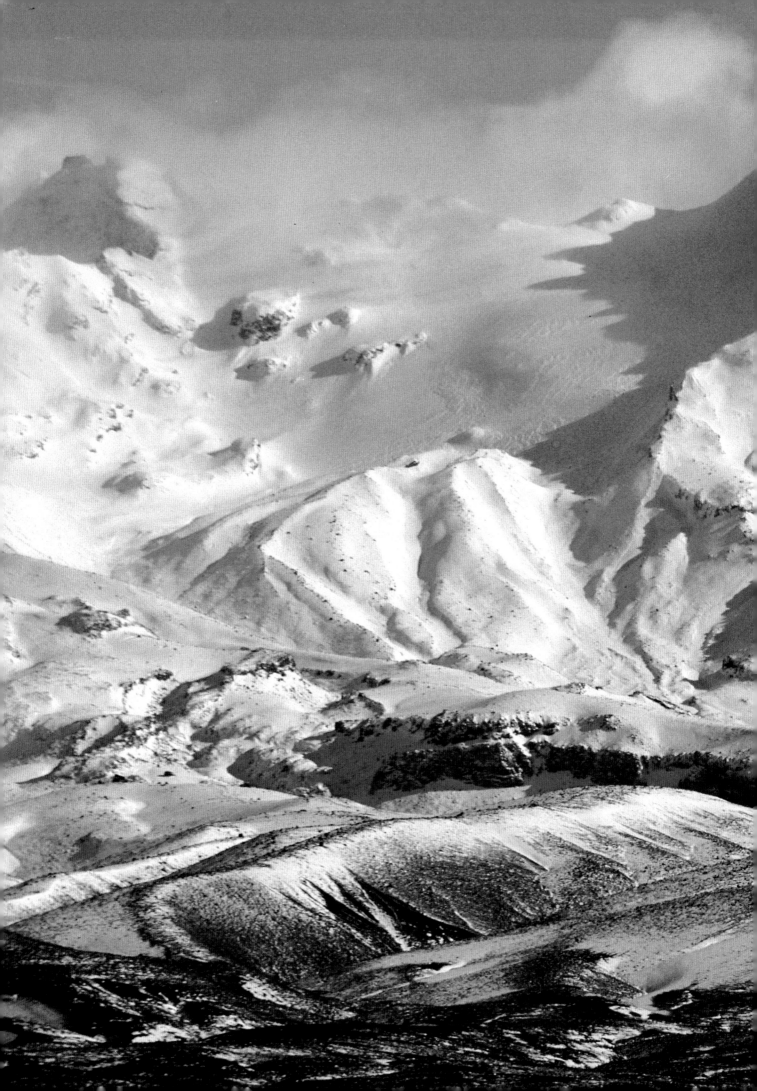

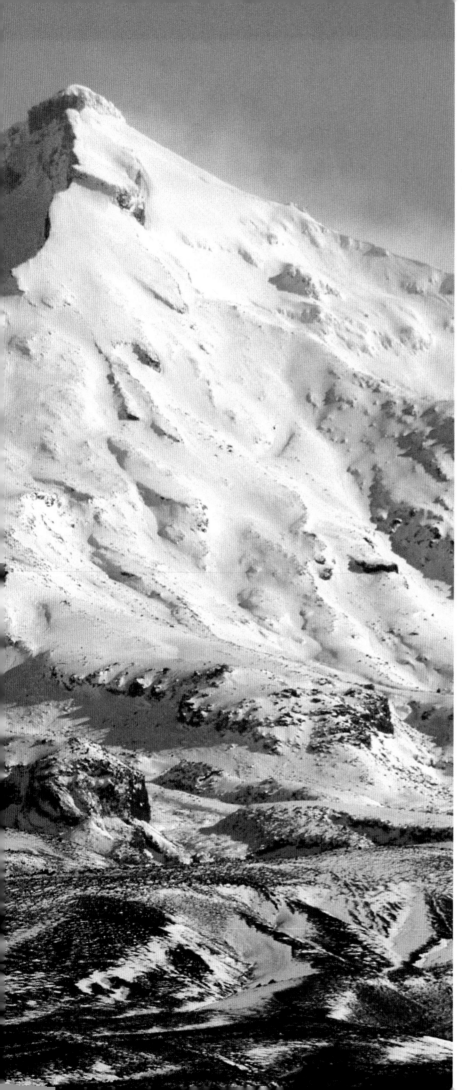

Mountains and high country dominate much of the New Zealand landscape, particularly in the South Island, and, in clear weather, from almost any part of the country it is possible to view high hills or mountains.

The mountains of the North Island are generally of volcanic origin, and Mount Ruapehu, the highest at 2797 metres, is still active, as are its close neighbours, Ngauruhoe and Tongariro.

The Southern Alps are the most spectacular of our mountain landscapes. Extending for much of the length of the western side of the South Island, they have been shaped by glaciers and eroded by streams. At their southern end are the impressive, sheer-sided mountains of Fiordland, formed

With an altitude of 2797 metres, Mount Ruapehu is the highest mountain in the North Island. It is still an active volcano with a crater lake containing highly acidic hot water. Both the temperature and the level of the lake fluctuate considerably. The eastern side of the mountain is illustrated.
ABOVE Several varieties of mountain daisy grow on the subalpine slopes of most mountains in New Zealand.

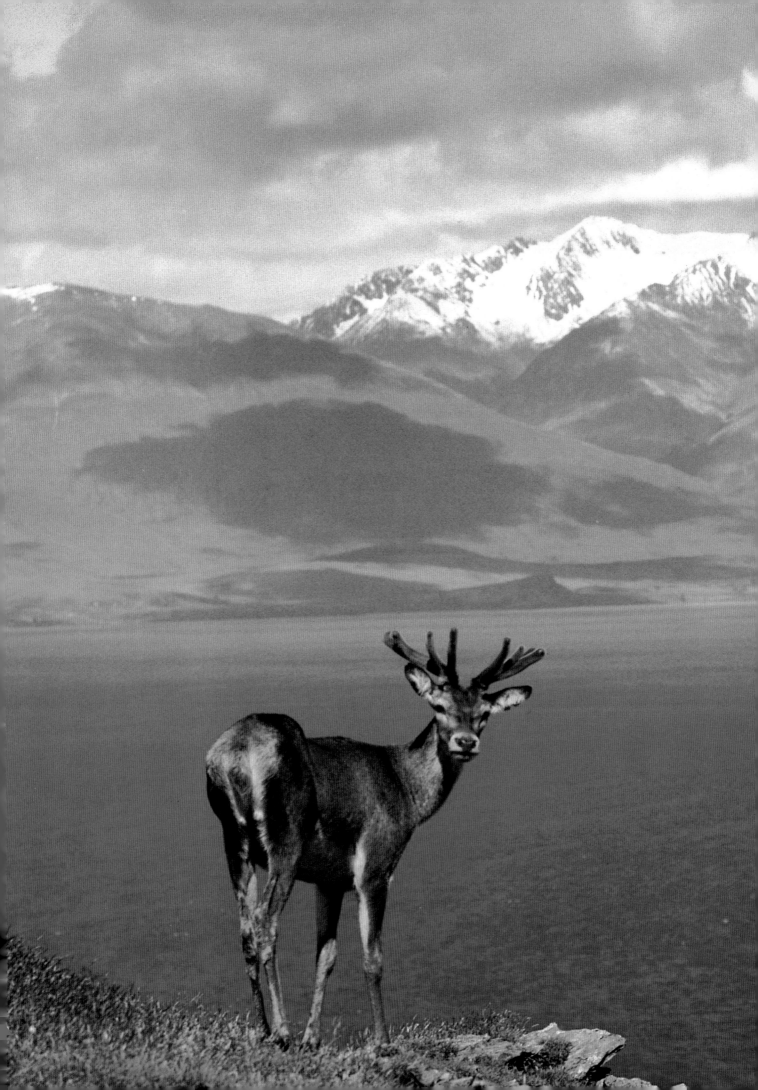

of deep troughs gouged out by glaciers. Extending to the north is a chain of bold granite mountains which border the Westland plains, and over to the east are the Inland and Seaward Kaikouras, geologically young, and still rising.

Most of the Southern Alps carry substantial snowfields, and when compacted, the snow supplies ice to several large glaciers. In contrast, North Island mountains have comparatively small snowfields and consequently lack glaciers.

Taranaki, or Mount Egmont as it is usually called, is considered to be the most beautiful of the North Island mountains. Its symmetrical cone is often clearly visible from the mountains of the central plateau, 130 kilometres away. Mount Hikurangi is the highest mountain in the east of the North Island. Its summit is the first part of New Zealand to be illuminated by the rising sun, and is sacred to the Maori.

The land surrounding the central mountains of the North Island consists of a thick layer of ash and pumice which was spewed out by earlier vulcanism. This ash blanket completely covered a primeval forest which grew on the eastern side of the mountains and now forms the unusual Rangipo Desert.

A small area on the moist western side of Mount Ruapehu was apparently sheltered from volcanic showers, as luxuriant mixed podocarp forest grows here at the foot of the mountain.

Throughout most of our mountain regions, subalpine forests of beech trees grow to the timberline. The altitude of this limit of tree growth varies with climatic conditions, but it is generally higher in the North Island and in alpine Marlborough than in southern regions. On North Island mountains and the eastern side of the Southern Alps, mountain beech is the commonest subalpine tree species. It occupies a wider range of habitats than does any other species of New Zealand tree.

Deer were first introduced into New Zealand in 1851 for sporting purposes. They multiplied rapidly, spreading to native forests where they caused considerable damage to the undergrowth and regenerating trees. In the alpine herbfields they grazed the more palatable species such as buttercups, gentians and hebes. Consequently the less palatable species such as the celmesia daisies and spaniards now predominate in these habitats.
OPPOSITE A red deer.

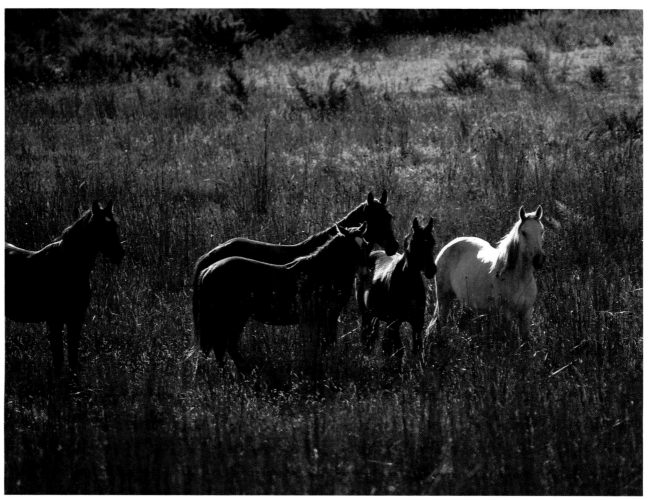

ABOVE Small herds of feral horses are found in some open country regions such as the tussock lands of the eastern Rangipo Desert, and in parts of Northland.

RIGHT Heather and ling were introduced to the Tongariro National Park, and both species have found the environment favourable and have spread on the moist western side of the mountains.

Silver beech grows to the treeline on the moist western slopes of the Southern Alps, and also on some North Island mountain ranges such as the southern Tararuas.

One of the most striking trees of the montane and subalpine forests is the kaikawaka, or mountain cedar, whose pyramidal crown protrudes from the beech-forest canopy. This species has a most attractive flaking bark which peels off in strips.

Towards the upper limits of the timberline the trees become progressively more gnarled and stunted until they are replaced by low shrubs, spaniards, various cushion plants and a variety of alpine flowering plants. This transition is often far more complex than just described, and varies considerably from one area to another.

The wildlife living in the high-country landscapes of the South Island differs in both its mammalian and bird inhabitants from that found in the North Island. Red deer occur in the sub-alpine and lowland forests of both main islands. Here, in the past, they have caused considerable destruction by browsing foliage and destroying regenerating trees; today their numbers are being reduced by hunting and capture for commercial deer-farming. Much larger than the red deer, the wapiti was introduced from the United States and liberated in Fiordland, where it mainly occupies

A dust storm on the Rangipo Desert. Winds are often fierce, and the prevailing westerlies are channelled between mountains to sweep the light soil into drifts against the rocks.

OPPOSITE Mount Taranaki. This 2518 metre dormant volcano was named Egmont, after the Earl of Egmont, when James Cook first sighted it in 1770. This photograph was taken looking west from near Whangamomona. The foreground forest no longer exists, having been converted to pastureland.

RIGHT A view of Mount Taranaki taken from Mount Ruapehu, 130 kilometres away. According to Maori myth, Taranaki moved away to the west from the central mountains after a quarrel with Tongariro. In 1900, the Egmont National Park was gazetted. This extends for 33,000 hectares surrounding the mountain and contains a wealth of interesting flora and fauna.

areas of rainforest. The true high-country species, the chamois and Himalayan thar, were liberated near Mount Cook in the early part of this century. Both species thrived and extended their range north and south, causing damage to the extremely sensitive alpine grasslands and herbfields. They descend to the lower shrub belt in winter. Both mammals are now being controlled.

Certain bird species occur only in the South Island. One of these, the takahe, which also used to live in parts of the North Island, was thought to be extinct early this century. However, in 1948 Dr G. Orbell rediscovered the birds living in the Murchison Mountains to the west of Lake Te Anau. (A small lake in the area now bears his name.) During harsh winter conditions, the takahe

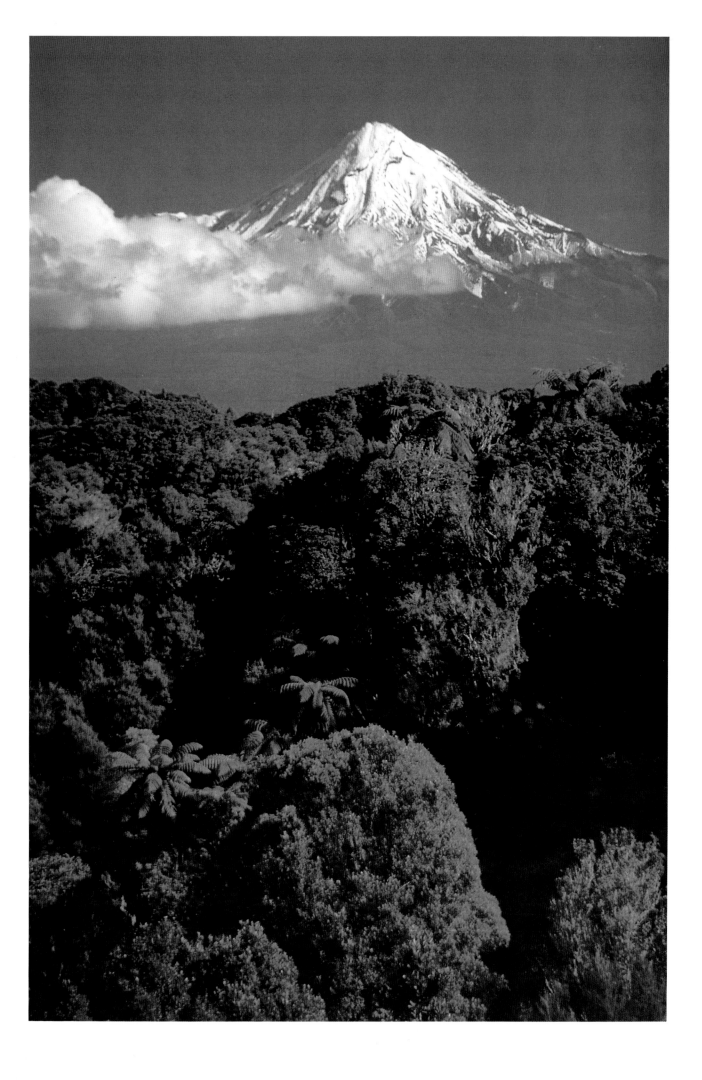

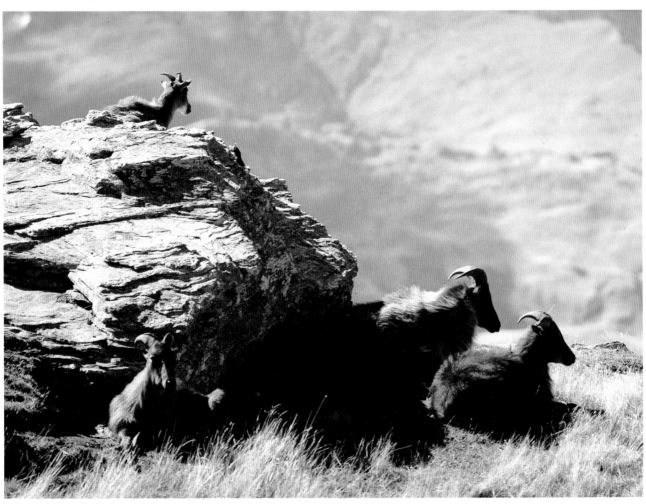

leaves the exposed tussock uplands and shelters in patches of beech forest where it feeds on fern roots and other vegetation. Red deer invaded these forests during the 1960s, eating out the understorey and thus depriving the takahe of its main winter food supply. Deer also fed on the red tussock of this region, the takahe's staple diet. These factors, combined with predation of eggs and chicks by mustelids, led to a rapid decline in the takahe population.

At the time of writing, takahe number less than 150 birds in the wild and a few more are thriving in captivity. However, deer and mustelids are now being controlled and the breeding of takahe chicks in captivity at the Te Anau wildlife reserve is proving successful.

The kea, the only alpine parrot in the world, is endemic to New Zealand and occurs throughout the Southern Alps. This highly intelligent and engaging bird is familiar to trampers and tourists for its inquisitive and destructive habits. Although it is strictly protected in national and forest parks, the kea is frequently destroyed by high-country farmers because of its alleged habit of attacking sheep.

Our smallest bird, the rifleman, is common in subalpine beech forests of both main islands. It appears constantly on the

OPPOSITE TOP Mount Cook at sunset. The Maori named the 3764-metre mountain Aoraki or Aorangi, the cloud piercer.
OPPOSITE BOTTOM Himalayan thar were liberated near Mount Cook early this century. They multiplied and spread north and south along the alps, causing damage to the sensitive alpine herbfields. However, their numbers have now been controlled.
BOTTOM RIGHT The snowberry (*Gaultheria* species), is a small creeping plant found in many alpine herbfields. It is often unnoticed until it produces its large fruits. In Fiordland the fruits were a favourite food of kakapo.
BOTTOM LEFT The largest of the buttercups, *Ranunculus lyallii*, often erroneously called 'the Mount Cook lily', grows in many moist subalpine locations in the South Island. Large clusters of these beautiful metre-tall plants can often be found bordering mountain streams and tarns.

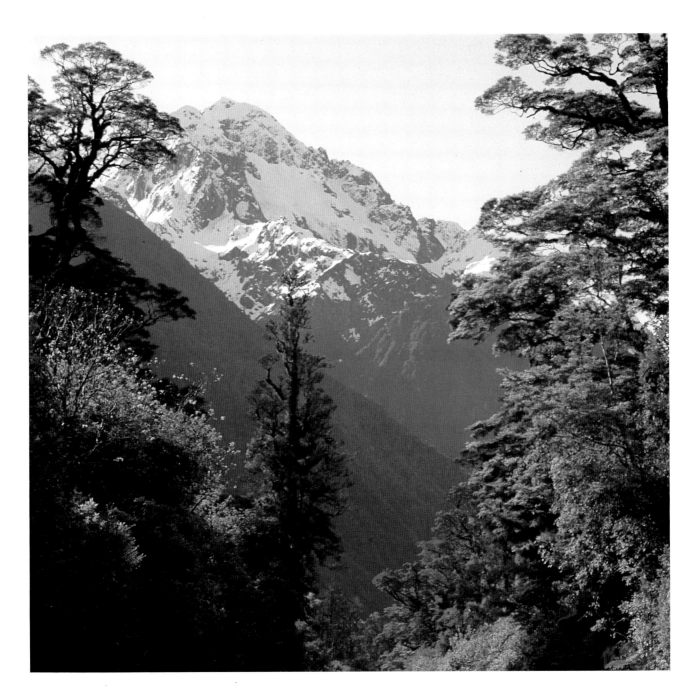

Beech trees frame peaks of the Darran Mountains, west of the Hollyford River in Fiordland.

'The solemn peaks but to the stars are known . . .'
— M. Arnold

move, flicking its wings as it spirals around tree trunks in its search for small insects and spiders.

Only slightly larger, and strictly an alpine species, the rock wren is found only in the South Island, where it inhabits areas of tumbled rock and herbfields. Rock wrens are weak fliers and have unusually large feet. They are more often seen bobbing up and down amongst alpine vegetation and around rocks. During winter, when the rockfalls are blanketed in snow, it is thought that rock wrens are able to live in the spaces and crevices between the rocks, and continue to find insect food.

Another species which is absent from the North Island is the brown creeper. It inhabits subalpine and lowland forests of the South Island and Stewart Island.

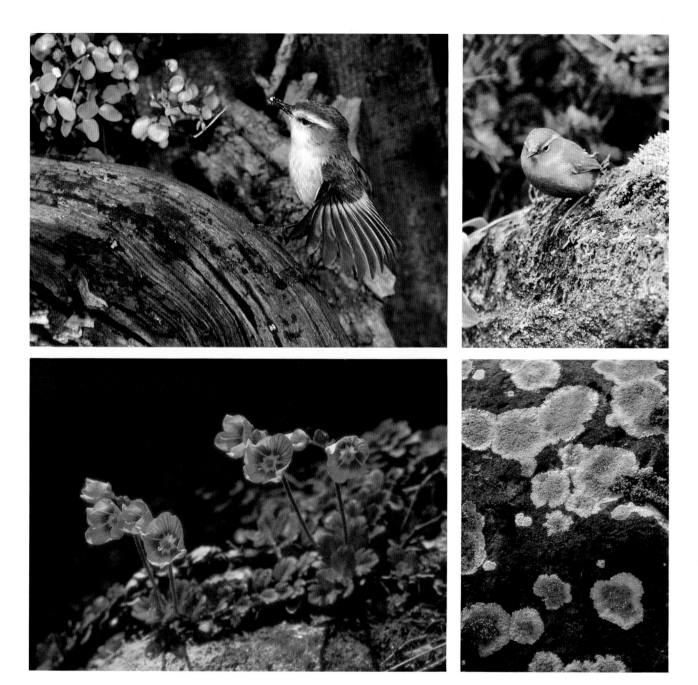

The New Zealand pipit inhabits open ground in alpine regions. It is similar in size and colouring to the familiar introduced skylark found in lowland pastures, but can be distinguished by its slimmer build and habit of constantly flicking its tail as it searches for insects among the rocks and tussock. Pipits can also be seen near the coast; frequently they feed along the tideline of ocean beaches.

Blue ducks are endemic to New Zealand. They were once common on many of our waterways, but are now restricted to living on fast-flowing, turbulent mountain rivers, particularly those which have forest growing on their banks. This species is an insect feeder and is unusual in having a soft flap at the tip of its bill. The purpose of this adaptation is not understood, but it may

TOP LEFT The rifleman is our smallest bird, measuring only eight centimetres in length. It is quite common in montane and subalpine forests of both the North and South Islands, and shows a distinct preference for beech forests.

TOP RIGHT The rock wren, found only in the South Island, is a true alpine species, inhabiting avalanche-tumbled rockfalls and herbfields.

BOTTOM LEFT *Parahebe* flowers. These beautiful low-growing plants are found in moist alpine and subalpine locations. The flowers of this species (*P. hookeriana*) vary in colour from pink to lilac.

BOTTOM RIGHT Patterns on a lichen covered rock.

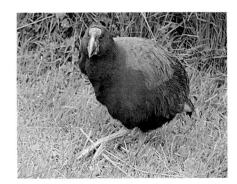

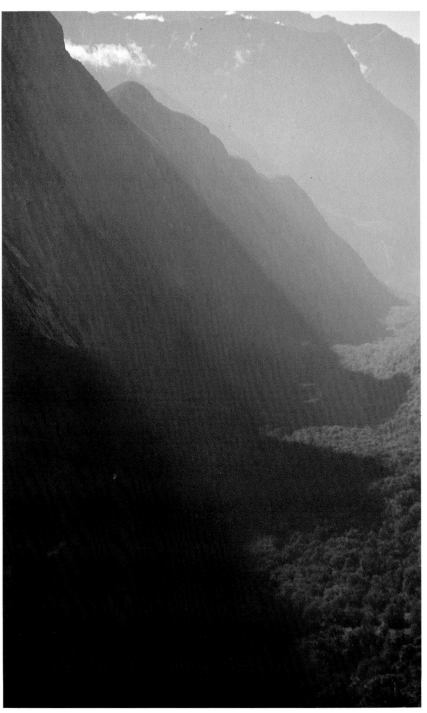

TOP LEFT The takahe, a large endemic rail, was thought to be extinct early this century. However, in 1948 Dr G. Orbell rediscovered a colony of the birds living in the Murchison Mountains west of Lake Te Anau. The lake (opposite) now bears his name.

ABOVE A mountain harebell of the *Wahlenbergia* genus, abundant in tussock grasslands.

RIGHT Differing shades of blue colour the steep spurs extending into the Sinbad Valley from Mitre Peak in Fiordland.

serve to protect the bill when the duck is plucking insects from rocks in turbulent water.

Many of the small introduced passerines such as starlings, dunnock and finches inhabit the high country. These form a substantial part of the diet of one of our most spectacular birds, the New Zealand falcon or bush hawk. Smaller than the slow-flying harrier of the lowlands, the falcon can be recognised by its rapid wing-beat and longer tail. It is an extremely aggressive bird when its nesting territory is encroached and it will not hesitate to vigorously attack a man or his mustering dogs. For this reason falcons are sometimes shot by farmers.

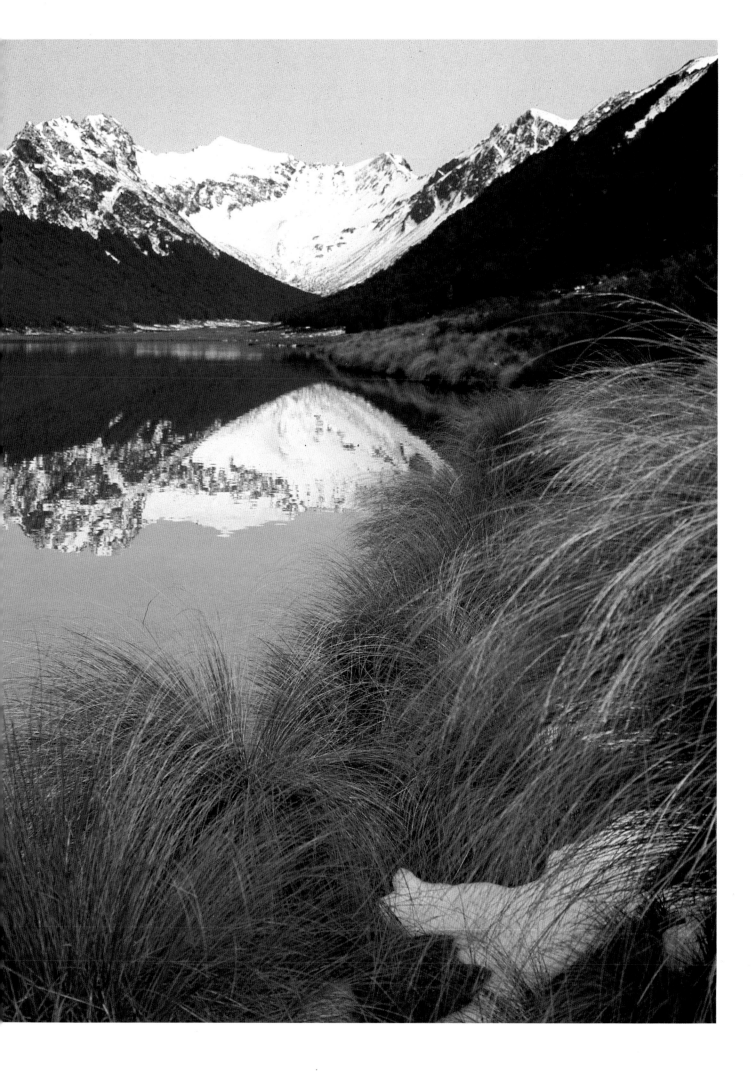

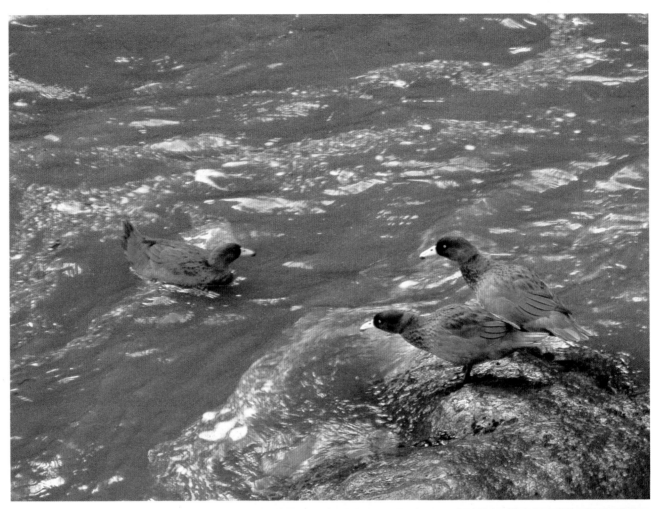

TOP The endemic blue duck, which has no close relatives anywhere in the world, was once found on many New Zealand rivers. It is now confined to turbulent high-country streams and rivers which are fringed with forest. The blue duck feeds on aquatic invertebrates, particularly caddis fly larvae, and insects which drop from the surrounding trees. The duck's bill is peculiar in having a fleshy tip which is thought to give protection when the bird is feeding around submerged rocks in turbulent water.

RIGHT A pattern of frosted grasses.

I well remember an encounter while I was tramping in high country at the head of Lake Ohau. As I emerged into a clearing from some low subalpine bush, without warning I was suddenly struck on the head by a female falcon. She quickly circled to gain altitude before folding her wings to repeat the attack. I hastily

TOP Numerous species of coprosma shrubs grow in New Zealand. They produce succulent fruits which provide food for birds.

LEFT Mount Hikurangi at 1754 metres is the highest non-volcanic mountain in the North Island. It is the dominant peak in the inaccessible Raukumara Ranges near East Cape, and is the first part of New Zealand to be touched by the sun's rays each morning. Hikurangi is revered by the Maori, whose mythology names it as the resting-place of Maui's canoe.

found a branch of foliage to hold above my head for protection against her rushing dives until I had left her territory. There was a steep, rocky ravine close by and I imagine she had her nest there, sheltered on a ledge of rock.

On another occasion I found this aggressive trait rather unnerving. I was building a hide on a rocky bluff and needed both hands to hold on while being repeatedly assaulted by a falcon. Fortunately the falcons appeared to ignore the completed hide and I was able to watch their nesting behaviour from close quarters without disturbance.

Several species of birds found in lowland habitats move to upland regions to feed during warmer months. Tuis, bellbirds,

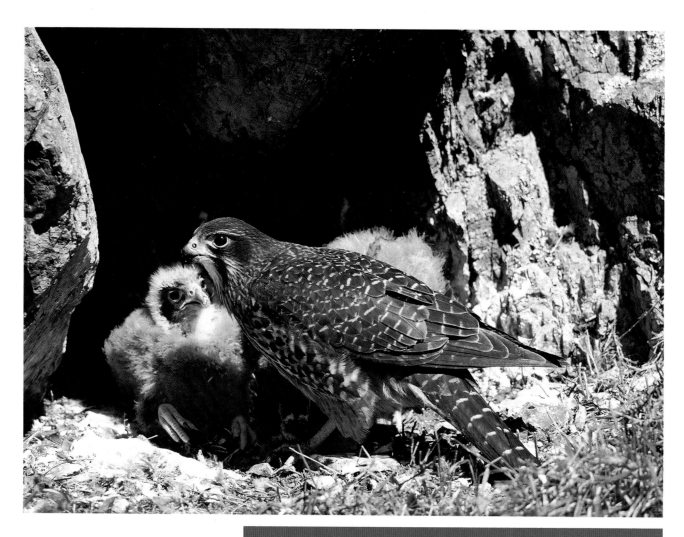

TOP The endemic New Zealand falcon is mainly a bird of the South Island high country. It is also found in the North Island, south of the central plateau, where it often inhabits forest. The falcon is an aggressive predator, feeding mainly on small birds and rodents, and will occasionally attack domestic fowls. Falcons sometimes nest in clumps of perching astelia in trees, but more commonly their nest site is on the ground beneath an overhanging rock or on cliff ledges
RIGHT A pylon hide, built on a rocky bluff to photograph the falcon pictured above.

silvereyes and parakeets can all be found in subalpine forests at these times. Some other birds nest at surprisingly high altitudes. Black-backed gulls, South Island pied oystercatchers and banded dotterels, which all nest in lowland habitats, can also be found nesting above the timberline, and the inhospitable Rangipo Desert provides a nesting habitat for the banded dotterel.

The kakapo is the world's largest parrot. It is nocturnal and, although possessing well developed wings, is flightless. The

LEFT The Seaward Kaikoura Mountains are very young in geological terms, and are still rising.
RIGHT The kea, or mountain parrot, inhabits the alpine regions of the South Island. It is now fully protected by law.
BOTTOM A view of Mount Cook taken from near Tekapo. At 3764 metres, Mount Cook is the highest mountain in New Zealand.

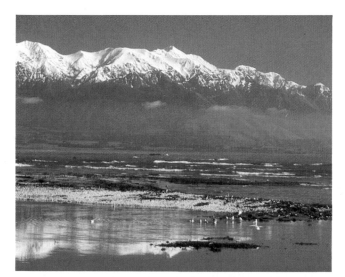

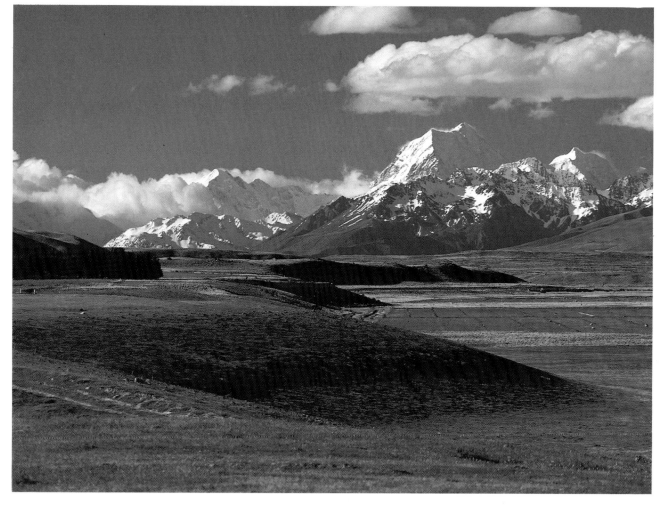

The mountain cedar or kaikawaka is a conifer and one of the most spectacular trees in montane and subalpine regions. It grows on the moist western slopes of central North Island mountains and on parts of the South Island's West Coast. The tree has a pyramidal shape and an attractive russet-coloured flaking bark.

kakapo was a common bush bird in the 1800s and occurred in the central North Island, although it was always more prevalent in the South Island and Stewart Island. Early this century numbers began to decline rapidly, probably due to predation by rats and mustelids. Today less than a dozen male kakapo are scattered in subalpine areas of Fiordland, and a small breeding colony survives precariously in the south-west of Stewart Island, constantly under threat of predation by feral cats. It is also possible that a few birds may exist in north-west Nelson. In 1982 twenty-two kakapo were relocated to the safety of Little Barrier Island, where they are doing well but have not yet bred.

In 1974, I was privileged to join Wildlife Service officers in a search for kakapo in Fiordland. We camped in the Esperance

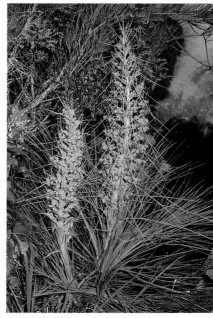

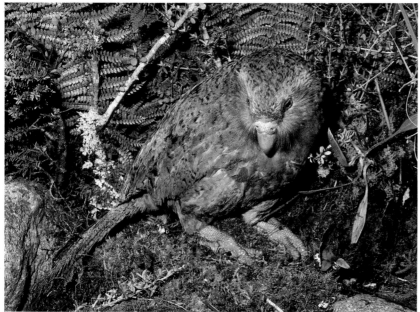

TOP LEFT The mountain cabbage tree (*Cordyline indivisa*), with its broad, thick leaves, grows in montane regions where there are gaps in the forest canopy.
TOP RIGHT Spaniards, or speargrasses, are members of the carrot family. They are commonly found growing in high-country tussock grasslands.
LEFT The nocturnal, flightless kakapo is the world's largest parrot. Less than a dozen ageing male kakapo survive in Fiordland, and a small breeding colony exists on Stewart Island. Recently, over twenty birds were transferred to the safety of Little Barrier Island.

Valley with its towering sheer-sided walls, and later flew by helicopter to camp on a high ledge above the bushline at the head of the Sinbad Valley. We had a magnificent view overlooking virgin beech forest in the valley below. Running down to this valley floor from the south side of Mitre Peak was a succession of steep spurs and on fine days these assumed different shades of blue as they receded into the distant Milford Sound. Fiordland is noted for its torrential rainstorms, and these occurred frequently during our stay. Our tents were complete with flysheets and attached floors, and were tightly secured on rocky ground, yet one night, during a particularly wild storm, our tents were awash as torrents of water roared from hundreds of waterfalls pouring off the rock walls around us. After such rainstorms the wind would

The seedhead of a snow tussock glistens as the sun emerges after rain.

abate, the sky clear and the sun would transform the scene, with the wet rock faces glistening and the raindrops sparkling on the tussock heads.

It had been known for some time that less than a dozen old male kakapo were surviving in Fiordland. One of these birds had his territory on a high, scrub-covered spur above our campsite. Here we built a hide which we occupied each night to watch his nocturnal mating activities. He repeatedly sent out resounding deep booming calls in an attempt to attract female kakapo, even though his attempts were in vain as today no female birds survive in the region.

It was later decided to transfer this lone male and we captured him by baiting a cage-type opossum trap with apple. A

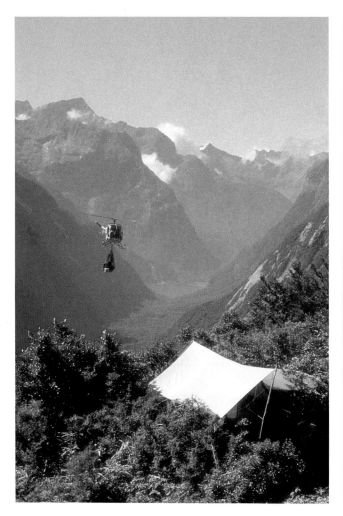

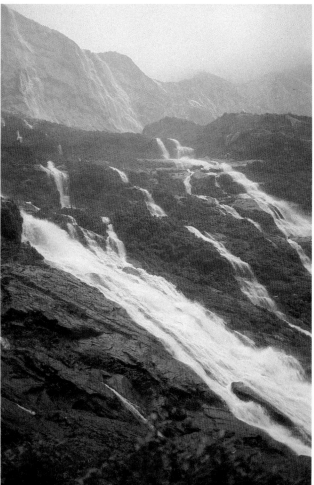

small helicopter was able to balance with only one skid resting on a prominent rock to uplift me with the kakapo and fly us to the Esperance Valley. As there was no door on my side of the helicopter and we flew skirting the mountain bluffs and forest canopy, I felt the trees were within touching distance.

The kakapo was housed in a spacious aviary in the Esperance Valley camp and soon became quite tame, accepting a variety of vegetable foods, with apple his favourite. Today, this male kakapo lives with the others which, as already mentioned, have been transferred to the sanctuary of Little Barrier Island in an attempt to establish a new breeding colony.

ABOVE Paradise ducks inhabit the high country as well as lowland areas.
TOP LEFT A helicopter bringing supplies to our 'kakapo search' campsite at the head of the Sinbad Valley in Fiordland on a rare sunny day.
TOP RIGHT Water cascades from the steep slopes during a Fiordland rainstorm.

As the popularity and development of some of our mountain areas has increased, access roading to skifields has scarred hillsides in those areas. However, most of our high-country landscape remains unspoilt, with the rugged mountains and forested hills forming an imposing backdrop to our open country, wetlands and forests.

eight

THE URBAN LANDSCAPE

The urban landscape is indeed the habitat of Man. There is a definition stating that 'to render urban is to remove the rural character'. In our rural regions we see considerable evidence of Man's development and his occupation, but in the towns and cities his settlement and presence is total. The growth is continual, with town-centre buildings rising and competing with each other, and housing estates creeping into the surrounding countryside and forest fringes.

It is in our largest cities that commerce and Man's pressured activities amidst sterile structures is most obvious. However, there is need for relief from daily mechanism, so we find buildings reserved for cultural use and display, and even in small roadside settlements, shops

Most towns and cities in New Zealand have parks and open spaces where one can relax and escape the hustle and noise. Auckland has numerous extinct volcanic cones within its boundaries; many of these have attractive parks and recreation areas surrounding them. The rim of the Mount Eden crater, provides all-round viewing of Auckland's sprawling metropolis.

filled with local art and craft works. As well, in most towns and cities, areas have been set aside as parks or developed to provide sporting facilities.

Within busy city streets, bright, well tended plots of flowers and potted trees impart a sense of nature, and in some centres colourful markets have added a more casual, lively charm to the city scene of recent years.

Many New Zealand settlements are associated with waterways. The indented coastline is notable for many deep, natural harbours, and these are now often encompassed by towns and cities. In fact, Auckland straddles an isthmus, with harbours on either side. The boating scene close to most of these built-up areas is therefore a familiar sight. In numerous bays along the coasts, smaller housing developments have been established as holiday and retirement retreats. As well as these seaside settings, many urban expansions border lakes or are located alongside rivers.

In New Zealand we are fortunate in that, as well as our proximity to the water, we are also close to forest reserves, with the suburbs of some cities spreading into the fringes of forests.

As settlers arrived in New Zealand, they built their dwellings and planted trees from their homelands, so that now these exotic or introduced trees thrive more obviously in the urban landscape. Evergreen native trees are often seen in town gardens and established parks, as well as mature exotic trees and flowerbeds. The introduced trees add welcome colour to the urban landscape, particularly when seen grouped together or grown to a grand size with age. In spring the new leaves are the brightest green and soon cover the branches to provide welcome pools of shade in

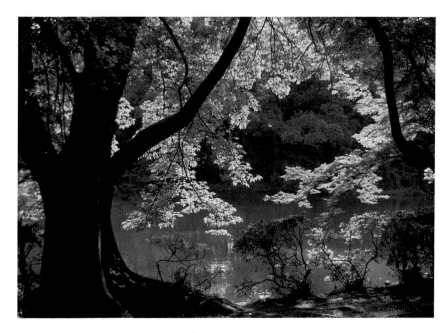

The early settlers introduced many varieties of deciduous trees and shrubs. They brighten the urban scene with their blossoms and soft green leaves in spring, provide welcome shade in summer, and add colour in autumn with their tints of russet and gold.

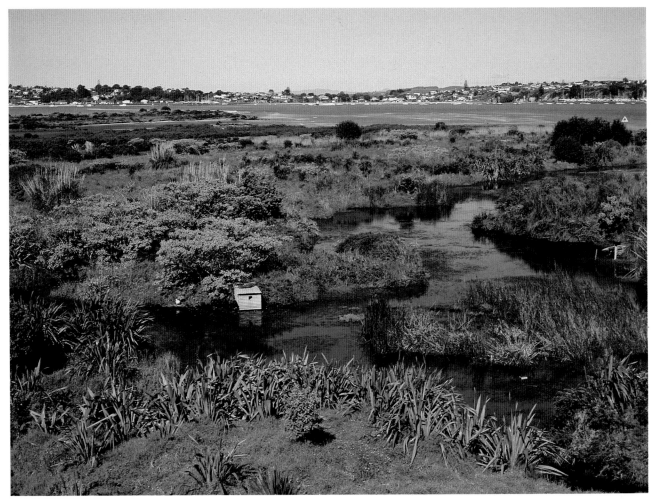

TOP RIGHT The trail of silver left by a snail supplies evidence of its nocturnal peripatetic journey.

TOP In 1973 the Auckland City Council proposed to use land round the Glen Innes spit as a refuse dump. However, local residents and conservationists campaigned to save the area, and today it has been developed into a valuable nature reserve, with well constructed paths and lookouts where one can watch many species of swamp and wading birds, all on the city doorstep.

BOTTOM RIGHT A duck with her ducklings on a small lake in the gardens at Queenstown.

summer. In autumn, the magical change occurs, with dying leaves of gold and russet brightening the duller days, until finally we are left with only a pattern of bare branches etched against the winter sky. The seasonal changes in these deciduous species are more dramatic in the colder districts, where autumn trees produce the most brilliant colours.

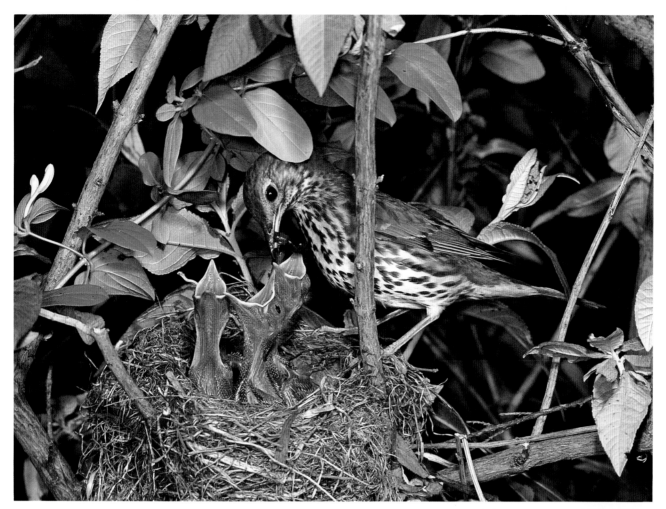

Away from the gardens, parks and city centres are the industrial areas. In the past those scatterings of basic buildings have sprung up about each other in a sterile and monotonous commercial style. However, today many of the industrial complexes have been designed attractively and set among neatly arranged trees and shrubs.

Rubbish-tips and sewage-treatment plants have a necessary place in the urban landscape, and are in most cases sited away from populated areas. They attract certain forms of wildlife, especially rats and a few feral cats which prey on them. Rubbish-tips attract the scavenging, black-backed gulls which circle around the belching earthmovers, searching for morsels of food. Large flocks of starlings, sparrows and finches, and in northern districts, mynas, flock in winter to feed on piles of the dry dredgings from settlement ponds, and ducks and various waders feed around the less polluted oxidation ponds.

A surprising variety of bird species live and nest in city parks and suburban gardens. Feral pigeons, starlings, sparrows and red-billed gulls are a familiar sight, as are ducks and pukeko around park lakes. These lakes will often attract welcome swallows and kingfishers. Native bird species live and nest in many suburban gardens, silvereyes, fantails and grey warblers being the commonest. Tuis, and in some districts bellbirds, come to feed in

TOP A songthrush at its nest in a town garden.
ABOVE City parks provide open space and tranquillity to escape from the noise of traffic.

Most New Zealand towns and cities have public gardens with colourful beds of flowers. Some have conservatories or heated glasshouses where exotic tropical plants are cultivated.
ABOVE A glasshouse in the Auckland Domain.

'Within the summer garden's lingering murmurs and every busy hum of life unseen, is yet an idle air, when all seems still, unending.'

— *L.M.M.*

our gardens on nectar-producing flowering trees and shrubs.

Some true forest-dwelling birds, for example the morepork, have adapted to inhabit town gardens, where they feed on mice, small birds and insects. They are often attracted to feed on moths which flit around street lights.

Various seabirds are a common sight along the waterfronts of our coastal towns and cities. Gulls, terns and shags may be seen perched on wharves and sea walls, and some of them nest in the quiet bays of our harbours. Large colonies of shags nest close to the city in Auckland's Orakei Basin, and in the Manukau Harbour, and black-backed gulls have nested on city buildings. Little blue penguins come ashore at night and are occasionally killed by traffic. This hazard exists along the waterfront road around Wellington's eastern bays.

Even within densely populated areas, most New Zealanders own gardens. These gardens are a part of our lives and we become familiar with the wildlife which may frequent them. We are able to attract more birds and butterflies to our gardens by planting certain flowers and shrubs, providing feeding tables and building nest-boxes for starlings.

Tuis, bellbirds and silvereyes may be lured into the garden by nectar-bearing flowers, and can be enticed to feed from

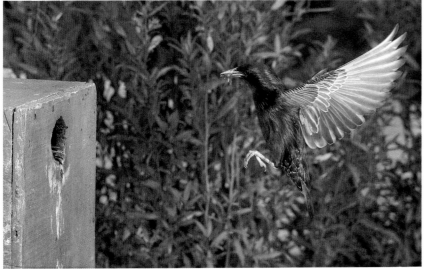

containers of sugar solution. However, bees and wasps will also be attracted by the sugar. Thrushes are usually seen searching the lawn, now and again pausing to snatch up an earthworm. Blackbirds, finches and especially sparrows are often close by, and always ready for crumbs.

During winter, birds visit our gardens frequently in their constant search for food. At this time, silvereyes are common and

TOP Steps lead through an urban garden where a starling nest-box may be seen in the background.
BOTTOM LEFT A starling flying to its nest-box.
BOTTOM RIGHT Domestic cats are natural hunters and, unfortunately, frequently catch small birds. For this reason bird tables and birdbaths should be positioned well away from cover where cats are likely to lie in wait.

Monarch butterflies taking nectar from *Achillea millefolium*. 'Swan plants' are the host for their caterpillars and can be grown to attract them.
ABOVE Autumn-tinted leaves add colour to our gardens when deciduous trees are grown.
OPPOSITE PAGE At dawn a songthrush melodically proclaims his territory from a treetop.

seem to particularly fancy pecking at lumps of lard or fat provided for them.

The placing of starling nest-boxes on trees or posts in the garden brings much interest as we watch the birds' preparations and the subsequent rearing of the chicks.

In midsummer the garden is alive with the sounds of birds and cicadas, and the activities of an abundance of other insects. In some instances birds may damage fruit or disturb newly sown seed, but they will also aid the gardener by taking snails and insect pests. Whatever the time of year, we are able to keep our gardens alive with birds by encouraging them in many ways.

The New Zealand urban scene is a young one by world standards, with no town or city more than 150 years old. As development has been so rapid, buildings tend to be streamlined and glossy, so there is an absence of that feeling of antiquity, the mellowed, historically enduring quality typical of the very old cities and villages of the world. However, more recently in some new building schemes the early colonial style has been recaptured. Eventually New Zealand's urban landscape must mature, and with this the spirit which Man contributes to it.

BIBLIOGRAPHY

Annotated Checklist of the Birds of New Zealand. Ornithological Society of New Zealand Inc. (Convenor F.C. Kinsky), Reed, 1970

BULL, P. C., GAZE, P. D. and ROBERTSON, C. J. R., eds., *Atlas of Bird Distribution in New Zealand.* Ornithological Society of New Zealand Inc., 1985

DALY, G. T., in *New Zealand's Nature Heritage,* (partworks). Hamlyn, 1974-6

FALLA, R. A., SIBSON, R. B. and TURBOTT, E. G., *The New Guide to the Birds of New Zealand.* Collins, 1979

FLEMING, C. A., *The Geological History of New Zealand and its Life.* Auckland University Press and Oxford University Press, 1980

FLEMING, C. A., in *New Zealand's Nature Heritage* (partworks). Hamlyn, 1974-6

HALEY, DELPHINE, *Seabirds.* Pacific Search Press, 1984

HARGREAVES, R. P., in *New Zealand's Nature Heritage* (partworks). Hamlyn, 1974-6

HARRISON, PETER, *Seabirds.* Croom, Helm Ltd and Reed, 1983

MARKS, A. F. and ADAMS, NANCY M., *New Zealand Alpine Plants.* Reed, 1973

MILES, SUE and MOON, GEOFF, *The River, The Story of the Waikato.* Heinemann, 1983

MOON, G. J. H., *Refocus on New Zealand Birds.* Reed, 1967

MOON, GEOFF, *The Birds Around Us.* Heinemann, 1979

MORTON, J. E. and MILLER, M. C., *The New Zealand Sea Shore.* Collins, 1973

POOLE, A. L. and ADAMS, N. M., *Trees and Shrubs of New Zealand.* Govt Printer, 1979

Wild New Zealand. Reader's Digest, 1981.

INDEX

Note: figures in bold type refer to illustration pages and captions.